FLYING FREE

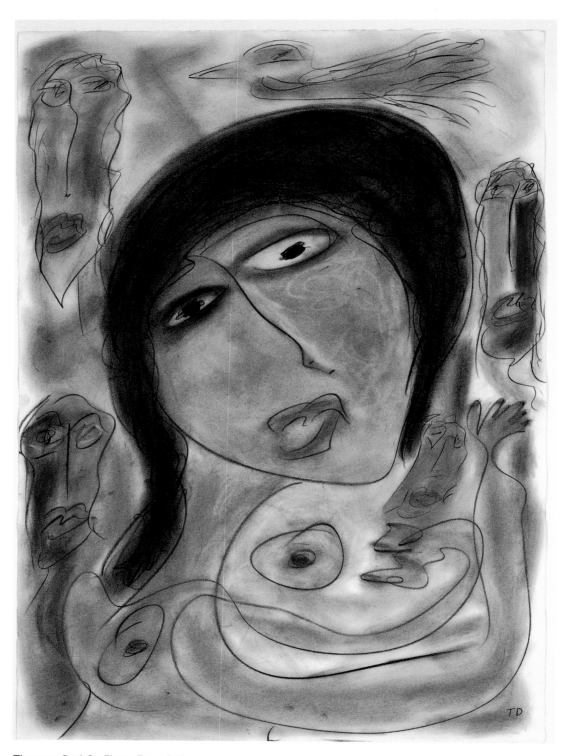

Thornton Dial, Sr., Flying Free (Woman's Head)

Twentieth-Century Self-Taught Art from the
Collection of Ellin and Baron Gordon

FLYING FREE

By

Ellin Gordon

Barbara R. Luck

Tom Patterson

Artists' Biographies Compiled by Laura E. Pass

Catalog for an Exhibition Organized by
The Abby Aldrich Rockefeller Folk Art Center

Published by The Colonial Williamsburg Foundation
Williamsburg, Virginia

In Association with University Press of Mississippi
Jackson, Mississippi

Published by The Colonial Williamsburg Foundation,
Williamsburg, Virginia, in association with
University Press of Mississippi, Jackson, Mississippi

Library of Congress Cataloging-in-Publication Data

Gordon, Ellin.
 Flying Free : twentieth-century self-taught art from the
collection of Ellin and Baron Gordon / by Ellin Gordon, Barbara R.
Luck, Tom Patterson ; artists' biographies compiled by Laura E. Pass.
 p. cm.
 "Catalog for an exhibition organized by the Abby Aldrich
Rockefeller Folk Art Center."
 Includes bibliographical references.
 ISBN 0-87935-174-8 (C.W.)
 ISBN 1-57806-029-X (Mississippi)
 1. Outsider art—United States—History—20th century—
Exhibitions. 2. Gordon, Ellin—Art collections—Exhibitions. 3.
Gordon, Baron—Art collections—Exhibitions. 4. Outsider art—
Private collections—United States—Exhibitions. I. Luck, Barbara. II.
Patterson, Tom, 1952– . III. Pass, Laura E. IV. Abby Aldrich
Rockefeller Folk Art Center. V. Title.
N6512.G66 1997
709'.73'0747554252—dc21 97-6988
 CIP

Front cover: Vollis Simpson, *Bicycle Man*
Back cover: Jon Serl, *The Blue Barrel*

Photographs of the Gordon collection by Tom Green
Front cover photograph by Tim Gabbert and Sean Phillips

Book design: Helen Mageras

Printed and bound in Canada

CONTENTS

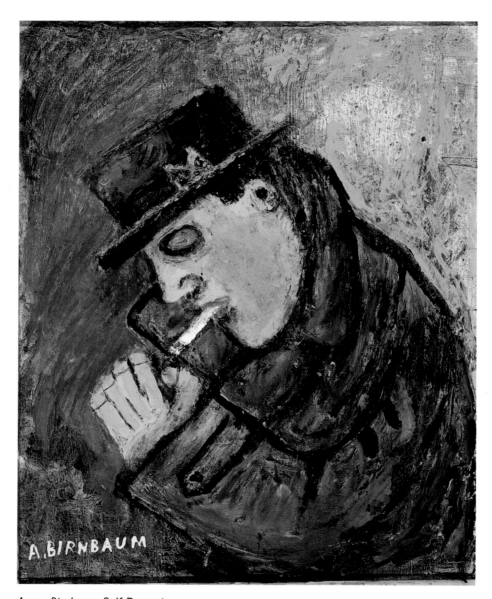

Aaron Birnbaum, Self-Portrait

The Abby Aldrich Rockefeller Folk Art Center, part of Colonial Williamsburg's extensive museum operations, is pleased to present one of the most important of its recent exhibits featuring folk or self-taught art of this century. *Flying Free: Twentieth-Century Self-Taught Art from the Collection of Ellin and Baron Gordon* is an appropriate culmination to the many years of friendship Colonial Williamsburg has enjoyed with these active and discerning collectors. Ellin and Baron were attracted to Colonial Williamsburg in large part because of the Folk Art Center's long-standing interest in acquiring, researching, and displaying the art of those whose aesthetic expressions are derived largely through intense self-development and experimentation with a myriad of materials, ideas, and the recording of both spiritual and temporal experiences.

Abby Aldrich Rockefeller, the founder of Williamsburg's premier collection of folk art, was, like her husband, John D. Rockefeller, Jr., deeply interested in the creative and historical forces that shaped this nation's history. She was especially attracted to the artistic work of little-recognized Americans regardless of age, race, level of training, or acceptance as "artists" by elite society and the art establishments. She, like the Gordons, built an outstanding collection based largely on her own assessment of the art quality or aesthetics of selected works. Abby Aldrich Rockefeller was also among the very small group of private collectors and modernist artists (whose work she also collected) who recognized a strong relationship between the nonrepresentational art being produced in their time and that of past centuries. The extraordinary works by twentieth-century self-taught artists owned by the Gordons also reflect this deep appreciation and understanding of art freed from the constraints of academic techniques and formulas.

It is always rewarding when an institution's mission and vision are closely shared and supported by its donors. Ellin and Baron Gordon are among those who, over the years, through gifts of objects, support of programs, and many hours of collegial "folk art" conversation, have shared our dreams and goals. Thus, it is a great pleasure for us to present their collection to the public and ultimately to share with our visitors one of the most remarkable collections of its kind in America today.

Robert C. Wilburn
President
Colonial Williamsburg Foundation

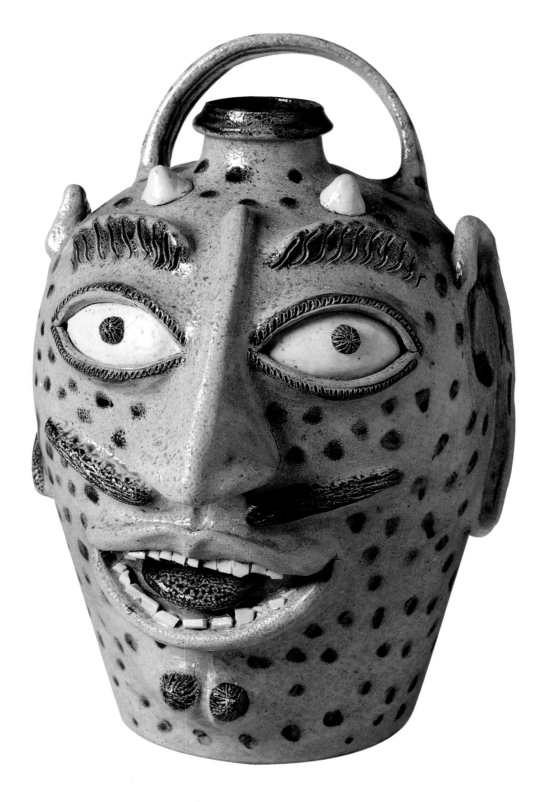

Billy Ray Hussey, Face Jug

ACKNOWLEDGMENTS

Our ideal museum has a warm, inviting, nonthreatening ambience. It is a place to lose ourselves and forget the outside world. An environment where visitors can marvel at centuries-old material, or have their senses awakened by new and previously unseen images. An opportunity to see the creations of artists who have ventured beyond the accepted norms of their time and confronted us with original concepts and often startling visions. A place where the desire to linger in one gallery is matched only by the pull to go on to the next and see what awaits, beyond the door.

As the oldest institution, and one of the few in the country, devoted solely to folk art, the Abby Aldrich Rockefeller Folk Art Center certainly meets our "ideal museum" criteria. We have returned time and time again to see new acquisitions and exhibitions, to visit familiar and favorite pieces, and generally to increase our knowledge in the field. We were delighted to see the new addition to the Center that opened in 1992, allowing for additional loan exhibitions and for more of the permanent collection to be on view as well as the possibility of expanding the museum's twentieth-century holdings.

We were thrilled when Carolyn Weekley, director of museums, approached us several years ago about the possibility of an exhibition of our collection at the Abby Aldrich Rockefeller Folk Art Center, with emphasis on the twentieth-century material. We respect Carolyn for her unmatched expertise in the field of American folk art, and we are extremely grateful to her for her enthusiasm and constant encouragement for this project (while she was working on two other major exhibits). We would like to express our sincere appreciation to Carolyn and all of the Colonial Williamsburg Foundation for giving us this opportunity to share our collection with the general public. Our hope is that the exhibit will introduce many visitors to a field that is evolving all around them, but of which they may be totally unaware.

Our special thanks to Robert Wilburn, president of the Colonial Williamsburg Foundation, for his interest in this material. To Graham Hood, vice president for museums, our most sincere thanks for his hours and hours of lively and soul-searching discussions with us about folk art and for his continuing reassurances and confidence. It is hard to find the words to thank Barbara Luck, curator of paintings. As curator of *Flying Free,* we admire her for her grace, perseverance, and humor during this process. She has been our inspiration and friend, and she has made the whole experience a memorable one for us, and undoubtedly for her as well. We have enormous respect for Barbara's talent as a curator and for her depth of knowledge and keen insights in the field of American folk art.

We were particularly fortunate to have had the opportunity to work with the fine staff of the Abby Aldrich Rockefeller Folk Art Center. They included Laura Pass, curatorial intern, who spent many, many hours compiling the artists' biographies and the bibliography; Anne Motley, collections manager, who

somehow managed to keep everything organized and orderly; Debbie Green, secretary, who assisted us with the mailing list and numerous details; Jon Prown, associate curator of furniture and sculpture, for his input on a number of objects; Shirl Spicer, assistant curator of musuem education, who was a great help in planning and carrying out the exhibit's programming components; Pat Bedtelyon, whose secretarial skills added to the smooth functioning of the project; and to Osborne Taylor, James Parker, Jay Gallop, and Robert Jones for their patience and good humor while lifting, carrying, and otherwise exerting themselves on behalf of the show. Our thanks also to the docents. Their enthusiasm is contagious, and the result of their hard work is apparent in the interest of the visitors to the Folk Art Center.

Flying Free utilized the talents of many people at the Colonial Williamsburg Foundation including Joe Rountree, director of Publications, who answered our constant questions from the perspective of vast experience and with good humor; Tom Green, whose expertise in photography adds special dimension to the catalog; Helen Mageras, who designed the stunning catalog; Rick Hadley, exhibition designer, whose exciting plans invite the visitor to explore further; Ed Moreno, mount maker, whose efforts contributed to both the secutity and the aesthetic presentation of the objects; Suzanne Coffman, editor/writer, whose careful attention helped shape this catalog; Liza Gusler, curator of museum education and exhibitions coordinator, who guided the structure of various programs associated with the show; Steve Ray, objects conservator, whose expertise on materials was helpful in terms of both advice and treatments; and Al Louer and Sarah Houghland in the Development Department, whose assistance with funding challenges was essential.

A special "thank you" to Tom Patterson for his thoughtful and provocative essay. We were delighted when Tom agreed to contribute to the exhibition catalog. His essay is written from the vantage point of firsthand knowledge of many of the artists and his solid experience as a frequent author on the subject of twentieth-century self-taught art and artists.

Finally and always, the artists deserve our highest praise and our warmest thanks for their talents, their willingness to let us share their dreams, and for their inspiration.

Ellin and Baron Gordon

Few aficionados of American folk or self-taught art who open this volume need an introduction to the superb collection of Ellin and Baron Gordon. As two of the most passionate followers of the field over several decades, they are well known to private collectors and scholars as well as to the many museums that in recent years have mounted an impressive array of exhibits and catalogs devoted to those American artists classified in such terms as "self-taught," "folk," "outsider," or "others." Selections from the Gordons' collection have been included in many of these shows. Ellin and Baron are exceptional in the energy they have expended in refining their collection and have always been generous with their time and knowledge of the subject. Needless to say, their love for and support of the Abby Aldrich Rockefeller Folk Art Center, where Ellin often serves as a volunteer, is a source of great pride and appreciation for all of us who have had the privilege of working closely with them. Among their many kind and generous deeds has been the gift of funds to help support the publication of this catalog.

Over the years of our friendship, and more recently as we began the formal planning for the catalog and the exhibit, we've held a number of lively and thoughtful conversations with Ellin and Baron about their collecting activities, which date back several decades, the individual artists represented in their collection, and the field of "folk art" in general. Like most discussions, comments ranged from the very detailed to broader issues, including the selection of a title for the exhibit and its catalog that reflected both the museum's and the Gordons' philosophy about the art and its makers. It was soon apparent that none of us fully endorses any of the given classifications for the rich and diverse objects represented within this volume, although each descriptive has its salient and useful purposes. Definitions, and hence meanings, like words themselves, change with time and cultural context. We have all observed, as Tom Patterson and Barbara Luck explain in their essays, that most of the categories popularly used through the years to order this material are largely self-serving, coined with the good intentions to suit particular cultural attitudes toward art and society at given times.

After much discussion, we settled on a title that seemed to express the most obvious qualities associated with the art and its makers within those moments of creation—*Flying Free!* And we agreed to use the term "self-taught" because it seems characteristic of the backgrounds of most of the artists represented here. But we must stress that "self-taught" in this context does not imply that the aesthetic sensibilities or efforts of the men and women featured in this catalog are in some way inferior by any art historical measures or standards.

The catalog essays serve as three separate viewpoints on the Gordon collection. We thought this arrangement would be useful to readers who wish to understand the material through the reactions and

ideas first of the collectors; second of a museum curator, Barbara Luck, who has spent more than twenty-five years studying the full range of material often called folk art; and third of a freelance writer, Tom Patterson, whose thoughtful probing brings fresh insight into the environments and experiences that influenced certain artists' lives and thus their art. Taken together, these essays function not only as personal statements by their authors but also as guides in analyzing the material and its makers, as alternate ways of gaining an appreciative understanding of the forces that shaped this richly imaginative and often provocative art.

Ellin and Baron Gordon's collecting is heavily marked by their love of shapes, forms, and color. The boldness and directness of twentieth-century self-taught art became especially appealing to them after years of forming more collections of rare books, Chinese export porcelains, and other materials. Their earliest folk art purchases were mostly nineteenth-century stoneware, paintings, signboards, and painted furniture. As Ellin has stated, "None of our friends was collecting this kind of art" when they began in the 1960s. First influenced by Bert Hemphill, often called the "father" of twentieth-century folk art, Ellin and Baron began to acquire key examples of twentieth-century self-taught art in the 1970s. Their collection is now large, filling their house on every wall and surface. Baron was the first to acknowledge that this serendipitous overflow is "wild because we have so many things stacked in a bathtub." Those of us who have worked with the Gordons in selecting objects for the exhibit know that few artworks stay in one place, even bathtubs, for long! Their home "exhibits" change constantly, at least weekly, so that new arrangements of art provide new relationships between artists and artists, art and art. It is a moving feast for the eyes, a never-ending series of visual experiences from which the Gordons take great pleasure as they continue to build upon their already vast knowledge of the material. Metaphorically, the Gordons' collection functions as their art creation, an evolving aesthetic unit that they constantly balance and rebalance as each new acquisition arrives. But, as Ellin points out in her essay, it is the **quality** of what they collect that is important to them.

Visiting self-taught artists and collecting their work has been nearly a full-time pursuit since the Gordons' move to Virginia. Ellin speaks of these exciting trips throughout her writing, of meeting diverse artists and recalling the wide range of works they have seen to date. Baron, ever the futurist and strategist, would quickly add, "Just think what it's going to be like in the twenty-first century!"

The essay by Barbara Luck, curator of paintings, focuses more closely on the art and on some of the artists' revealing insights about their work. Barbara cautions us in a more personal way about art historical values and how we, the public viewers of art, have been conditioned through years of scholarly theory and standardized interpretation to view and appreciate art according to prescribed standards and formulas. Her comments go further in probing how these various attitudes toward art have, in turn, created prejudices that often underscore the implications of inferiority associated with terms such as "folk," "nonacademic," "self-taught," and other sorts of American art.

Barbara's discussion of the artists' materials and their conscious selection of used items as well as ideas brings a new level of understanding to many of these works. The concept of the medium being an essential part of their message is not new in art criticism, but its application in the study of the works of today's self-

taught artists has been given little notice. As Barbara thoughtfully points out, used and recycled materials often have special meanings for artists. The concept of cultural inheritance, not through mimicry but reuse of materials, is an important notion put forth in Barbara's comments.

Guest essayist Tom Patterson, who is well known for his various articles and more recently the fine exhibit catalog *Reclamation and Transformation: Three Self-Taught Chicago Artists,* brings yet another viewpoint to the Gordons' fine collection. His discussion of terminology used in describing these works of art is especially useful in helping us understand the pitfalls of classification and historical attitudes about the roles of artists. Descriptives such as "outsider," often misused and little understood even among some collectors, are addressed in Tom's provocative opening paragraphs. His extended comments on a number of the artists represented in the catalog amply illustrate the myriad of "creative agendas" (as he calls them) that characterize this art and thus make classification difficult. It is the diversity of the art, its embodiment of often disparate values, the spiritual and temporal concerns and experiences as well as the preoccupations that might seem repetitive if not obsessive to many viewers, that Tom so eloquently addresses in these pages. Through a number of biographical and critical commentaries on individual artists, he successfully cautions us against forming generalities about these artists—that is, lumping them summarily into specific classifications such as "outsider" or "self-taught" or, worse still, assuming that their experiences and motivations are nearly the same. His essay thoroughly addresses the often-misunderstood messages of art in relationship to cultural contexts.

Finally, for those readers who wish to learn a bit more about individual artists, particularly those not mentioned in the essays, Laura Pass, Folk Art Center curatorial intern, prepared the brief biographical sketches that appear later in the catalog. Much of the material gathered for these notes was assembled by Ellin Gordon, whose valuable knowledge of the subject and whose extensive library, including not only published works but clippings and private photographs, were invaluable.

As a whole, this catalog may seem somewhat unconventional to readers who are accustomed to a general essay followed by formal catalog entries with biographical notes. This arrangement was intentional. Our purpose in modifying the traditional art catalog format was to produce a published work more in the spirit of the material it covered. Thus, the authors were free to offer their own insights and observations as well as to select those works from the Gordon collection that best illustrated their points of view. Our departure from traditional formats is neither unique nor uncommon, but rather a small yet important effort to join forces with those scholars and collectors who wish to deepen the dialogue and thus enhance our understanding of and public appreciation for the material.

Graham Hood
Vice President of Collections and Museums;
Carlisle H. Humelsine Curator

Carolyn J. Weekley
Director of Museums

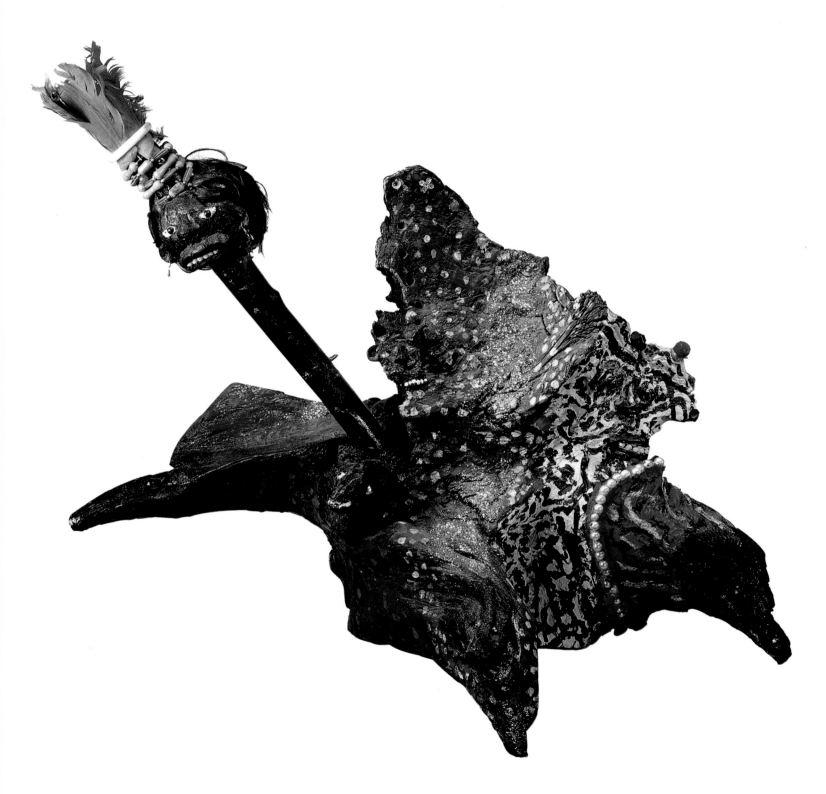

Bessie Ruth White Harvey, Untitled

MUSINGS ON AN OBSESSION

By Ellin Gordon

"Ellin, hurry if you want to go with us." That is my mother calling to me. We are living in Westchester County, New York, for the summer. I scramble to fasten my sandals, because I don't want to be late and at age six or seven, I am thrilled to go with my mother and her friends to "antique" along Route 7 in Connecticut. Were those a collector's early stirrings?

Baron grew up in a Norfolk, Virginia, neighborhood lined with large Victorian wood houses with wonderful porches where everyone gathered on summer evenings to discuss the day's events. You and your neighbors on either side and across the street were undoubtedly related, and children were always in and out of each others' houses. Baron does not have particular memories of art or music in his home, but he has warm recollections of his father's love of books, reading groups, and many discussions about literature. He cannot remember when he first knew he wanted a fine library, but he knows the desire goes way back. Was that desire a collector's first stirrings?

Our childhoods were filled with the usual children's pastimes for those World War II years. For Baron it was baseball cards, war cards, stamp collecting, electric trains, and scouting. I was occupied collecting miniature china, amassing and trading playing cards, drawing, and going to the movies.

When Baron grew older, travel was a great interest, and I believe he had visited every state in the country by the time we were married. I was much more of a stay-at-home. Growing up in New York City, there were many enticements nearby. Museum visits were frequent, Saturday afternoon Philharmonic children's concerts required, ballet occasionally, and the biggest treat of all was going to the theater. When Baron and I pause to question the onset of our collecting disease, we think back to book auctions at Sotheby's, Chinese export porcelain at the East Side Antique Show, and later weekend and late-night drives to New England searching for folk art. Today we are still searching, but now for the exuberant, robust work of twentieth-century self-taught artists. Childhood memories make these desires a bit more understandable.

I don't remember Baron mentioning anything about art or any particular interest in the arts until he was in the navy. When his ship visited Haiti, he purchased some paintings that he could not resist. I made my first purchase, a Renoir etching, after I graduated from college. Although not a very adventurous first step, I was quite pleased with myself. We cannot locate Baron's earliest treasures. I still have my Renoir, but it is no longer on the wall, having been replaced by a small nineteenth-century landscape that was in turn replaced by a twentieth-century self-taught painting.

Shortly after we moved to New York City in 1955, Baron met Richard (Dick) Feigen when they were both working on Wall Street. Before Dick left the Street to pursue a career as a successful art dealer, he and

1

Baron spent many Saturday afternoons in and out of New York art galleries, where Baron had his first exposure to contemporary art. He loved it. At that time, Dick's special interest was the German Expressionists, and I believe he was the first person to hold an exhibit of that genre in New York City after World War II. Many of the works spent short periods on the walls of our small apartment while the two men tried to convince me that I loved the work; I didn't. I found the paintings too strong, too disturbing, and looking back, I think I was unsure of my own taste and uncomfortable with a style that was so visceral and strident.

Our adventure into eighteenth- and nineteenth-century American folk art began in the mid-1960s, when we were building a contemporary house in Purchase, New York, about twenty-five miles from New York City. The house had a deck stretching across the back, and I thought cobalt-decorated stoneware would look wonderful on the bench that ran along the deck. Baron said that was a terrible idea. He thought that "stuff" was junk and old-fashioned. Driving through Maine to visit our son Jonathan at camp, however, we passed a farmhouse on the top of a hill that was covered with decorated stoneware of every shape and size. All of it was for sale! Even Baron had to admit the pieces looked tempting just sitting there, and when he found out that their costs ran from eight to fifteen dollars, he happily joined in the selection. Just as he is today, he was careful and particular about his choices. I was thrilled, and we drove off with a dozen jars and jugs in our station wagon. We were hooked.

At that time in our lives, we did not think of ourselves as "collectors" or as building a "collection." But our knowledge of American folk art came about naturally as we were furnishing our home, and our weekend activities of choice, usually with a child in tow, included museum exhibitions, antique shows, auctions, and antique shops. By asking endless questions, by looking and touching, and by reading, we began to learn about American folk art. A William Matthew Prior portrait was our first purchase after our stoneware binge. We found the painting when we stumbled into Mason Stewart's shop in Southbury, Connecticut, while looking for stoneware. We had not heard of Prior, but that did not trouble us, as our taste was based on the aesthetics of a piece and its emotional impact, not on its provenance, history, or intrinsic value. Baron, however, did insist on endlessly checking conditions and authenticity while I waited impatiently, just as concerned with the look of the painting and always confident it was authentic. These are traits we both maintain today, and thirty years later, we have the same arguments. Ironically, it makes for a balanced assessment of acquisitions. Like most collectors, we've made mistakes, and we believe that we have learned from them. More often we remember with regret the great pieces that we did *not* buy.

During these same years, we became intrigued with painted furniture and decorative objects. The surfaces appealed to us not only for their workmanship and decorative qualities but also for the wonderful warmth and patinas they emanated. We knew where we would place every piece of furniture we bought and on what walls we would hang the two-dimensional works. After all, we could always pile another painting or painted sign onto the high walls. Today we are still stacking works, although we are in a smaller, traditional house with lower ceilings and lots of moldings and we have an unquenchable desire for twentieth-century self-taught art. If a piece has the qualities that we want or is a masterpiece or by an unknown artist—we buy. We never worry at all about space; we ran out of that years ago.

Sometime during the late 1960s, Baron had an encounter that was to affect our collecting lives and also

Upstairs landing. Overleaf: *Den.*

3

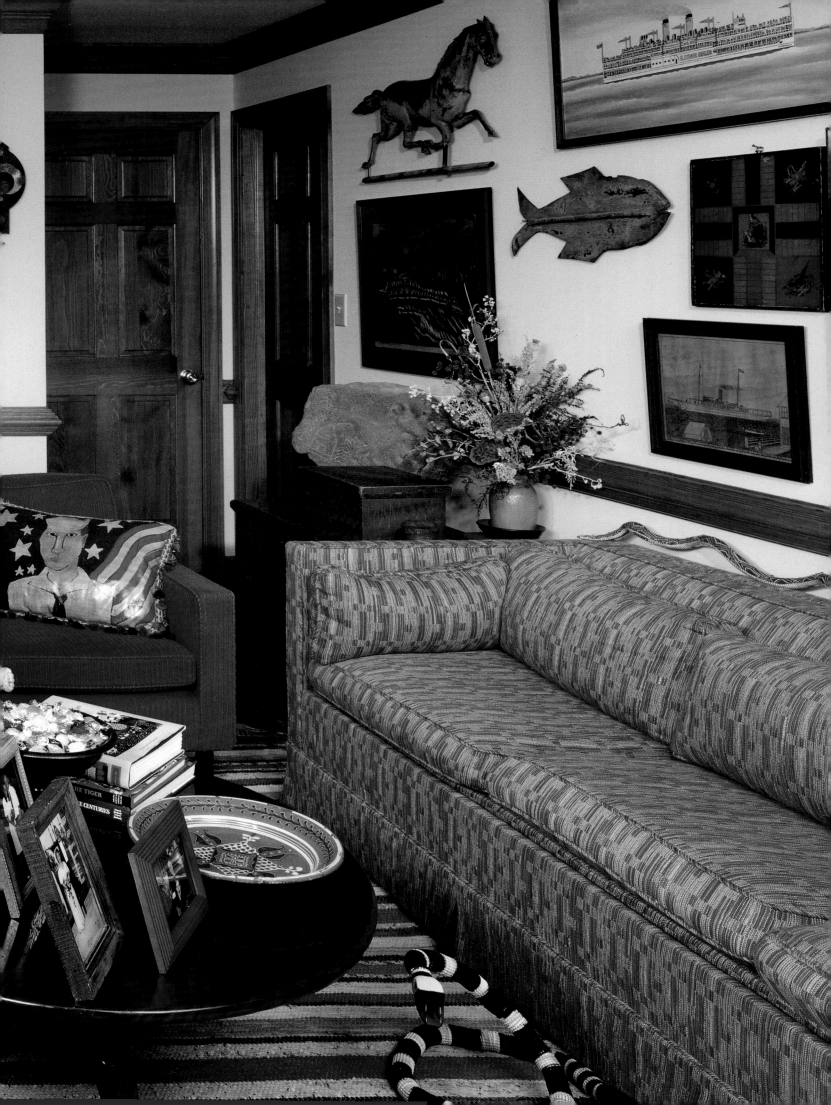

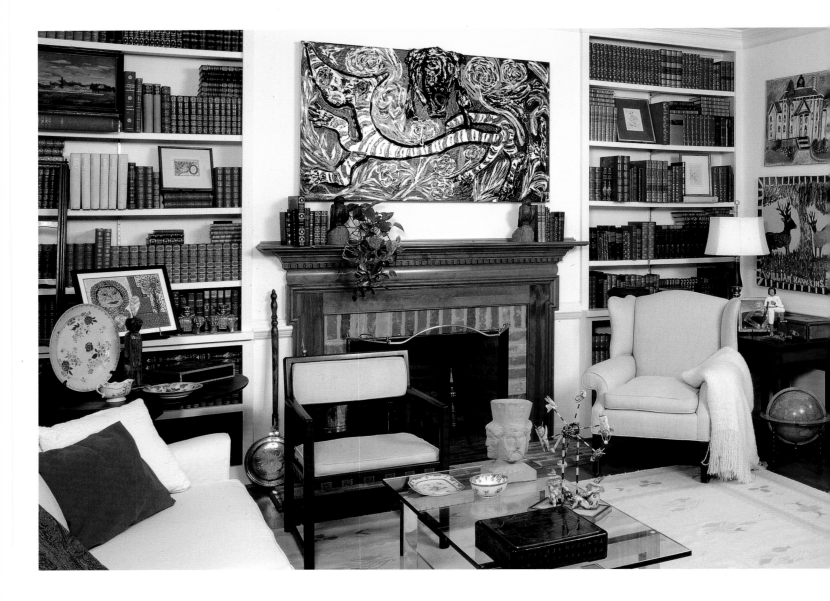

add a wonderful dimension to our circle of friends. One evening before dinner, he stopped for a visit at the Museum of American Folk Art in New York City. While wandering through the exhibit, he started talking with another gentleman, who turned out to be Herbert Waide Hemphill, Jr., a founder of the museum and the curator of the show Baron was attending. Before the visit was over, they had exchanged names and telephone numbers, and in a short time, Bert became an important part of our lives. A collecting legend, Bert has had an enormous and positive influence on a whole group of today's collectors.

Initially, we were only interested in Bert's eighteenth- and nineteenth-century collection and not in that "wild twentieth-century work." Over the years, he would gently prod, then urge, then push us toward the twentieth-century material. In 1976, to humor Bert, we stopped at the shop of his friend Jeff Camp—The Folk Art Company located in Richmond, Virginia. We had a wonderful afternoon with Jeff that stretched well into the evening. We bought four "Uncle Jack" Dey paintings, among them *White Crow,* which is in the current exhibit. The artist was a retired Richmond policeman. We also purchased a carved and painted wood frog by Miles Carpenter of Waverly, Virginia, which is also in the exhibit. When we returned to Purchase, we tried living with our new art but soon decided it was not for us. Perhaps we were too accustomed to the warmth and comfort we found in the earlier, more traditional, and largely utilitarian folk art pieces. The blatant and bold characteristics of our new purchases seemed too jarring, and we were unable or unwilling

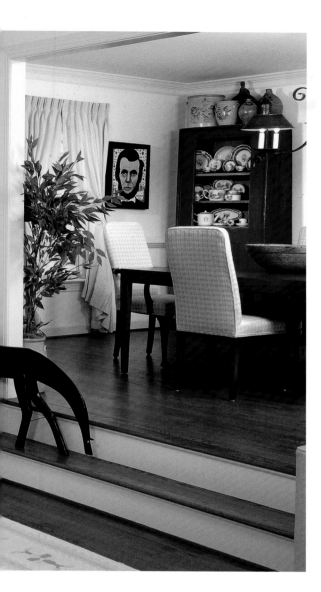

Living room, with view into
the dining room.

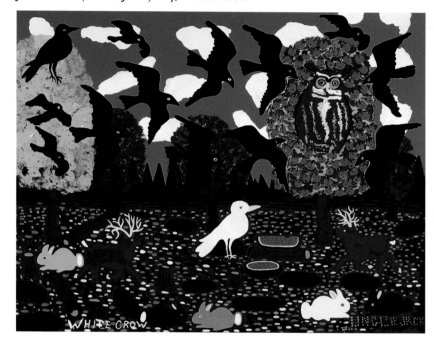

John William ("Uncle Jack") Dey, White Crow

to make the adjustment. At some point, the Deys found their way into the storeroom and the Carpenter frog accompanied me to my school office, where the walls were covered with student art and where the frog was quite comfortable and inspired constant inquiries from students and parents.

We stopped collecting nineteenth-century folk art in the late 1970s, when we knew we were going to move and we would have less space. It was not a difficult decision, because the pieces we still craved were so costly and the prices in the field had risen so sharply that a lot of the fun was gone for us. I often wonder, if twentieth-century self-taught art had been as expensive in the eighties, would we have jumped into the fray quite so enthusiastically? I think not. Two of the wonders of the twentieth-century field are the still relatively reasonable prices and the fact that Baron does not have to worry if the work is a fake. It is also true that the field is dynamic and ever changing as new artists are discovered.

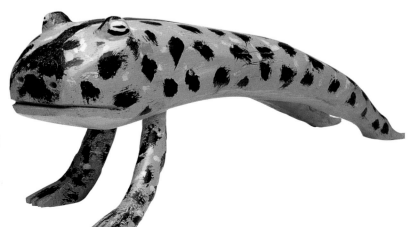

Miles Burkholder Carpenter, Leaping Frog

In 1986, a few years after moving to Williamsburg, we received a telephone call from Chris Gregson, curator of the Meadow Farm Museum in Henrico County, Virginia. He was planning an exhibit of Dey's work and asked to borrow our paintings. We were delighted to lend them, and at the opening of the exhibit, we met a number of twentieth-century-art collectors from Richmond, including Ann and William Oppenhimer, who were organizing the Folk Art Society of America. Everyone was generous with their suggestions of folk and self-taught artists to visit. The group's enthusiasm was contagious, and we were off again.

In retrospect, after moving to Williamsburg, we must have truly missed our weekend antique outings. We missed the search and the excitement, and even the acquisition. I don't think we were ever conscious of what a large amount of our time had been spent "collecting." Filling that void, combined with the anticipation of meeting the artists who created much of the work we would be viewing, intrigued us. This route would be a change for us from the nineteenth-century folk art we had purchased, most of which was by anonymous artists. It also turned out to be an opportunity to rectify what we came to believe was our earlier mistake of not concerning ourselves with documentation. With names, addresses, and maps tucked safely in the glove compartment of our car, we were off and quickly immersed in a new world of artists, fellow collectors, dealers, and miles and miles of unpaved roads.

We had no problem adjusting to our new interest. Baron and I reasoned that folk art did not stop on December 31, 1899, and that twentieth-century folk or self-taught art did not just sprout on January 1, 1900, without any ancestry, DNA, or genes. It did not seem such a long, improbable distance from eighteenth- and nineteenth-century gravestone carvings to the sculpture of Raymond Coins, or from Edward Hicks's images of the peaceable kingdom, sometimes with biblical messages included, to Howard Finster's biblical lessons in paint. Minnie Adkins was surely inspired by Hicks in her *Peaceful Valley* painting and carving that is shown in the exhibition. Billy Ray Hussey's highly innovative clay pieces have a definite connection to nineteenth-century work, since he still uses nineteenth-century baking techniques. Compare his cobalt-decorated face jug in the exhibit to a nineteenth-century face jug in the Folk Art Center's collection, and I

Raymond Coins, Adam and Eve

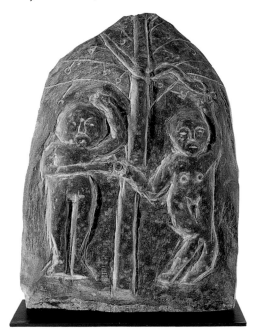

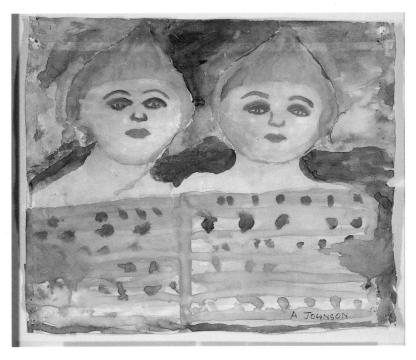

Anderson Johnson, Heads of Two Angels

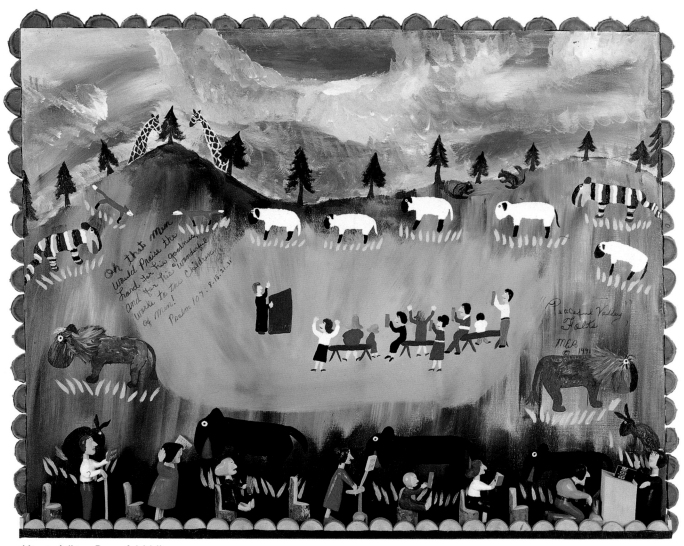

Minnie Adkins, Peaceful Valley

believe you will find similar joy and whimsy in both pieces. Vollis Simpson's complex wind machines are surely direct descendants of the simple nineteenth-century weather vanes and more complex whirligigs. In nineteenth-century pottery workshops, it was common practice, and a thrifty one, to make an "end-of-the-day" piece from leftover trimmings of clay found on the floor, pieces that were unique and personal. Were these the equivalent of twentieth-century "found materials"? We began to realize that the same creative and inventive impulses, which include making something pleasing to the creator out of very little, were deeply felt by the artists of both centuries.

The roots of the work of Anderson Johnson, a twentieth-century African-American artist in the exhibition, lie in his ancestry and his love of the Bible, yet many of his portraits of patriotic figures and women with children remind us of the popular nineteenth-century American portrait poses. Ted Gordon's strong and sometimes unnerving frontal images seem to have a connection to early folk portraits. S. L. Jones's sturdy and straightforward figural carvings remind us of the earlier cigar store figures, and Jack Savitsky's *Princess Mae* and Freddie Brice's *Tug Boat* hold the same fascination and appeal for us as nineteenth-century marine paintings. Ronald Cooper's *Sin Street, Any City,* shown in the exhibit, is concerned with the temptations and evils of life today, just as many nineteenth-century artists depicted events and exposed the inequities of life during that period. The more we traveled and the more we learned about twentieth-century

self-taught art, the more comfortable we became with the natural continuum from nineteenth- to twentieth-century work.

The steady stream of European immigrants that came to America in the nineteenth century tended to congregate where their fellow countrymen had settled before them. Consequently, communities and cultures developed that grew out of the traditions the settlers brought with them from Europe. The new Americans found comfort and support in their young communities through familiar language and customs, and the older generations encouraged those that followed to revere the established traditions and to cherish their heritage. Unlike twentieth-century self-taught art, much of the nineteenth-century folk art that is familiar to us was learned at the side of a parent or grandparent or neighbor. Techniques and tools were passed down from one generation to the next, and consequently, regional styles began to emerge and traditions were reinforced. Much of nineteenth-century folk art, whether from New England, Pennsylvania, New York, Virginia, or the Carolinas, was functional as well as decorative, and it was not long before an experienced eye could detect the section of the country where a piece had originated.

The blurring of regional boundaries that had developed in the nineteenth century continued naturally in the twentieth century and will surely continue at a more rapid pace in the telecommunications world of the twenty-first century. There are artists today living the same isolated existence they have for all of their lives. The difference today is that they have television and sometimes access to small neighborhood libraries, and the difficulty of transportation has greatly eased. Still, particularly in rural areas, the general store and the barbershop remain popular gathering spots to visit and hear local news and gossip, but now there is frequently a television turned on in the background and the news is not just local. Can the Internet be far behind? Self-taught artists, no matter what their level of formal education, are quick to absorb new information, and the effect of the electronic age on their art, as in all contemporary art, will be an interesting phenomenon to watch in the twenty-first century.

Although the lack of academic training and the need to create are common threads that run through

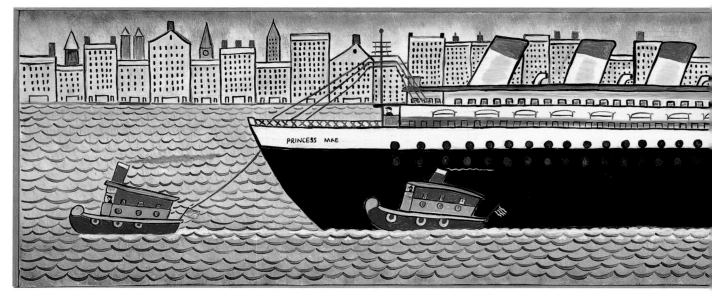

John ("Jack") Savitsky, Princess Mae

nineteenth-century and twentieth-century American folk art, there are also distinct differences between the self-taught artists of both centuries. Nineteenth-century folk art celebrated community values and spirit, traditions and ethnicity, whereas the twentieth-century art values the individual, the idiosyncratic, the artist who creates from his imagination, the art that breaks with tradition. Sometimes the work is so nontraditional that artists' families have been known to destroy it; they do not understand the work, and it makes them uncomfortable and embarrasses them. Limits and boundaries are unknown quantities to the twentieth-century self-taught artist. The wonder of the art is found in innovation, removing of boundaries, and separation from what has gone before. One caveat: as the twentieth century draws to a close, a number of self-taught artists seem to be developing a family tradition, similar to those in the nineteenth century, and encouraging children and other members of their families to paint or carve. Sometimes the work seems to

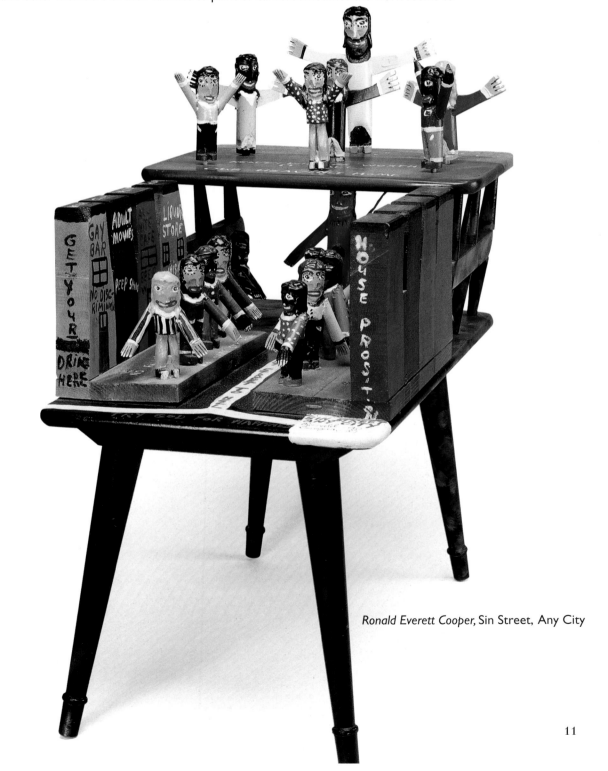

Ronald Everett Cooper, Sin Street, Any City

11

be unrelated to the star of the family, such as that of the Reverend Howard Finster's grandson, Allen Finster, in his three-dimensional pieces. Others, such as Mose Tolliver's daughter, Annie, have a direct connection to their predecessors' styles. In Santa Fe, master carver Felipe Archuleta's son and grandson, Leroy Archuleta and Ron Rodriguez, are definitely following in the master's footsteps. The sons of Thornton Dial, Sr., his brother, Arthur, and a cousin, Ronald Lockett, have already received recognition for their distinctive work. Earnest Patton's carving has a distinct relationship to that of his cousin, Edgar Tolson, as does that of Edgar's son Donny. Our hope is that the inspiration of the masters will not stifle the innate creativity of those following, that instead it will give them hope and encouragement to keep striving for their own style.

Undoubtedly, Baron's early attraction to the German Expressionists is closely related to his love and enthusiasm for the self-taught art we collect. By the time we were reintroduced to the twentieth-century material, I seemed to have lost any hesitancy about bold or disturbing work, and I threw myself into the pursuit as eagerly as Baron. Now I even like the German Expressionists! We both respond immediately to the vigor and expressiveness of the twentieth-century self-taught work. It seems to jump off the canvas and into our hearts and consciousness with its awkward perspectives and oddly shaped forms transmitting feelings of anguish, love, frustration, and joy. Often what others find so disquieting, uncomfortable, or mystifying about self-taught art is what we find so gripping. Bold with startling colors and raw edges or gentle with sensitive lines and pale hues; witty, whimsical, sometimes quirky and almost carnival-like; seldom tranquil, the work seems to dare the viewer to react. At the same time, the art speaks to us with great dignity and clarity. But why had we not been attracted before? Does that say something about our contrariness, or does it say something about our connection to this genre and these artists who are so idiosyncratic, independent, and unconcerned about the opinions of others?

Ron Steve Rodriguez, Bear with Fish in Mouth

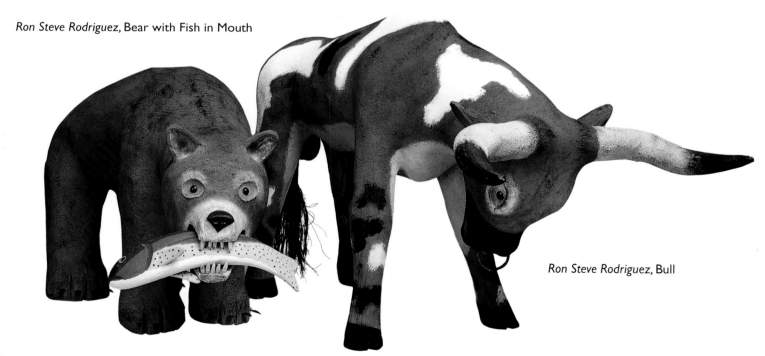

Ron Steve Rodriguez, Bull

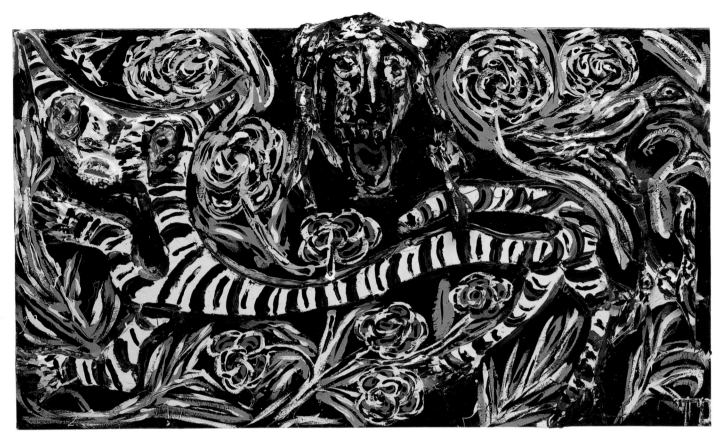

Thornton Dial, Sr., Love Piece: Scrambling through the Flowers

Much of what we have learned from twentieth-century self-taught art and its artists is about drive and obsession and the human spirit. The ability that many of the artists share is the determination to rise above obstacles that most of us would find insurmountable and a philosophy of accepting what is dealt to you and dealing with it. At the same time, we know there is not one "typical" profile of the twentieth-century self-taught, folk, visionary, outsider, or nonacademic artist that underlies his or her distinct individualism. Urban and rural, young and old, educated and uneducated, raised in poverty or comfort, healthy, ill, sociable, antisocial, caring family, lonely childhood, isolated, or lacking privacy, these artists are comfortable with themselves, although not always at ease with the rest of us. Seemingly driven, they unabashedly bare their souls, with no veneer to hide behind or to protect them.

Many of the artists began to create their art to conquer loneliness, frustration, poverty, or anger or to rise above depression following a family tragedy. Others create to fulfill visions sent by God, voices heard in dreams or religious experiences, or to fill empty hours remembering the past. Some artists have been encouraged to work as therapy for a mental or physical problem, and there are those who began as part of a prison art program and found, as a result of the experience, both comfort and success. But these artists do not create to sell their art or to receive accolades; they paint or draw or carve to fulfill personal needs to quiet the demon within.

Self-taught artists seldom think of themselves as "artists," and even after success, many are still surprised that their work has received recognition as "art." Today there are certainly self-taught artists who have met with success in the commercial art world, and some who have gained recognition in their lifetimes

may continue to create to please the marketplace. But the single quality that all the artists share is the obsession to create and the inability to stop. Driven by this need, it becomes their very existence, a reason to get up in the morning and start again.

How wonderful to be S. L. Jones at age ninety-five and each morning reach for a pen and paper to start the day's drawing, since illness has made carving too difficult for him. It must take enormous determination for Dwight Mackintosh and Gaetana Menna, one in California and one in New York City, to arrive each morning at their workshops for the disabled, set to work, and barely take the time to eat lunch. Jessie Cooper started painting biblical scenes on recycled furniture, found objects, even on a cow's skull that is in the exhibit, to reinforce her religious beliefs and give her the strength to surmount grave family problems. Geneva Beavers's fanciful and bold paintings began as a result of the loss of a child and a desperate need to be occupied.

Thornton Dial, Sr., Lonnie Holley, and Purvis Young, African-Americans living in the South, all create out of the need to express their observations on the social structure of life today and the hard realities of the black experience in America. Bessie Harvey turned to her African-American heritage to create spiritual creatures out of tree limbs and other people's cast-off materials, and they in turn brought some serenity to her life after family tragedy and poverty almost overwhelmed her. Inez Nathaniel Walker in New York and Herbert Singelton in Louisiana both started their work as a result of prison art programs. Jon Serl, a free spirit who left home at an early age, zigzagged across the country, supported himself as necessary by circus work, the vaudeville stage, farming, and on and on, and then at middle age found some measure of peace painting. He then painted continually until the day he died at age ninety-eight. The self-taught

Gaetana ("Thomas") Menna,
Yellow Man

Inez Stedman Nathaniel Walker, Cocktails

artist has a compelling need that must be fulfilled, a need that causes each to pick up a pencil or brush, penknife or chisel, but unlike artists of other genres, each seems unable to stop. Although the quality of the artists' work may vary, they are generally prolific and do not seem to suffer from periods of "artist's block."

As in any art movement, there will be the masters whose work will live on and there will be those equally talented who, sadly, by some quirk remain undiscovered. There will be artists whose work does not measure up and will disappear with time. We are confident that there will always be a new self-taught artist just around the corner, for it is the nature of mankind and part of the wonder of the human spirit, this urge and obsession to create. We are equally sure there will always be the challenge, the perseverance, and the obsession luring the curator, the dealer, and the collector to discover the undiscovered artist. A new talent who brings great energy and inspiration to stone or canvas or a provocative new style to the genre that evokes joy and fervor, an artist who just might become a master in the twentieth or twenty-first centuries.

It is usually after one of our visits to an artist or to a gallery that we decide for the hundredth time that we must now seriously redefine and focus our collection. We remind each other that things are getting out of hand and our daughters, Tricia and Alison, remind us that things have gotten out of hand. As soon as we make the decision to narrow our goals, we are invariably introduced to interesting, unfamiliar work, meet a new artist, or spot an outstanding piece for our collection, and phft, there go our new goals. Talk about obsession! We console ourselves about our weakness by reminding each other of the timelessness of great work and how we are giving the art love, exposure, and care in the meantime. How could we possibly stop?

Not long ago, we asked a twentieth-century expert his opinion of a particular collector and his collection. The answer was: "Oh, he's not a collector, he only buys one piece at a time." We do not suffer from that malaise. Baron has a terrible case of the "package deal syndrome." Unlike many collectors who are guided by a particular dealer or mentor, probably a wise decision, we have chosen to rely on our own instincts and emotions, which undoubtedly leads to missteps and errors. But, being out there on our own is part of the joy we share in collecting. Consequently, our collection has gaps, but it has great meaning for us and has enriched our lives and expanded our horizons in many ways, including the way we view art and our fellow human beings.

Although I write here of our independence, we have bought a great number of pieces from dealers and often have sought their advice. They bring great knowledge, judgment, and vision to their profession, and they are the people that go out on a limb to bring artists to the public's attention. The dealer is aware of the range of an artist's work, whereas it is often difficult or impossible for curators or collectors to view as complete a spectrum as they would like to make informed decisions. Since our 1987 eye-opening visit to the Cavin-Morris Gallery in New York City, we have found dealers to be generous with their time, forthcoming with their knowledge and expertise, and, most importantly, patient and understanding of our quirks and habits.

The friendship of: Shari Cavin and Randall Morris; John Ollman of the Fleisher/Ollman Gallery, Philadelphia; Phyllis Kind and Ron Jagger, Phyllis Kind Gallery, New York City and Chicago; Kerry Schuss and Frank Miele, New York City; Bill Arnett, Charles Locke, Robert Reeves, Atlanta; Jo Tartt, Joe Adams, Washington, D. C.; Mike Smith, At Home Gallery, Greensboro, North Carolina; the late Howard Smith, Mayoden,

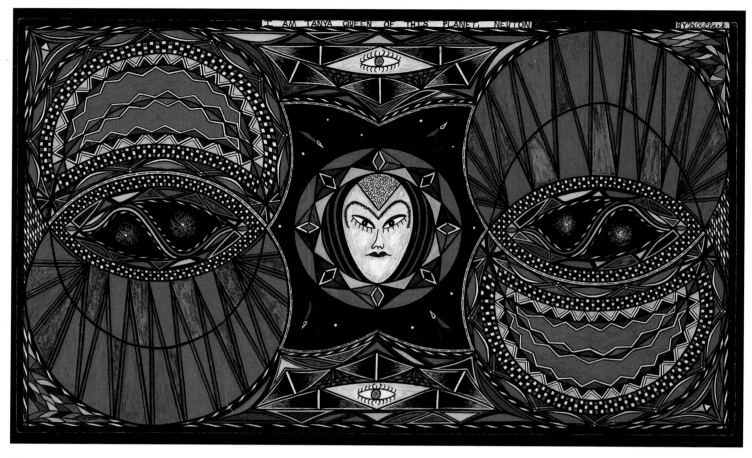

Henry Ray Clark, I am Tanya Queen of This Planet, Neuton

North Carolina; Adrian Swain and the staff at the Kentucky Folk Art Center, Morehead, Kentucky; Aarne Anton, Gene Epstein, Roger Ricco, Luise Ross, and Jim Linderman, all in New York City; Jim Hedges, Rising Fawn Gallery, Lookout Mountain, Tennessee; Joy Moos and Tamara Hendershot, Miami; Larry Hackley, Kentucky; Carl Hammer, Chicago; Marion Harris, Simsbury, Connecticut; Marcia Weber, Montgomery, Alabama; A. J. Boudreaux, Richard Gaspari, New Orleans; Pat Parsons, Burlington, Vermont; Richard Edson, Baltimore; Bonnie Haight at Creative Growth Art Center in Oakland, California; and Betty Marks at HAI (Hospital Audiences, Inc.) in New York City. There are many others, and they have all added dimension to our collection as well as to our collecting life.

One of the highlights of recent years has been the contacts we have had made with a number of professionals in the art world, starting with the indefatigable, creative, and long-range visionary, Robert Bishop, the late director of the Museum of American Folk Art in New York City. A few years later, in 1975, we met Beatrix Rumford, then director of the Abby Aldrich Rockefeller Folk Art Center, who impressed us enormously with her knowledge and awareness, her administrative skills, and her accessibility. At that time and with Trix, we began our long and gratifying relationship with the Folk Art Center, which culminates, but will not end, with *Flying Free.*

At some point in the late 1980s, we met Lynda Roscoe Hartigan, curator at the National Museum of American Art, Washington, D. C., who, aside from her superb curatorial talents, helped to guide

the museum's gift/purchase of the Hemphill collection, which played a major role in establishing credibility for twentieth-century self-taught art in the contemporary art world; Gerard Wertkin, director of the Museum of American Folk Art, a scholar as well as the leader of a strong and growing institution in New York City that is devoted to both historic and contemporary folk art; Russell Bowman, director of the Milwaukee Museum of Art, which now, under his leadership, houses the Michael and Julie Hall Folk Art Collection; Joanne Cubbs, curator of folk art at the High Museum in Atlanta, who has helped to give self-taught art a greater audience in that part of the country; Roderick Moore, director of the Blue Ridge Institute, Ferrum, Virginia, whose research and exhibitions have given exposure to lesser-known self-taught artists from the eighteenth through the twentieth centuries; and Lee Kogan and Stacy Hollander at the Museum of American Folk Art, whose research has added immeasurably to the field of American folk art. During this period, we also met Don Walters and soon after, Richard Miller, both extremely talented former curators of the Abby Aldrich Rockefeller Folk Art Center and both good friends. Richard Miller introduced us to Paul D'Ambrosio of the New York State Historical Association, Cooperstown, New York, an institution that is actively adding to its twentieth-century material.

In 1994, we met Rebecca Hoffberger, whom we respect and admire for her vision and unabashed courage to dream, initiate, build, and open in 1995 the American Visionary Art Museum in Baltimore. Adrian Swain, at Morehead State University, a cofounder and now curator and art director of that institution's Kentucky Folk Art Center, was an earlier friend who has done a remarkable job of discovering, encouraging, and showcasing local artists, truly a prototype effort that we wish other localities would follow; Chris Gregson, at Meadow Farm Museum in Henrico County, Virginia, an artist himself, has befriended, researched, exhibited, published, and continues to build a twentieth-century collection for that institution; Seymour Rosen, director of SPACES, an organization devoted to preserving environments, a prime example of his leadership being Watts Tower in Los Angeles; Jan Riley, who, as curator of the Virginia Beach Center for the Arts, Virginia Beach, Virginia, invited us, taught us, and guided us with great patience through our first curating experience; Robert Hobbs, professor of art history at Virginia Commonwealth University, Richmond, Virginia, also a curator and author; Betty-Carole Sellen, author; Alice Rae Yelen, assistant to the director of the New Orleans Museum of Art, who envisioned and curated the museum's traveling exhibition "Passionate Visions of the American South: Self-Taught Artists from 1940 to the Present," an outstanding show that added immeasurably to the visibility of self-taught art in this country. Alice and her husband, Kurt Gitter, are good friends who have recently had an exhibition of their splendid personal collection of self-taught art at the Birmingham Museum of Art, ably curated by Gail Trechsel, director.

A special perk of our collecting life is the new friends we have made from all over the country. In this group there is no question, no matter how busy the professional life or how active the family unit, that twentieth-century collecting is among the top priorities. We have all become friends through our collections, much like meeting the parents of your children's school chums. Among them: Beth and Jim Arient, Ann Hill and Monty Blanchard, Didi and David Barrett, Georgine and Jack Clark, Patty and Dale Cook, Estelle Friedman, Marshall Hahn, Barry and Allen Huffman, Patricia Lorenz, Sylvia and Warren Lowe, Kay and George Meyer, Gladys Nilsson and Jim Nutt, Ann and William Oppenhimer, Randy Siegal, Stephanie and

John Smither, Sue and George Viener, Ruth and Bob Vogele, Catherine Roseberry and Rob Womack, and Jan and Chuck Rosenak, who have written two books on the field of contemporary self-taught art that have had significant impact, and again, Bert Hemphill. We thank all of them for their graciousness and for the good times we have shared together and look forward to in the future.

Diversity is often cited as one of the great qualities of our democracy, with all its difficulties and all its glories. We feel the artists in our collection represent that glory at its very best. They inspire us, and we respect their unusual creativity and talent. They are each unique individuals, driven by great inner strength, vitality, and determination. Twentieth-century self-taught artists are challenged by their own vision and remain, or remained throughout their lifetimes, undaunted by the opinions of others and uninhibited by previous concepts or rules as they continue to conquer enormous obstacles while traveling down their bumpy road. They do not seem to lose their way.

Baron and Ellin Gordon with grandson John Patrick ("J. P.") Allgood

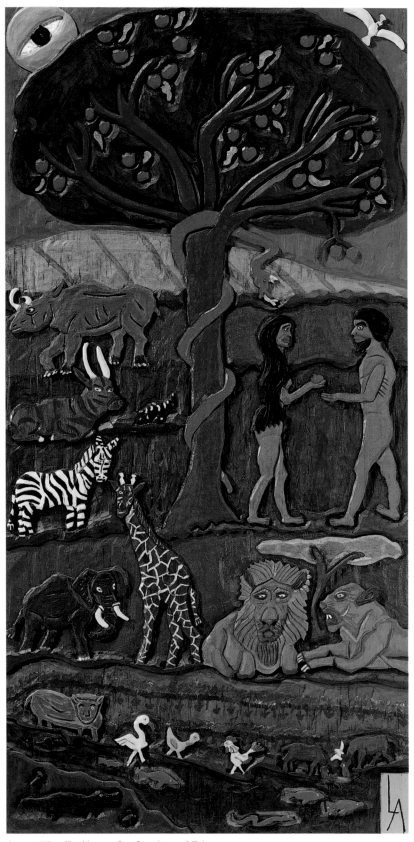

Leroy ("Lee") Almon, Sr., Garden of Eden

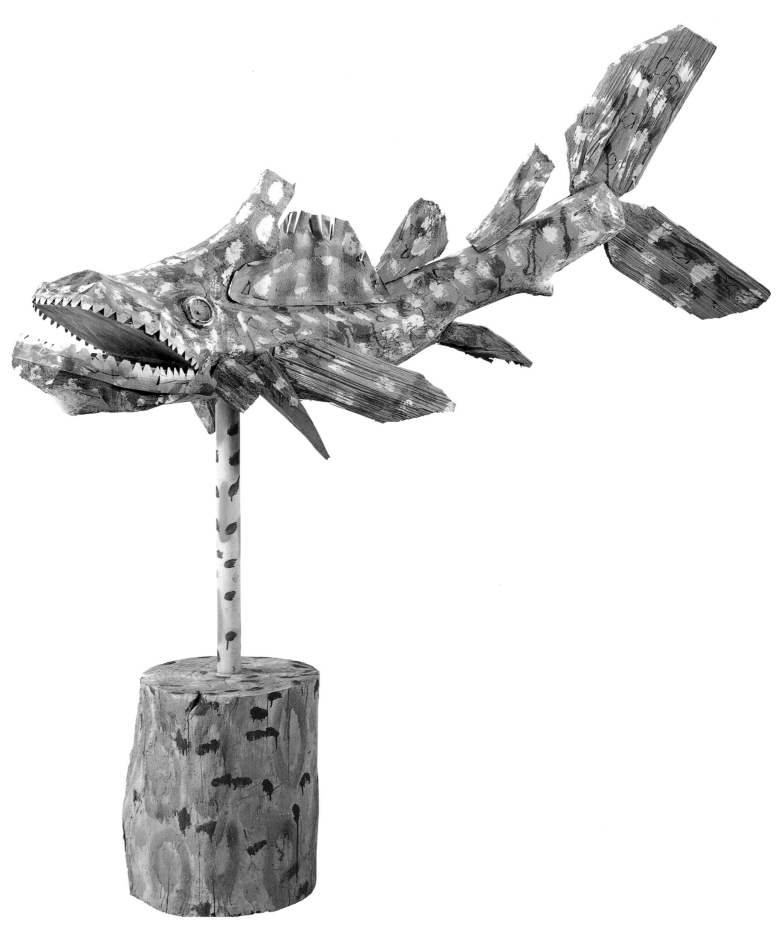

Robert Howell, Fish

"I KNOW WHAT I LIKE":
Armchair Philosophizing on Contemporary Self-Taught Art

By Barbara R. Luck

"I don't know much about art, but I know what I like." Thus have generations of Americans (and others) asserted their independence from academic theory and proclaimed themselves masters of their own aesthetic fates.

The idea has great merit. The elimination of an interpretive middleman—whether in art or any number of other disciplines—has the appeal of directness and reflects self-awareness and self-confidence. It implies the assumption of personal responsibility associated with emotional and psychological maturity. Why should we blindly subscribe to other people's qualitative aesthetic judgments, or even their definitions of art? If we "know what we like," is it really necessary (or desirable) to "know much" about art?

Indeed, hasn't history made fools of the so-called "experts" more than once? Those European impressionists, *fauves,* and expressionists scornfully denied space in reputable galleries and official competitions may not have laughed all the way to the bank. But for the most part, their early believers and backers lived to enjoy the support of popular opinion, not to mention economic remuneration, whereas the academicians ultimately ate crow. It is a story to warm the hearts of Americans in love with the Horatio Alger ideals of inherent virtue and hard work rising to the top like cream.

On the other hand, "knowing what we like" becomes, if not dangerous, then at least stultifying if, in smug self-congratulatory fashion, we allow it to shut off opportunities for discovery and continued growth. If we automatically dismiss an object simply because it fails to correspond to our preconceived ideas of what's "likable" (or legitimate, acceptable, and meaningful as artwork), then who's the loser? The object will endure, but the moment will pass, and we will have missed a golden opportunity to think about *why* we like and dislike what we do, which is but one of a multitude of ways of learning who we are, both as individuals and as a society.

Peremptory dismissals of challenging objects (those that "push the envelope" for us) are understandable; self-revelation can be disquieting or even frightening as well as gratifying. But avoiding those challenges only postpones them and if we fail to entertain them now, we'll have other chances—in other guises—for the rest of our lives. Ultimately, on one of those occasions, we may find that we feel strong, inquisitive, courageous, adventuresome, or just plain foolhardy enough to peep beneath the surface of our rigorously protected personas and see what's *really* there.

Newcomers to contemporary American self-taught art are apt to find much that is instinctively and immediately "likable" in the Gordon collection. Who wouldn't warm up to the bold expression of pure,

unadulterated primary color displayed in Geneva Beavers's *Garden Creatures,* or in William Hawkins's *Two Deer?* Who could resist the sinuous, organic forms of Joseph Yoakum's *Mt. Eboa?* Or the delicate, intricate patterning of Peter Minchell's *Storm?* Is it possible to suppress a grin at the garden-variety humor and playful antics of Miles Carpenter's *Leaping Frog,* or a childlike thrill of delight at the sight of his fabulous *Root Monster?*

Among the pieces in the Gordon collection, however, exhibit visitors or catalog readers can also— fortuitously—expect to encounter other objects (or other aspects of readily "likable" objects) that fail to fit their comfortable, well-worn concepts of art. In the latter event, this essay is no attempt to convert skeptics, much less to foist academic theory or (far worse) personal preferences onto a resistant audience. It simply suggests that visitors and readers approach the material with an open mind, consider why their initial reactions are what they are, and weigh whether alternative viewpoints might have any validity.

We don't necessarily have to know much about art to do the weighing. Those of us wedded to the instantaneous gratification of our senses can discover interesting new possibilities opened up, if not by art theory (though there is plenty of room for that), then by the human drama played out in the lives of the makers. The prominence of the subject's mouth in the Gordons' picture by Kenny McKay (*Untitled ["Hi, Sis!"]*) is characteristic of the artist's work, although full, large sets of teeth are more often depicted than the tightly closed lips seen in this example. The artist's preoccupation may stem from the complete removal of

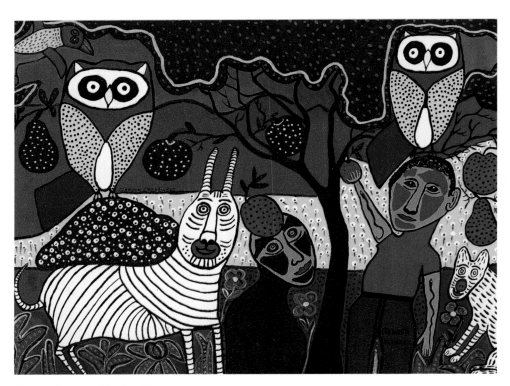

Geneva Beavers, Garden Creatures

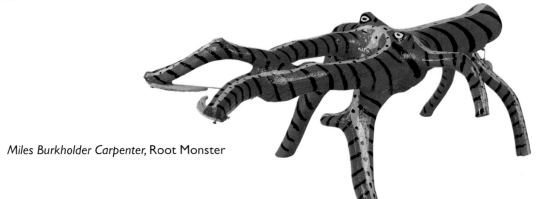

Miles Burkholder Carpenter, Root Monster

his own teeth during the 1960s, a method of preventive dental hygiene practiced by state mental hospitals at the time.[1]

The Gordons' *Statue of Liberty* by Mose Tolliver shows the well-known female figure with benignly pursed lips (or is she sticking out her tongue?). A Tolliver portrait in another collection initially seems terrifying because of its wildly distorted mouth lined with sharply pointed teeth. How differently we read that same painting once we learn that Tolliver is showing himself—*laughing!*[2]

Laura Pass's biographical sketches provide the skeletal basis for exploring critical aspects of the lives of the artists represented in this catalog; Tom Patterson's essay sheds indispensable light on the social context in which they work; and the Gordons draw on valued personal relationships to illuminate the people whose artworks are featured. The facts and insights provided by these catalog contributors can lead to unexpected and rewarding interpretations.

Twentieth-century self-taught art has elicited extremes of reaction in America, and both camps claim articulate spokespersons. Do we love it or hate it? Is it powerful art that taps into the mainstream of the human creative process, or is it mindless, childish doodling? Is it genuine, or is it hype? Each side has its vehement defenders on the street and on the written page. The genre's novelty gives it freshness, vigor, and currency. But that same novelty may also obscure distinctions that, in time, will seem obvious or

Moses Earnest ("Mose") Tolliver, Statue of Liberty

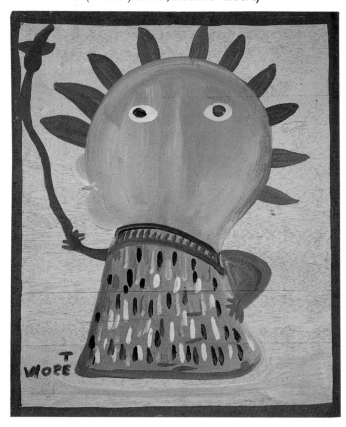

Kenny McKay, Untitled ("Hi, Sis!")

23

commonsensical. For instance, how does a brilliant colorist relate to a fine draftsman? What does a conceptualist have in common with a formalist? What, if anything, do the expressions of rural African-American visionaries share with the creations of the mentally afflicted of our inner cities? For that matter, what does the art of different mentally afflicted artists have in common? Jean Dubuffet scathingly noted that "there is no more an art of the insane than there is an art of dyspeptics and people with sore knees."[3] Many diverse threads can be found in the colorful and multitextured fabric of twentieth-century American self-taught art but, at this point, the distinctiveness of those threads is seldom acknowledged or sufficiently explored. Time and perspective will help us sort out distinctions (and more accurately discern commonalities). At present, radical differences are too often blanketed—and largely obscured—by the adrenalin rush of discovery.

A compelling impetus for indiscriminately lumping together the varied strands of modern-day self-taught artwork stems from attempting to define ourselves by projecting an alien (foreign, different, opposite) "other." We construct our identities on a foundation of contrasts, just as we map our paths through the world in relation to polarities. Even when we can't define precisely who we are, we usually have strong opinions about who we are *not.* Thus doves and hawks, Protestants and Catholics, men and women, whites and blacks, Americans and Japanese, all play off one another, each half of each pairing providing the other with direction and definition. Similarly, when our analyses of folk art and outsider art break down, we fall back on "antidefinitions," i.e., we say what we think they aren't: folk art isn't academic art, or outsider art isn't "mainstream" art.

Contemporary self-taught art may seem distinctly the work of some unaccountable, opposite "other" to many Americans, especially those new to the field. (That same sense of foreignness has undoubtedly helped distort the original meaning of the controversial term "outsider" with reference to such art, even as it has helped disseminate the word.) For those weaned on popular forms of expression, such as naturalistic representation, self-taught artists' renderings of visions, dreams, myths, legends, and spiritual beliefs may

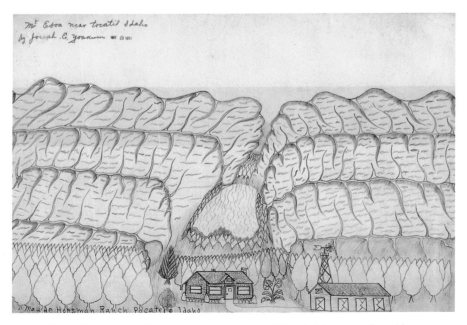

Joseph Elmer Yoakum, Mt. Eboa near tocatil Idaho (Maude Horsman Ranch)

seem unfathomable. Even art lovers accustomed to the unaccustomed by the revolving door of postmodern trendiness (minimalism, conceptualism, deconstruction; what's next?) may feel distanced by the anti-intellectualism of self-taught artists' passionate, direct expressions of emotion.[4] Social, economic, and cultural differences between artists and viewers can also contribute to a sense of disconnect. Assuming, based on their buying power, that patrons of establishment art are affluent, or at least comfortably well off, can they ever truly understand the viewpoints shaped, for instance, by successive generations of life at significantly lower income levels?

Even the materials and techniques used by self-taught artists may seem alien to self-defined "insiders." Those who respect time-honored, well-honed skills and technical proficiency (the "craft" of art making) might understandably disdain self-taught practitioners' idiosyncratic applications of found materials. These ingredients include both natural and man-made objects (the commodity-oriented world's "trash") and range from broken tree limbs and bottle caps to mud, spit, and turnip greens. Likewise, the artists' styles and techniques cover a bewildering range, fluctuating from crude, slapdash, and barely controlled to repetitive, cramped, and obsessively tight.

A blanket sense of "otherness" projected onto self-taught artists not only obscures the rich diversity of their efforts. It has two other unfortunate effects that superficially seem opposed but that, in fact, have much in common. The first is the simple dismissal of contemporary self-taught art from consideration, both as a valid expression of art and as a meaningful statement about the human condition. The second, in apparent contrast to the first, is its wild embrace.

"Otherness" may be viewed as repellant or contemptible in the first instance. In the second, it is conceived not only as exotic, intriguing, and alluring but also—potentially far more troublingly—as a "fix." Like Rousseau's "noble savage," contemporary self-taught artists fall victims to the wishful thinking of others when they are romantically conceived as long-sought missing links that can heal the psychic wounds of a troubled modern society out of touch with the source of its vitality. Such projections reveal less about the artists and the artworks than about the unmet needs of those elevating the objects and their makers to elemental, mystical, even shamanistic status.

Widespread attitudes toward the work of mentally afflicted artists provide some examples. Aesthetic considerations aside, pieces by such makers are eminently worthy of study because of the unique insights they offer into the workings of the human mind. Nevertheless, we slip into false idolatry when we set these artists on pedestals as seers capable of godlike powers if, at the same time, we do not *also* acknowledge their common humanity and the unspeakable pain and torment many of them endure. Art exacts a price. Sometimes it is a horrifying one. We insult the makers and their works if we overly simplify and romanticize true acts of creation.

The all-too-human proclivity to "read into" an artwork is usually eager, even avid. It may also seem to be well-intentioned in its perception of positive or desirable qualities, and it may seem insightful when the perception contains an element of truth. But in reality, the tendency is often desperate, deceptive, self-motivated, and frankly patronizing. It is the opposite of listening respectfully while the object speaks for itself and for its maker. It inhibits cultivation of the open, receptive frame of mind that is essential to real learning.

Perhaps most distressingly, it generates an aura of bogusness that contaminates the public's impressions of a much larger, quite valid body of work.[5]

Self-taught artists are indeed capable of creating works of great power and profound meaning. But we might be reasonably skeptical when jaded gallery habitués find spiritual enlightenment in an artist's recycled plastic bottles: are the critics projecting such a state to fill some void in themselves? Exactly what is it they experience in viewing the artwork? How do their experiences compare with the artist's? If the artist truly created the work as an expression (or act) of spiritual enlightenment, can that state of mind or soul be conveyed from artist to artwork to viewer, like the Olympic torch? Can it be swallowed, like a pill? No work of art can ever have the same meaning for its maker as for its subsequent viewers; each piece inevitably takes on a life of its own from the moment of its creation. We only delude ourselves when we fail to distinguish between the artists' intentions and the fabrications of our own minds.

We need not doubt the sincerity of Howard Finster's desire to communicate the word of God to the broadest possible audience through icons of popular culture, such as R. E. M. and Elvis Presley, and through saturation (this fundamentalist preacher's biblically referenced works now number in the tens of thousands). We might, however, also usefully ponder what differences exist between the message Finster intends and the message his audience perceives. To what extent has commodification dispersed Finster's word (as opposed to his work)? To what extent has it altered it? Assuming some differences, what is it that impels us to read messages that have not been sent? Skepticism may have legitimacy in some cases—but only if it drives us to look deeper, to ask searching questions, and to consider an artwork's inherent multiple (and inevitably multiplied) layers of meaning.

How might we distinguish the sacred from the profane or the genuine from the delusional? In paradoxical fashion, one conceivable answer seems both impossibly difficult and pathetically simple: we must open ourselves to all possible sources of information—yet we must also learn how to process for ourselves what we receive. Swallowing whole the spoon-fed, "quick fixes" of others' opinions will hardly answer what puzzles us or cure what ails us, either as individuals or as a society—although, compared with searching, independent thought, it is definitely easier and, therefore, devilishly enticing! As Walt Kelly's comic strip character Pogo forthrightly declared, "We have met the enemy and he is us."[6] At least we can *enhance* our ability to recognize a work's integrity and creativity when we are not blindly groping for plugs to fill the holes in our own souls.

In order to peel back and examine more closely some of an artwork's multiple layers of meaning and to expand our thoughts on plastic bottles, we might further explore the recontextualizing of old materials (which, it should be noted, is generally only mechanically related to environmental "recycling" with regard to self-taught artists).[7] What about spiritual content? When Anderson Johnson declared, "I like to take nothing and make something of it. That's the way of the Lord," the committed lay preacher likely drew on his knowledge of Genesis, in which God created the earth from a formless void and man from dust. In still another Christian analogy, Thornton Dial, Sr., compared the new use of old materials to Jesus' resurrection.[8] Can contemporary churchgoers doubt a plastic bottle's spiritual potential for such artists? At the same time, however, the typical WASP art viewer is apt to drop the subject there, oblivious to the rich *African* spiritual

traditions these two artists (and others) bring to their work. The concept of recycling can have very different connotations for different ethnic groups and social strata.

However cultural baggage is transmitted—whether it is taught or, more controversially, metaphysically or genetically passed along—we all bear the legacy of innumerable preceding generations.[9] The fact that we continually reinterpret that information to suit shifting needs and circumstances may obscure its origins and lead us to deny direct linkage. But whether we are conscious of it or not, and whether we purposefully exploit it or not, the inheritance is there. As a simple example, the ancient foundations and pagan trappings of Christmas festivities are seldom at the forefront of Christians' consciousness in their annual celebrations of Jesus' birth. Yet many of them realize that lighting candles and decorating with evergreens about the time of the winter solstice has a basis in druidic and predruidic rites. Acknowledgement of ancient origin is hardly a denial of contemporary meaning; it simply underscores the vitality of human culture.

As surely as druidic rites have been transformed and reinterpreted by white Anglo-Saxon Protestants, so, too, have ancient African beliefs about birth, life, death, and rebirth been adapted—and often fervently christianized—by contemporary African-Americans. Furthermore, the relevance for the visual arts is fundamental from a culturally inherited standpoint since, in early African societies (among others), art and religion were fused. Historically art was developed to serve and express religious belief; a separate, secular arts tradition would have been unthinkable, pointless, profane. Many contemporary works still reflect this fusion.[10]

Howard Finster, Faith to Move Mountains

Thoughtful scholars like Robert Farris Thompson and Maude Wahlman set a larger stage on which we can better understand and appreciate the appearance of recontextualized (found or recycled) objects in works by contemporary African-American self-taught artists.[11] These authors' observations on the power and meanings traditionally attributed to specific colors, materials, and objects and on the ways that Africans and African-Americans have effectively combined them to express fundamental beliefs help us view American "trash" in a new light. Empty bottles hung in trees and shards left on graves defy typecasting by affluent white society as a "poor man's decorations" when revealed as Kongo means of protecting houses and deflecting evil spirits. Writing about African-American environmental artist Henry Dorsey (and charitably assessing affluent attitudes toward material goods), Thompson perceptively noted that "Dorsey rescued objects thrown away by persons trained to see only single functions in them."[12]

Through Thompson's and Wahlman's eyes, we can also begin to appreciate the overarching principles of an aesthetic and a philosophy quite different from that inherited by Americans of European descent. The asymmetry, improvisation, and multiple patterning that often distinguish works by contemporary African-American self-taught artists are visual hallmarks of societies in West and Central Africa (the original homelands of most of the slaves brought to America in the eighteenth and nineteenth centuries). Furthermore, these three distinctive visual characteristics are based on far more than mere stylistic preference: Thompson quotes numerous African and African-American variations on the belief that "evil travels in straight lines" (or follows a predictable path).[13] Reasonably enough, asymmetry, improvisation, and multiple patterning might all be expected to thwart such a passage.

Visual expressions stemming from African spiritualism are clearly most dominant in works by African-American artists. The influence hardly stops there, however. In the ethnic "salad bowl" of contemporary America, European-Americans, Asian-Americans, Native Americans, African-Americans, and others continually borrow back and forth, adopting and adapting forms if not concepts to suit their own purposes. Sometimes closer ties are forged through socioeconomics than through race or ethnicity.

Socioeconomic factors add a critical layer to our reading of recycled ingredients in a self-taught world. Although obvious, these elements are often overlooked. Many twentieth-century self-taught artists were born and raised in impoverished situations; for older practitioners, their straitened circumstances were further aggravated by the Great Depression. Their parents and parents' parents may have scraped through comparable hard times, building on successive memories of struggle and, often, despair. "Making do, or doing without" becomes a way of life for individuals like these, and nothing can be "thrown away" in the face of such unrelenting need; if superfluous, an article will be saved against eventual want or else given, traded, or sold to someone else. In this sense, recycling as a modus operandi sets the stage for aesthetic forms of reuse.

A bent for saving and reusing may not necessarily derive from immediate want or even from firsthand experience of it. Those who once practiced thrift out of necessity often retain it as an ingrained personality trait long after the wolf has left the door. In other scenarios, the well-heeled children of stringent savers may rebel against their parents' frugality with lives of extreme indulgence—but they are just as likely to repeat, nearly verbatim, the hoarding habits they absorbed as youngsters.

J. T. ("Jake") McCord, Girl with Dog

Finally, oral and documented family traditions of difficult past times are sometimes passed on out of admiration and respect for departed relatives or family friends who, through sweat and self-denial, paved the way for the easier existence of succeeding generations. Ideals of moderate consumption and an honest work ethic are thus handed down and perpetuated over time.

Many have proven that despair and bitterness are not inevitable by-products of economic struggle. Surviving a hand-to-mouth existence can elicit justifiable pride, for it requires tapping immeasurable and sometimes unexpected personal resources of resilience, humor, imagination, ingenuity, pluck, and sheer grit. Emotional and psychological stress are hardly peculiar to a minimum-wage existence, but they are often part and parcel of it. In any case, developing one's own, incomparable, artistic *style* of surviving hard times can be a way of taming the devil, saving one's sanity, and laughing at the worst the world can dish out. Those who not only "get by" but do so with individualistic creativity illustrate admirably the indomitable nature of the human spirit.

Bessie Harvey, now highly regarded for her haunting, animistic stick sculptures, seems to have viewed her beleaguered past as an essential antecedent to her artwork: "All of these struggles I went through made me what I am. My art came from my struggle." Artist Ronald Lockett similarly observed, "Really, if I wouldn't

Raymond Coins, Dog Tomb

have had so much adversity, I don't think I'd be doing this today."[14] None of this suggests that creativity is inseparably yoked to difficulty, of course—only that it may be evoked in different people by different circumstances. Wealth, a leisured life, and art lessons are no more prerequisites for artistic ability than poverty, stress, and lack of training.

In some instances, active choice and unabashed stubbornness have helped unleash artistic potential. Jon Serl shunned the conventionally comfortable lifestyle his artwork ultimately made possible, instead preferring a ramshackle dwelling shared with dogs, chickens, and mice to the "sissy way" of life spent "pushing buttons" on TVs, radios, and other modern amenities. Determinedly independent in both his living and his painting, Serl affirmed, "Whenever someone says 'do it,' I find a way not to do it."[15]

Many artists, whether latent or practicing, experience a burst of incredible creativity when propitious raw materials appear. When a neighbor promised Edgar McKillop some walnut trees in return for clearing them away, the sometime blacksmith succumbed to a singular vision and began felling, hewing, chopping, and carving day and night, eventually creating a yardful of extraordinary fantastical creatures.

Some artists say (or imply) that their choices of materials are accidental, or that they are mere matters of convenience. Minnie Black shrugged off the start of her career by saying, "A stray gourd appeared alongside my driveway. I had a gourd garden, so I just started making things out of 'em." Mr. Imagination says, "I like to make my art out of things I've found because they're there and they're free." Nevertheless, "Mr. I" also admits that "sometimes it's like these things call out to me so that I'll notice them." Among other artists who claim materials speak to them, Ralph Griffin states that "I look at a piece of wood and it tells me what it is." Some receive more explicit direction from their materials, as when Raymond Coins says, "I'll roll the rock

around and see what it makes."[16]

Several plainly attribute the "voices" or directives received from or about their materials to God.[17] William Edmondson (ca. 1882–1951) received a holy mandate to chisel about the same time a truckload of limestone was accidentally left on his property and, later, he frequently claimed that his carving was "just doing the Lord's work." Other artists seem impelled or influenced by pervasive, animistic, less sharply defined spiritual forces. Thornton Dial, Sr., for instance, observed that "anything you pick up, somebody know about. You picking up the spirit of somebody. . . . Leaves fall off a tree got a spirit in them. Cows, dirt, rocks, the whole world, all that stuff carry on life." James Harold Jennings believes that "everything we have on the earth and all of our powers comes from the sun, the moon, and the stars."[18] Given these views, it is hardly surprising that many artists feel they have been purposely shown or led to specific materials, that finding or receiving them is not merely serendipitous but fated, ordained, or meant to be.

Their ideas seem entirely consistent with theories promulgated by scholars in fields ranging from religion to the applied sciences, where the "purely accidental" is questioned with increasing degrees of articulation and definition. Modern chaos theories posit the interrelatedness of all action, citing the flutter of a butterfly's wings that affects weather formations thousands of miles away. Geophysicists tell us that the erosive force of a single drop of rainwater has "repercussions from deep within Earth to the nearer reaches of space."[19] Is it hard, then, to believe that self-taught artists are drawn to certain materials (and work as they do) for reasons, whether or not they (and we) can always comprehend them?

The work of Purvis Young illustrates another aspect of the new use of old materials. Expressing strong, abstractly—often symbolically—rendered feelings about the tough inner-city Miami ghetto where he was born and raised and now paints, Young combs his deteriorated neighborhood for cast-off materials, which he then incorporates in his art. Anything found in the trash is potential grist for his mill: desk drawers, doors, mirrors, even tossed library books. Thus, as Joseph Jacobs points out, Young's community is not only represented in the artist's subject matter of buildings, traffic, funerals, and people. It also *literally* appears in his work, in the form of the raw materials he uses, providing yet another take on Marshall McLuhan's contention that "the medium is the message."[20]

Many of Young's paintings were "given" to his community in a very direct way: he nailed them onto its boarded-up buildings. In a broader sense, he gives Overtown something much more critical and elusive. By claiming the community's eyesores and transfiguring them into works of meaning and value, he blazes a trail of hope through his demoralized urban neighborhood.

Young has obviously renewed his own life in the process of art making, having risen above the heavy odds of his background, which included a prison sentence for armed robbery, served from ages eighteen to twenty-two. Others are very conscious of their use of aesthetic expression as a means of recycling or reinventing themselves. Charlie Lucas claims he is "after the true meaning of me" in finding unique and expressive ways to combine odd pieces of scrap metal. Of his own art making, Lonnie Holley says, "I got an opportunity to recycle, in a sense, my own innerness." For artists whose ultimate rewards lie in self-discovery, the vicissitudes of the marketplace are endured with relative equanimity. Perhaps they have seen too many of life's ups and downs to be overly impressed by fame and fortune—or irrevocably embittered by a

Gregory Warmack ("Mr. Imagination" or "Mr. I"), Cane with Head

31

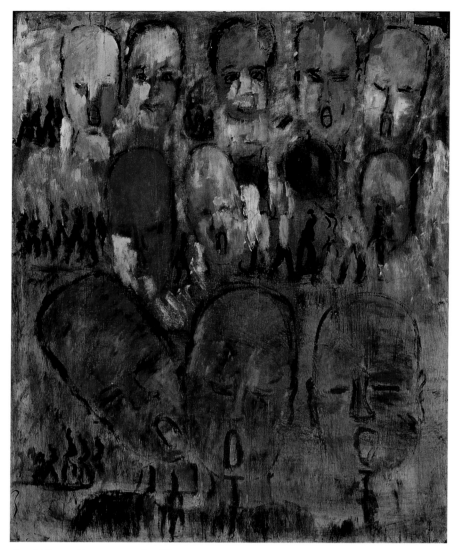

Purvis Young, Faces over the City

lack of them. When Bessie Harvey vowed that she'd "rather be at peace with a biscuit and butter than to live in hell with steak and gravy," her meaning seems clear: self-expression and control of her own destiny were her priorities, not fame or money.[21]

Some have suggested that this essay address, at least in part, why the Abby Aldrich Rockefeller Folk Art Center takes an interest in contemporary American self-taught art, not only in borrowing and exhibiting selections from the Gordon collection but also in acquiring such works for its permanent holdings. The suggestions have often come from those with some form of vested interest in terminology and in whether the material described herein should be considered "folk art" or not.

Enough debate over this and related issues has been printed to sink a battleship. "Folk," "outsider," "naive," "visionary," and "self-taught": the pros and cons of these terms and many more have been argued

Lonnie Bradley ("Sandman") Holley, Out of Mother's Blood, the Eye

for years, and likely will continue to be for years to come. Names and methods of classifications are how we make sense of the world; beyond mere convenience, they can even be critical to survival.[22] Nevertheless, semantics can be taken too far, as when debate over language overwhelms and impinges on our direct sensory responses to the material. Louis Armstrong said, "If you have to ask what jazz is, you'll never know." Some of us need to relax, enjoy, and learn from our emotions more than from our intellects. Instead of asking "why" the Abby Aldrich Rockefeller Folk Art Center chooses to endorse this material, might we not more profitably ask "why not?"[23]

Some of the oldest, simplest definitions of folk art are still useful; Nina Fletcher Little's claim that "folk art was the tangible expression of the average man's creative impulse" shows more than Yankee economy of verbiage.[24] It has no direct reference to social class or static societies, it has equal significance when cast in the present tense, and it readily includes the material in this catalog. The Center has used the term "self-taught" to describe the Gordon objects in keeping with widely preferred contemporary usage—but the objects are the same and have the same relevance to the Center, which has never been exclusively con-

cerned with works produced for the status quo of fixed ("folk," in the folklorists' sense) societies. Eccentric, individualistic forms of expression are not peculiar to the twentieth century; they have always been with us and have always been honored (indeed, highly respected) by the Center.

What did the 1801 inhabitants of rural Hardy County, Virginia (now West Virginia), think of Godfrey Wilkins's walnut chest that is decorated and inscribed in high-contrast (probably sulphur) inlay? Besides giving the maker's and client's names and the place and date, the inscriptions on either side of the front say:

READ THES UP

AND READ THES DOWN

Meanwhile, on both ends of the chest, Wilkins's celebratory mood and supreme self-satisfaction are documented in the inscriptions "WEL DON." Surely this wonderful example of individualistic expression got a chuckle out of Wilkins's neighbors; the simple fact of its survival also tells us that it was valued (and that humor was valued), both by Wilkins's contemporaries and by subsequent generations.[25]

We also frequently overlook or discredit historical objects that "break the mold" in less fluid socioeconomic (more "folk") situations than the Virginia backcountry. Pennsylvania Germans are often cited as the epitome of static societies in America. But how often do creatures like Jacob Weiser's fantastical, barb-tailed *Merman* show up among Pennsylvania German fraktur?[26] For many who are unfamiliar with a particular historical genre (such as fraktur), all such *types* of objects may take on a superficial "sameness" that is frequently dispelled by closer observation and broader comparison. If, indeed, "the past is a foreign country,"[27] many of us can be found guilty of typecasting its inhabitants and their material culture.

Similarly, are not the objects of contemporary production often seen as more idiosyncratic than they are because too many of us look at them from our *own* "outsider" status? Surely Bessie Harvey's African-American contemporaries recognized and responded to her evocative stick sculptures long before scholar Judith McWillie elucidated their meaning for white society as having derived from "African twisted root charms and bottle trees."[28]

Certainly there are differences between nineteenth- and late twentieth-century society and culture in America. One can hardly ignore the impact of technology in spreading and "democratizing" information and images. But has our tolerance (not to mention our endorsement) of individuality and eccentricity increased? Such a conclusion seems questionable. Vast population increases allow for greater overall numbers but may not have altered the proportion of the unconventional elements in human nature that are, after all, necessary for the mental balance of society as a whole.

Despite or, more likely, because of all its potential for misconceived "otherness" readings, contemporary American self-taught art has unimaginable potential for bringing people together, thereby serving one of art's highest purposes. When "knowing what we like" can be expanded from the familiar images and concepts we grew up with, or feel safe with, to include the meaningful expressions of the entire spectrum of

human experience, we might begin to accept the unacceptable in ourselves—and to find common ground with those whom we once ignored, condemned, or feared. Social hierarchies have no more merit than aesthetic ones, unless they promote the Ideal (versus ideals).

In a memorable mixture of down-home common sense and insightful personal observation based on extensive aesthetic exposure, Abby Aldrich Rockefeller remarked: "To me art is one of the great resources of my life. I feel that it enriches the spiritual life and makes one more sane and sympathetic, more observant and understanding, as well as being good for one's nerves."[29] Would Mrs. Rockefeller have approved the Folk Art Center's present-day efforts to share the works of contemporary self-taught American artists with its public? Her quoted remark can only lead one to conclude, resoundingly, "yes."

NOTES

1. Conversation with Elizabeth Marks, curator, Hospital Audiences, Inc., New York City, May 10, 1996, relaying information shared with her by Kevin Frech.

2. See Eleanor E. Gaver, "Inside the Outsiders," Art & Antiques (Summer 1990), pp. 78–79, where a laughing, real-life Mose Tolliver is shown along with the self-portrait he describes as "how I look when I laugh."

 Physiognomically, isn't there a fine distinction between laughing and crying? Don't we also acknowledge the sometimes fine line between love and hate?

3. Jean Dubuffet, L'Art brut préféré aux culturels, exhibition catalog (Paris, 1949), unpaginated; trans. Allen S. Weiss and Paul Foss in Art Brut: Madness and Marginalia, a special issue of Art & Text, no. 27 (December 1987–February 1988), pp. 31–33, as quoted by Sarah Wilson, "From the Asylum to the Museum: Marginal Art in Paris and New York, 1938–68" in Maurice Tuchman and Carol S. Eliel, Parallel Visions: Modern Artists and Outsider Art (Los Angeles, 1992), p. 132.

4. Although originally coined to describe the art of those with severe mental disturbances, the European term "art brut" (raw art) is an apt descriptive of the unmediated vehemence found in many perfectly sane artists' works.

5. A considerable body of reviews, criticisms, and lengthier literature reflects sharp skepticism, even cynicism, and some of it raises valid, hard questions. See, for instance, Larissa MacFarquhar, "But Is It Art?" New York (January 29, 1996), pp. 38–43.

6. As quoted in Robert Wernick, "Let's hear it for the lowly sound bite!" Smithsonian, XXVII, no. 5 (August 1996), p. 63. Pogo's sentiments, if not his exact words, go far back in time and have been expressed by numerous historic and literary figures; Sir Thomas Browne (1605–1682), for one, noted, "Yet is every man his greatest enemy, and, as it were, his own executioner." (Religio Medici, pt. 2, sec. 4, as quoted in John Bartlett, Familiar Quotations …, 14th ed. rev. and enl., ed. Emily Morison Beck [Boston, 1968], p. 330).

7. Many writers have looked at recycling or recontextualization in the work of contemporary self-taught artists. One insightful essay on this subject is Tom Patterson, "Adhocism in the Post-Mainstream Era: Thoughts on Recycling, Redemption, and the Reconfiguration of the Current Art World," in Tom Patterson, Reclamation and Transformation: Three Self-Taught Chicago Artists (Chicago, 1994), pp. 11–13.

8. On Johnson, see Kimberly Nichols, "Artists' Biographies," in Alice Rae Yelen, Passionate Visions of the American South: Self-Taught Artists from 1940 to the Present (New Orleans, La., 1993), p. 314. In part, Dial's quote reads, "Old life just makes new life. That's what recycle is all about. When God died, he rose again." Southern Queens Park Association, Inc., Thornton Dial: Strategy of the World (Jamaica, N.Y., 1990), p. 4, as quoted in Yelen, Passionate Visions, p. 57.

9. The transmission of cultural values is the subject of widespread anthropological study and speculation. In the context of contemporary self-taught art, it is fleetingly referenced in Andy Nasisse, "Aspects of Visionary Art," in University Art Museum, Baking in the Sun: Visionary Images from the South, Selections from the Collection of Sylvia and Warren Lowe (Lafayette, La., 1987), p. 11. Also see note 11 below.

 In a corollary interpretation of one of his own sculptures, self-taught artist Lonnie Holley says that if a person "doesn't yield to the ways of the ancestors, he destroys time" (Yelen, Passionate Visions, p. 65).

10. Judith McWillie, for one, notes that "these artists don't separate spirituality and aesthetics" (Gaver, "Inside the Outsiders," p. 81).

11. See Maude Southwell Wahlman, "Africanisms in Afro-American Visionary Arts," in Univ. Art Museum, Baking in the Sun, pp. 28–43, and Robert Farris Thompson, Flash of the Spirit: African and Afro-American Art and Philosophy (New York, 1983).

 Another, later, book of Thompson's that deals even more extensively with the transmission of African cultural values across time and place is Face of the Gods: Art and Altars of Africa and the African Americas (New York, 1993).

 George Brandon's review of Face of the Gods alludes to some of the more controversial aspects of Thompson's analyses, calling Thompson's method of research, for instance, "fundamentally intuitive and poetic" (African Arts, XXVIII, no. 4 [Autumn 1995], pp. 109–110).

I am indebted to Andy Nasisse for calling my attention to both Thompson's 1993 book and George Brandon's review of it.

12. Thompson, *Flash of Spirit*, p. 158.

13. *Ibid.*, pp. 221–222. Wahlman quotes Thompson and provides additional insightful comments on African-American quilt patterns in her essay "Africanisms in Afro-American Visionary Arts" in Univ. Art Museum, *Baking in the Sun*. See particularly pp. 32–33.

14. On Harvey, see Gaver, "Inside the Outsiders," p. 85. Lockett is quoted in Kathy Kemp, *Revelations: Alabama's Visionary Folk Artists* (Birmingham, Ala., 1994), p. 102.

15. Gaver, "Inside the Outsiders," pp. 159, 85.

16. On Black and Griffin, see Yelen, *Passionate Visions*, pp. 299, 310. On Mr. Imagination, see Patterson, *Reclamation and Transformation*, p. 48. On Coins, see Univ. Art Museum, *Baking in the Sun*, p. 88.

17. One exceptionally creative and intriguing explanation of the inner "voices" some people hear is explored and developed in Julian Jaynes, *The Origin of Consciousness in the Breakdown of the Bicameral Mind* (Boston, 1976); bk. 2 is of special interest from a historical perspective.

18. On Edmondson, see Regenia A. Perry, *Free within Ourselves: African-American Artists in the Collection of the National Museum of American Art* (Washington, D. C., 1992), pp. 65–66. On Dial and Jennings, see Yelen, *Passionate Visions*, pp. 57, 66.

19. The Butterfly Effect (or "sensitive dependence on initial conditions") surfaced as a calculable factor in efforts to forecast weather. Using computer models, meteorologist Edward Lorenz deduced that order only *masquerades* as randomness— and that beneath a seemingly unpredictable surface lie patterns of infinite subtlety and beauty. See James Gleick, *Chaos: Making a New Science* (New York, 1987), especially chap. 1. On the impact of a raindrop, see Stearns A. Morse, "Phenomena, Comment and Notes," *Smithsonian*, XXVII, no. 1 (April 1996), p. 26.

20. Newark Museum, *A World of Their Own: Twentieth-Century American Folk Art* (Newark, N. J., 1995), p. 78. McLuhan's central premise (somewhat more complex than his simple catchphrase implies) was that societies are shaped more by the nature of the media by which people communicate than by the content of the communication. See Marshall McLuhan and Quentin Fiore, *The Medium Is the Massage* [*sic*] (New York, 1967).

21. Lucas is quoted by Gail Trechsel in her introduction to Kemp, *Revelations*, p. 14. Holley is quoted *ibid.*, p. 90. On Harvey, see Gaver, "Inside the Outsiders," p. 85.

22. A useful summary of the history of this "term warfare" appears in Jacobs, *A World of Their Own*, pp. 10–40.

 As used in this catalog, "self-taught" reflects the preference of many contemporary scholars, who perceive diminishing formal distinctions between folk art and academic art as the twentieth century draws to a close. In some ways, "self-taught" seems a more accurate, less controversial term for the type of material under discussion.

 "Self-taught," however, has its own problems. What constitutes instruction? Is it distinguishable from influence? How do we assess its effect on an individual's artwork? Several artists represented in the Gordon collection have received some degree of formal instruction. All, however, possess highly personal styles and have developed them largely on their own.

 Examples of some of the monumental consequences of misguided taxonomy can be drawn from the natural sciences. Because the gypsy moth was erroneously classified in the genus *Bombyx* (silkworm) in the late nineteenth century, it was being used for experiments in silkworm cultivation in a Boston lab, whence several specimens escaped. Without natural predators here, the moth has been devastating eastern forests ever since—and it has since been reclassified in the genus *Lymantria* (destroyer). (Sue Hubbell, "How taxonomy helps us make sense out of the natural world," *Smithsonian*, XXVII, no. 2 [May 1996], p. 143.)

 Although seemingly less critical, who can calculate the effects of muddled cultural classifications?

 Part of the vehemence of the debate over the term that best describes the kinds of objects in this catalog probably stems from sensitive "acceptance" issues, for instance, questions over whether the material is "art." By "naming" a thing, we publicly acknowledge its existence, its reality, and its presence. It is the simple, pivotal act that says, "I recognize that you are there."

23. Armstrong is quoted in David Schiller, *The Little Zen Companion* (New York, 1994), p. 8.

 Abby Aldrich Rockefeller likely would have taken a lively interest in present-day debates over the appropriate terminology for "nonacademic" art, but it seems highly doubtful that she would have allowed it to distract her from the delightfully eclectic mixing of "high" and "low" she favored in her own collecting and decorating. Photographs from the 1930s of the interior of the Rockefellers' 10 West 54th Street Manhattan brownstone reveal her felicitous integration of Dali, Van Gogh, Maillol, Lehmbruck, and Seurat with the likes of anonymous works by nineteenth-century artists and artisans.

24. Helen Comstock, ed., *The Concise Encyclopedia of American Antiques*, II (New York, [1967]), p. 341.

25. The chest is owned by Greenfield Village and the Henry Ford Museum, Dearborn, Michigan. It is illustrated as fig. 13 in Wallace B. Gusler, "The Arts of Shenandoah County, Virginia, 1770–1825," *Journal of the Museum of Early Southern Decorative Arts*, V, no. 2 (November 1979), p. 26. Ford Museum staff report the end inscriptions are "WEL DON," not "WELL DON" as cited in the foregoing article (telephone conversation with Andrea Wojtak, Research Center, Ford Museum, June 18, 1996).

26. The *Merman* is owned by the Abby Aldrich Rockefeller Folk Art Center, acc. no. 57.305.10, and is shown, among other places, in Beatrix T. Rumford, general ed., *American Folk Paintings: Paintings and Drawings Other Than Portraits from the Abby Aldrich Rockefeller Folk Art Center* (Boston, 1988), no. 258 on p. 317.

27. See David Lowenthal, *The Past Is a Foreign Country* (Cambridge, 1985). Lowenthal's book title is taken from the opening phrase of the prologue to L. P. Hartley's 1954 novel, *The Go-Between* (New York), p. 3.

28. Gaver, "Inside the Outsiders," p. 85.

29. The quote comes from a letter from Mrs. Rockefeller to her son Nelson, dated January 7, 1928, now in the Rockefeller Archive Center, North Tarrytown, N.Y.

Hubert Walters, Big Ben

David Butler, 7-Headed Dragon/Monster

THE MULTIPLE IDENTITIES OF CONTEMPORARY NONACADEMIC ART

By Tom Patterson

"Folk," "outsider," "self-taught"—the alternate use of these and other terms to describe works of art such as those in the Gordon collection reflects the general state of confusion and controversy now hanging over the field of scholarship that has grown up around this art in the latter half of the twentieth century. These terms don't actually tell us anything about the art itself. They are merely generalizations about the social and cultural identities of its creators. But when considered in relation to each other, the names that have been attached to this art seem to reveal contradictory views of the work and those who make it. Words such as "folk," "vernacular," and "grassroots" emphasize a community context of tradition, shared beliefs, and common origins. Terms such as "outsider," "isolate," and "idiosyncratic," on the other hand, suggest that the sources for this work are exclusively personal and individualistic. We seem to be talking about two entirely different kinds of art here, or two very different classes of artists. So, how is it that such vastly different characterizations came to be routinely applied to this cultural material?

The answer to that question is wrapped up in the assumptions and prejudices of those who invented these classifications and those who have perpetuated them. Both sets of terms assume it is important to distinguish this work from a Western tradition of "fine art" that has been defined as extending from ancient Greece to the postindustrial United States, so the common emphasis is on the perceived otherness of the art and the artists. But the alternate terminologies posit two distinct types of otherness, one of which is rooted in the traditions of rural communities presumed to be far removed from the metropolitan fine-art centers, while the other is related to notions of individual alienation that have been central to Western art and philosophy since the Romantic era.

On one level, this contradiction reflects our society's conflicted attitudes about art and the role of artists in local, national, and international cultures. In recent times, these attitudes have come into sharp conflict in the ongoing "culture wars" that began in the late 1980s, but they also underlie the confusion of terms that has been a persistent problem in the study, exhibition, and marketing of this ill-defined "other" art. One attitude is predicated on the notion that artists should use their talents as a means of perpetuating and reinforcing community values, whereas the other is based on the more modern concept of the artist as one who challenges prevailing assumptions about art and life.

The folk paradigm that some have imposed on this work evolved out of the interest in nonacademic American art that began to develop among collectors, dealers, and curators in this country during the 1930s and 1940s. At that time, such work was sometimes called "primitive," but it was more often characterized as folk art. In its loosest sense, the term "folk" refers to that category of humanity otherwise referred to as

the "common people." It is a class-based concept that seems to suggest that people of modest means are unable to create or appreciate "fine" art—a special subcategory usually reserved for the "crude," "unrefined" objects and images that commoners have made by hand. In the more precisely defined realm of contemporary folklife studies, folk art refers exclusively to craft traditions passed down through successive generations of a family or community.

The outsider paradigm had its origins in European modern-art circles, also during the early part of this century. The term "outsider art" didn't come into use until British writer and scholar Roger Cardinal coined it in the early 1970s, but this was his loose attempt to translate Jean Dubuffet's French designation *art brut,* which Dubuffet formulated much earlier and explained in a 1949 manifesto. According to the iconoclastic French avant-gardist, *art brut* is "anything produced by people unbesmirched by artistic culture, works in which mimicry, contrary to what occurs with intellectuals, has little or no part." Most of the artists Dubuffet and his latter-day followers have championed for creating such works have been individuals whom society has deemed incompetent due to mental disorders of one kind or another, and many of these artists have been residents of mental institutions. Others have been eccentric recluses, and virtually all have been staunch individualists whose art served primarily as a kind of private visual language for talking to themselves. In this respect, Peter Schjeldahl's tersely summarized definition is useful: "Outsider art is art produced by a culture consisting of one person."[1]

These seemingly distinct cultural subcategories collided in the 1970s, when this country and parts of Europe witnessed the beginnings of a newfound public interest in the creative activities of people on the margins of so-called mainstream culture. The collision was propelled by exhibitions such as "Naives and Visionaries," at the Walker Art Center in Minneapolis, and books such as *20th Century American Folk Art,* by pioneer collector Herbert W. Hemphill and scholar Julia Weissman, as well as by the emergence of artists such as Howard Finster and Eddie Owens Martin (a.k.a. Saint EOM), whose work and range of life experiences challenged previously held stereotypes about folk and outsider art.[2]

With the growing popularity of art by such independently motivated individuals during the 1980s, these two terms began to be used interchangeably to describe their work and that of many others who have little in common aside from their lack of formal art training. Because the latter characteristic is the only one that all of these artists share in common, some scholars and collectors have attempted to avoid the confusion of already problematic terms by referring to the artists as "self-taught." This characterization is preferable in many ways to others that have been applied to these autonomously creative people, and I will resort to using it with some frequency in this essay, just as I have elsewhere. But it should be noted that even this way of describing these artists and their work leaves something to be desired. In one sense, the designation "self-taught" reflects the personal initiative and capacity for self-empowerment that are considered essential ingredients in the American formula for success in any field. But in academic circles, the autodidact has generally been regarded with suspicion and even contempt, as one whose knowledge and skills are necessarily more limited than those of a trained professional. To some degree, this attitude has carried over into the art world, where the term "self-taught" can carry implications of inferiority, depending on who uses it. And because even the so-called "self-taught" artist relies on a variety of art-related skills learned from

others, the term devalues the artist's relationships with these noncertified teachers by ignoring their role in the artistic learning process.

Despite the inherently pejorative character of the names given to this art, it has come to occupy an important place in our postmodern culture, alongside the traditional and nontraditional art forms of many groups that until recently were relegated to the cultural margins. The realignment of cultural and aesthetic priorities that has begun to take place in the American art world over the past few years may eventually lead to a clearer view of folk/outsider/self-taught art and to a more satisfactory way of talking about it. But for now, the discussion of this work continues to take place in a semantic minefield where the resultant explosions occasionally illuminate larger issues involving cultural identity and cultural participation in a society that advertises itself as democratic. [3]

All of these terms are umbrella designations that attempt to cover a dizzyingly broad array of creative agendas, artistic styles, and art-producing cultural subgroups. One advantage of exhibiting work from a collection such as the Gordons' is that it provides an opportunity to consider the varieties of artwork typically included under these terminological umbrellas and to make some finer distinctions among them. This kind of exhibition also encourages closer consideration of the many different social and political factors that influence the creation and the reception of art described as "folk," "outsider," "self-taught," et cetera. The Gordon collection consists almost entirely of work from the United States, but the artists represented in it come from a variety of cultural backgrounds, and their cultural differences are evident in this exhibition. Although it isn't so broad as to represent a complete cross section of the U. S. population, this group of artists reflects something of the diversity of this country's citizenry, and their art embodies the varied ideals, concerns, dreams, aspirations, fascinations, and frustrations of several distinct American social groups.

One such group, represented more prominently here than in many other collections of nonacademic art, consists of immigrants from eastern and western Europe. Among this group is Aghassi George Aghassian, a Turkish Armenian who came to the United States as a teenager in the early 1920s. He couldn't afford to pursue his dream of becoming an architect and instead spent most of his life working in various low-level service jobs, first in New York and later in Columbus, Ohio, and Detroit. But when he was in his sixties, Aghassian began to draw, and the drawings he produced during the ten to fifteen years before his death in 1985 testify to the endurance of his architectural interests. Although he is mainly known for his precisely rendered exterior views of imaginary multistory buildings, he is represented here by a drawing of a brightly painted battleship. With its prominent cannon barrels that resemble giant ballpoint pens, this eccentric, radar-equipped military vessel is structurally similar to the towers and cathedrals that Aghassian depicts in other works. The fact that he has here chosen to draw a ship is significant because he came to this country by ship. Since it flies the U. S. flag and has characteristics of an ocean liner and a Mississippi-style riverboat as well as a battleship, this flamboyant craft can be seen as a maritime metaphor for Aghassian's adopted country.[4]

Another European immigrant artist represented here is German-born Peter Minchell, who also, coincidentally, depicted a ship in his drawing titled *Storm*. But this ship has been capsized by the violent force of the natural disaster that is the drawing's main subject. Like Aghassian, Minchell came to the United States as

a teenager, and he had early, unfulfilled aspirations toward a career in architecture. Instead, he became a Roman Catholic priest, but he left that line of work as a young man to get married, and he turned to construction work to earn his living. Minchell spent most of his life in the southern part of the country, first in New Orleans and later in Florida. There he had firsthand experience with hurricanes like the one portrayed in this drawing—fierce, ocean-borne windstorms that are unique to the Americas. He elaborated on his fascination with these storms in the handwritten caption at the bottom of this drawing, which contains historical and scientific data about hurricanes and expresses relief about the increased accuracy with which meteorologists can predict their movements in advance.

This is one of a series of natural-disaster drawings Minchell made in the early 1970s. As a former builder whose professional life had depended on careful planning and orderly building procedures, Minchell evidently had an acute awareness of the havoc that nature can sometimes wreak on such well-laid plans. And as an immigrant of low economic status, he presumably was well acquainted with the unpredictable hardships of life in the lower echelons of American society—circumstances that are aptly symbolized by the natural disasters he illustrated in this series. That he assumed life was going to get more unpredictable and dangerous for all of us can be inferred from the fact that later drawings in the series feature images of extraterrestrials and scenes of the world's end—subjects in which he shares an interest with several other artists whose work will be discussed later in this essay. He also shares with many of this exhibit's artists an awareness of the Western art tradition. As a child in Europe, he was exposed to that continent's artistic heritage, and during his teenage years there, he produced and exhibited watercolor drawings. In this country, while in his early twenties, he visited museums in Philadelphia and New York, where he was exposed to then-current American variations on the European tradition.[5]

Israel Litwak was a Russian Jew who came to this country early in his life and settled in Brooklyn, New York. He began drawing in the late 1930s, when he was sixty-eight years old, after a long career as a cabinetmaker. Although self-taught artists are often said to be indifferent to the official art world, Litwak was quick to seek approval from those quarters. Not long after he took up art, he brought some of his drawings to the Brooklyn Museum, whose curators were so impressed that they arranged for him to have a solo exhibition there in 1939. Litwak was a beneficiary of the first wave of interest in nonacademic art in this country, and his Brooklyn Museum show led to his inclusion in Sidney Janis's landmark book on the subject, *They Taught Themselves*.[6]

The drawing by which Litwak is represented here—*Jackson Falls, Wild River*—dates from the promising early period in his career. This tropical-looking landscape shows an environment far different from the urban locale where the artist spent most of his life—a place that might seem thoroughly Edenic were it not for the apparent turbulence of the "wild river" that fills the lower half of the composition. Like Peter Minchell's *Storm*, Litwak's drawing also portrays an emblem of the natural world's awesome and potentially overwhelming power. And it's an image that reinforces the romantic myth of the untamed American wilderness, which profoundly influenced European views of the Americas from the late fifteenth century until the first part of the twentieth. Litwak's initial experiences with the art world tended to confirm another myth about this country that was also popular in Russia and other parts of Europe in the late nineteenth and early

twentieth centuries—that the United States was a "land of opportunity," especially for poor immigrants seeking a better standard of living. But his early successes as an artist didn't lead to the kind of consistently "bigger and better" opportunities that this myth might have led him to anticipate, and by the 1950s, he was all but forgotten by the art establishment that had initially embraced him. If America is a land of opportunity, Litwak's experience taught him that it is also a land of "easy come, easy go," where the public tends to demand endless novelty in the fields of art and entertainment.

Aaron Birnbaum's timing was better than Litwak's, fortuitously. Like Litwak, Birnbaum is a Jewish immigrant who came to the United States as a teenager (in his case from Poland), settled in Brooklyn, worked at a trade for much of his life, and didn't begin making art until he was in his late sixties. But Birnbaum is almost thirty years younger than Litwak, and by the time he took up painting, it was 1960. As a young man, Birnbaum followed in the footsteps of both his parents and became a tailor. He went to design

Israel Litwak, Jackson Falls, Wild River

Peter J. Minchell, Storm

Aghassi George Aghassian, Boat

school and opened his own business as a designer and manufacturer of women's apparel in New York's garment district. In contrast to the stereotype of the obsessive self-taught artist who begins producing work out of an urgent compulsion, Birnbaum took up art more by casual happenstance, after his daughter gave him some painting supplies. His wife had recently died, and he had retired from his job in the clothing business. The daughter's gift was an attempt to encourage a hobby with which her father could occupy himself during this lonely transitional period. He quickly developed an enthusiasm for this new creative pastime, his pursuit of which happened to coincide with a period of renewed interest in nonacademic art on the part of the public and the art cognoscenti in this country.[7]

But unlike his older counterpart Litwak, Birnbaum didn't experience the mixed blessing of immediate recognition and overnight success. In another parallel with Litwak, though, he got his first taste of art-world recognition when he submitted examples of his work to the Brooklyn Museum. It was there that his paintings had their public debut, when several of them were included in a group show in 1975. Promoted by an agent who took an interest in it, Birnbaum's work found a wider audience in the 1980s—a decade during which outsider art became a bona fide media-hyped American trend—and his career reached a peak with a one-hundredth birthday celebration that the Museum of American Folk Art hosted for him in 1995. Essentially a memory painter, Birnbaum depicts people, scenes, and events that he remembers from his childhood in Poland and his early years in and around Brooklyn, but he has acknowledged that his paintings present an idealized picture of his past. Before coming to this country, he felt marginalized and persecuted for being Jewish, but there is no hint of this or any other unpleasantness in his work. That his encounters with anti-Semitism didn't diminish his pride in his Jewish heritage is evident in his painting of five *Rabbis* apparently reading from the scriptures in a temple or some other sacred setting.

Although Helen Salzberg is not an immigrant, she is like Birnbaum in that she lives near him (in New York City), is Jewish, and sometimes makes paintings that celebrate Jewish tradition, as in her painting of a bar mitzvah ceremony in this exhibit. The Manhattan-born Salzberg obtained undergraduate and graduate degrees in business at New York University, but she has been making art since her youth, and she has taken art classes at various museums and community centers in the city. While she was growing up, her father's job as a doctor allowed her family a comfortable lifestyle, and she and her late husband—an attorney—maintained a high standard of living throughout their years together. She remains financially secure and has three residences in different locales, and she belongs to a country club. These economic and social factors set her considerably apart from the standard image of the rustic folk artist or the isolated, lean-living outsider. Like Aghassian, Minchell, Litwak, Birnbaum, and a number of other artists whom I'll discuss later, she is a reminder that rural Protestant Christians from the South don't have a monopoly on nonacademic art, despite the impression often conveyed in some of the literature about this work.[8]

The tendency to associate American self-taught art with rural agrarian culture stems in part from early twentieth-century concepts of folk art that centered on handcrafted utilitarian objects of a kind that were more likely to be made and used in rural communities, where factory-produced goods were scarce and unaffordable to much of the population. And the popular concept of folk painting is based largely on the work of Anna Mary Robertson "Grandma" Moses (1860–1961), Israel Litwak's more famous contemporary,

Helen Salzberg, Bar Mitzvah Boy

who painted scenes of her childhood in a rural section of upstate New York. Since Moses's death, many other artists from similar backgrounds have emerged to create visual records of rural life as they experienced it. These artists make up one of the more obviously identifiable cultural subgroups typically included under our broad terminological umbrella.[9]

Prominent among several such artists represented in the Gordon collection is Minnie Adkins, a woodcarver and painter from a part of eastern Kentucky that has produced a surprising number of accomplished self-taught artists. She learned to carve small animal figurines and other miniature forms when she was a child growing up in this region during the late 1930s and the 1940s, but she set aside this creative activity as she grew older. It wasn't until the mid-1980s that she took it up again, this time as a means of earning an income after she and her husband, Garland, had fallen on hard economic times. Collectors and dealers responded almost immediately to her work, and over the next decade, she gained a widespread reputation for her carvings of animals native to the eastern Kentucky hills as well as for the paintings of animals and rural scenes that she began making during this period. A number of her two-dimensional

works feature panoramic views of the small farm where she and Garland (who took up woodcarving in the late 1980s) have developed their cottage art-making industry—a place she has named "Peaceful Valley." The one included here is a whimsical variation on this theme that incorporates images of giraffes, tigers, and other exotic animals not found in eastern Kentucky as well as a carved and painted Sunday-school scene in the lower part of the composition.[10]

After she began to achieve commercial success with her art, Adkins became an artistic mentor to her neighbors in this economically depressed part of the state, most notably Linvel Barker and several members of the Lewis family. All of these artists have become highly adept at woodcarving, but Tim Lewis is unique among them in that he works not only in wood but also in stone. A good example of his work in the latter medium is his *Standing Bear,* a lifelike portrayal of one of the black bears that are indigenous to this part of Kentucky. Lewis is also one of several artists represented here who make elaborately carved and painted canes—yet another tradition associated largely with the rural South. Closely related to these canes are the carved and painted snake effigies made by Oscar Spencer of Virginia.[11]

Another artist with rural roots whose work centers on images of animals is Geneva Beavers. She grew up on a farm in North Carolina but didn't start painting until she was sixty years old and long accustomed to her life as a homemaker and shipyard worker's wife in coastal Virginia. Beavers is one of a number of self-taught artists who began their creative careers in the wake of a traumatic event—in her case, the death of her twenty-five-year-old son in 1973. For her as for other artists who begin from a state of personal crisis and intense emotional stress, the work is a form of self-directed therapy. But that's not all it is. As Beavers told one writer in discussing her attitude toward her art, "I decided I wanted to do something well and not be a piddler, a Sunday painter." The conventional wisdom about nonacademic artists has it that

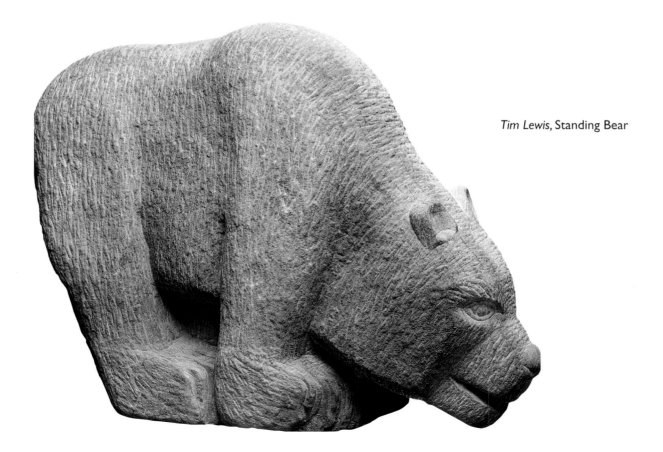

Tim Lewis, Standing Bear

Denzil Goodpaster, Dolly Parton Cane

Tim Lewis, Cane with Dog's Head holding newspaper in mouth

Tim Lewis, Hornbill Cane

Larry McKee, Skeleton Cane

Earnest Patton, Cane—Woman's Head with Snakes

Mona McCalmon, "Misty" Cane

David E. ("Dave") Rawlings, Black-Tailed Rattler

Oscar Lipscomb ("O. L.") Spencer, Brown Snake with Dark Brown, White-Ringed Diamonds on Back

O. L. Spencer, Short Green Snake

O. L. Spencer, Big White Rattler

O. L. Spencer, Little Snake with Raised Head

O. L. Spencer, Moxican

they don't concern themselves with such distinctions, don't discipline themselves to excel in their work, and don't even think of their creations as art, but Beavers is one of many artists who demonstrate the fallacy of such generalizations. She isn't a memory painter in the traditional sense, but she has acknowledged that her work is inspired in part by her childhood experiences watching the wild and domestic animals that lived on or passed through her family's farm. The animals in her paintings—like some of those in Adkins's *Peaceful Valley*—are often far more exotic than those one would find on a North Carolina farm, and in some cases, they're purely imaginary. In all cases, though, her animals look completely benign, innocent, even friendly. Joined by a brightly dressed human being in her painting *Garden Creatures,* several of these animals stare wide-eyed at the viewer from a scene that could be a kind of modern-day Garden of Eden. Adam wears blue jeans and a T-shirt and picks fruit from the Tree of Knowledge without having to be enticed into the act by Eve, who is nowhere to be seen.[12]

Shields Landon Jones has spent his life in the Southern Appalachian Mountains of West Virginia, where he grew up in a large family of poor tenant farmers. He dropped out of school after the eighth grade, and a few years later, he began what was to be a fifty-year career as a railroad worker. Jones is another artist who didn't begin working seriously at his art until he was older than sixty. It was his retirement from his longtime job and the subsequent death of his wife that motivated him to begin carving. Just as Geneva Beavers started painting to take her mind off her grief over her son's death, Jones put his woodcarving skills to use in order to help ease the pain of losing his wife of forty-five years. Like many other self-taught artists from rural backgrounds, he creates works based on his own circumstances and surroundings. As a child, he taught himself to carve small birds and animal figures, but when he took up this pastime again as an adult, he turned to the human society of Southern Appalachia for his subject matter. His carved and painted wood sculptures may or may not portray particular individuals he has known, but they obviously are inspired at least in part by his relatives, neighbors, and acquaintances in rural West Virginia.[13]

Jones's nuclear-family group exhibited here doesn't represent his own family, because he had eleven siblings, and he and his late wife raised four children of their own. The family portrayed here has only four members, all wearing the kind of simple, plain-looking clothes Jones's neighbors might wear, and the father is evidently a preacher, since he brandishes a Bible in his left hand and wears a necktie, usually reserved for church-related functions in communities such as Jones's. This religious reference, like the Sunday-school class in Minnie Adkins's *Peaceful Valley,* connects this sculpture to the work of many other self-taught artists who use their work primarily as a means of conveying religious messages and—at least in most of those cases—promoting their faith in the fundamental teachings of Christianity. I'll discuss several of those artists later in this essay.

The rural life that Gayleen Aiken portrays in her narrative drawings is an imaginary one. She is not the only artist represented here who depicts a life that is happier and more comfortable than hers actually has been, but she is unique in that she has invented an entire branch of her family, and these fictional relatives are the main characters in her art. Aiken has spent her life in and around the small town of Barre, Vermont, where she grew up in an economically deprived household in which both parents were increasingly disabled by illness. While still a very young child, she turned to drawing, music, and other creative activities to distract her from the hardships of her life, and she has continued to pursue them into her senior years. She was only nine years old when she dreamed up the Raimbilli family—an imaginary uncle and aunt and their twenty-four children, who, in her mind, lived an exciting and carefree life on a large, old-fashioned farm. Prominently displayed in her home today are life-size painted cardboard cutouts of the many imaginary cousins that she made during her childhood, and most of her drawings continue to center on the adventures of these perpetually young and innocent make-believe kinfolks.[14]

Aiken has never been married or given birth, and in her adult years, the Raimbilli cousins seem to have served as fanciful substitutes for the offspring she never had. Through her combination of imagination and drawing skills, she provides these eternal youngsters with the kind of warm, happy, secure childhood that her circumstances denied her. In the drawing shown here, each member of the Raimbilli family is identified by name, as is the artist, who appears alongside but slightly apart from them at the lower right, observing but

not participating in their lives of exuberant play and rewarding work. The palatial "big farmhouse" in the background and the adjacent "barn, mills, granite-shed-plants, and quarries" indicate that the Raimbillis aren't exactly poor dirt farmers. Aiken lives alone in modest quarters, and she clearly longs for the kind of life she has evidently glimpsed in the homes of more affluent friends or relatives. The nostalgic text in the lower right corner of this drawing suggests that she has created her own imaginary past set amid the domestic grandeur of a home such as the Raimbillis': "We miss our old Pretty Wallpaper, Fancy old chandeliers, old Doors, porches, Attics, old Country Hill & More(.) We might move back To one of our old Big Heirloom country Houses sometime Later."

Depictions of rural life can also be found in the work of some African-American self-taught artists, particularly those from the southern part of the country. The black experience of rural life in the South began, of course, with slavery, and African-Americans have long associated agrarian life in this region with the racial oppression and injustice suffered by generation after generation of blacks there. Josephus Farmer dealt directly with this shameful legacy in his painted bas-relief *Runaway Slave,* now in the Gordon collection and included here. Farmer was born in Tennessee within thirty years of the Civil War's end and the abolition of slavery in this country, and he no doubt heard firsthand accounts from relatives and older acquaintances who had been slaves about the horrors of being bought, sold, and owned. In this narrative piece that he made when he was about ninety years old, Farmer commemorated "a score of Virginia Negroes sold by their masters," depicting them "on their way to new owners in Tennessee." The black man fleeing a white pursuer in the upper left corner of the piece evidently escaped from this group during the journey. In a

Beverly ("Gayleen") Aiken, My Happy Raimbilli Hill Cousins

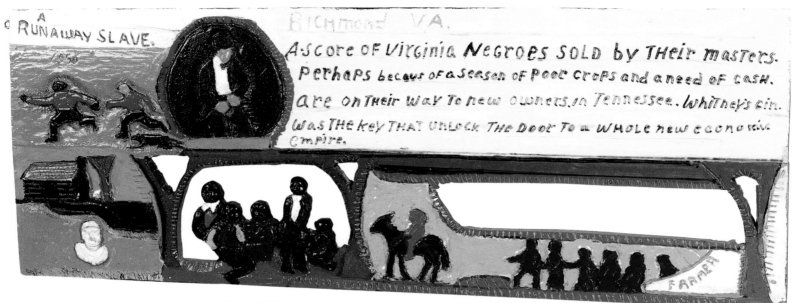

Josephus Farmer, Runaway Slave, 1850

thematically related vein is a mixed-media tableau by Farmer that is also included here. In this piece, titled *Dixie Land,* he portrayed a black farmer guiding a mule-drawn plow through a cotton field, living the "Dream of the Black Man" to own "40 acres of land and a mule"—the never-fulfilled promise that the federal government made to each of the newly freed slaves 120 years before Farmer made this tableau. Here Farmer presents a vision of the South as a place of African-American empowerment—the kind of place that "Dixie Land" might have become after the Civil War had it not been for the forces of hatred and bigotry, as manifested in the activities of the Ku Klux Klan, the White Citizens Councils, and far too many southern law-enforcement agencies that tried to intimidate African-Americans into staying "in their place."[15]

Farmer was one of many African-Americans who left their birthplaces in the South during the early years of this century and migrated northward in search of better job opportunities and a refuge from the racism of their white southern neighbors. Another black southerner who headed north during the Great Migration—as this demographic shift has come to be known—was Elijah Pierce. Pierce's own father had been a slave who freed himself and eventually established his own farm near Baldwyn, Mississippi. Growing up there around the turn of the century, Pierce learned to carve wood, evidently on his own, but inspired in part, at least, by the example of a favorite uncle who had a talent for woodcarving. As a young man in the 1910s, after the untimely death of his first wife and the less surprising death of his father, Pierce left Mississippi and spent two or three years as a vagabond. At twenty-eight, he was ordained as a Baptist minister, and he moved to Illinois for a few years before finally settling in Columbus, Ohio. There, he worked as a barber on weekdays and on Sundays conducted worship services at an African-American Baptist church, devoting any spare time he could find to carving small figurines and didactic bas-relief panels inspired by his

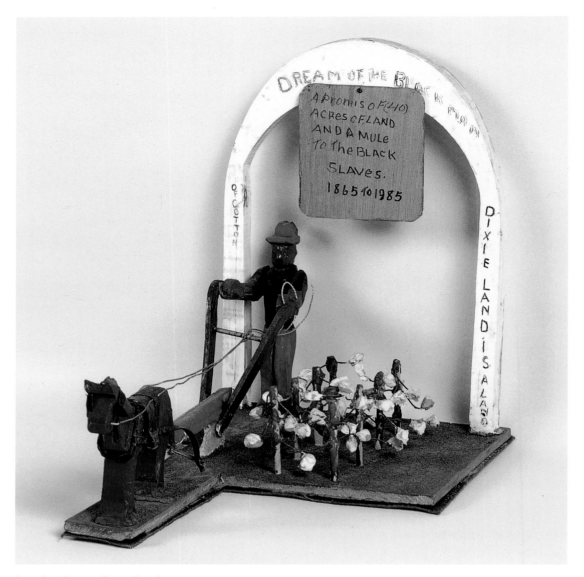

Josephus Farmer, Dixie Land

readings of the Bible. Often at the conclusion of a sermon he would present one of his carved pieces to a member of his church congregation, and he sometimes referred to his carvings as "sermons in wood."[16]

Like a number of other elderly self-taught artists, Pierce was "discovered" by the art world in the 1970s, and he enjoyed widespread acclaim for his work during the last decade before his death at ninety-two in 1984. His in-the-round portrait of baseball player Pete Rose wearing his Cincinnati Reds uniform and a Prince Valiant haircut is a good example of the occasional secular pieces that Pierce continued to make throughout his career. It dates from three years before his death and several years before Rose's professional downfall in an illegal gambling scandal, when he was at the peak of his fame as a national sports hero.

Also included here is a bas-relief *Crucifixion* that Pierce made in collaboration with his younger counterpart, Leroy Almon, a second-generation African-American woodcarver who was inspired by Pierce to start carving in the late 1970s, when he apprenticed with the aging artist for several months. Almost half a century younger than Pierce, Almon came of age during the early years of the Civil Rights movement, leaving his native Georgia in the late 1950s for two years of college in Kentucky and a brief stint in the army before settling in Cincinnati. In 1964, he moved to Columbus, where he worked as a salesman for a shoe company and later, for the Coca-Cola Bottling Company. He had lived there for almost fifteen years before he en-

countered Pierce one Sunday, when he visited Pierce's church and heard him preach. Almon took a strong interest in Pierce's art and assisted him in his dealings with the growing audience for his work, and eventually Almon decided to try his own hand at wood carving. Almon is one of the few artists represented here whose awareness of the audience for what he calls folk art preceded his own art-making career, which he has pursued with dedication since he returned to his hometown in Georgia in 1979. Almon is highly conscious of his role as a "folk" artist and evidently sees himself as a standard-bearer for a noble tradition. In his carved wood relief, *Garden of Eden,* he interprets a theme he knows has been treated by Pierce and countless other "folk" artists in their work.[17]

Southern-born African-American artists such as Almon, Pierce, and Farmer are more heavily represented in the Gordon collection than any other cultural group, and the same can be said of many—probably most—other significant collections of contemporary nonacademic American art. Because most major dealers and collectors of such art are white and affluent, while most of the artists whose work they collect are black and from economically underprivileged backgrounds, connoisseurship within the field of self-taught art has itself been equated with racism and economic exploitation. The self-taught art field is hardly immune to these social ills, and it's unfortunate—and appalling—that some self-professed admirers of this work insist on relating to it as the visual-art equivalent of an old-fashioned minstrel show. But in general, the reception of work by contemporary self-taught black artists has been no less respectful than that of their white counterparts' work, and the growing market for their art has resulted, for at least some of these artists, in a level of economic independence and self-determination that they had never known before. Given the degree to which racism and class prejudice permeate our society, however, these will no doubt remain problematic issues within this field as well as in many other segments of American culture.

Another second-generation African-American woodcarver from the South who is represented here is Herbert Singleton. Now in his early fifties, Singleton lives in the predominantly black, lower-income neighborhood of Algiers in New Orleans, where he was born and has spent most of his life. Like many of his neighbors in that part of the so-called Big Easy, he has had a violent and troubled past. He dropped out of school at age twelve, not long after his father left his mother to raise him and his seven younger siblings on her own. While she was at work in a local hospital, Singleton roamed the streets and eventually got involved with street gangs and criminal activity. When he was still a young man, he was arrested for drug-related offenses, as a result of which he spent more than a dozen years in Louisiana's Angola State Prison. Since then, Singleton has had other problems with the New Orleans Police Department, the most tragic of which led to the shooting deaths of his sister and two friends in a raid by police officers pursuing a murder suspect.[18]

Despite all the destructive forces that have affected his life, Singleton has maintained a strong creative impulse ever since his childhood, when he began to sculpt snake forms from mud and to carve shapes and designs on pieces of Mississippi River driftwood. When he was about thirty, he began making elaborately carved and painted canes and staffs, and he eventually expanded his artistic repertoire to include freestanding three-dimensional pieces and bas-relief plaques that he carved on old doors salvaged from demolished houses in and around Algiers. The latter works are his most striking and elaborate—subtly balanced narra-

tive compositions that deal with a variety of social, political, and religious themes. The one included here is among his more ambitious biblically inspired pieces and is thus thematically connected with the previously discussed relief plaques by Pierce and Almon as well as other religion-based works to be mentioned later. But in addition to pieces such as these, Singleton also makes bas-reliefs that deal with the history of racism in this country and others that depict the seamy side of New Orleans street life and his harrowing experiences in prison. His work, perhaps more than any other self-taught artist's, is uncompromising in its portrayal of the harsh realities of urban black life, and in that respect, he is one of the more socially relevant artists represented here.

Issues related to contemporary African-American life also find visual expression in the work of two black artists from Alabama—Lonnie Holley and Thornton Dial, Sr. Now in his late forties, Holley came of age, like Singleton, during the era of the Civil Rights movement, when his hometown of Birmingham was the site of fierce struggles over issues of racial integration and voting rights for black citizens. Like most nonwhites in "the heart of Dixie" at that time, Holley grew up under circumstances of economic deprivation and glaring racial injustice. He was raised largely by his grandmother, and early on, he developed a profound respect for women and their role in maintaining the social fabric of their communities. Later, when Holley began making art, this became one of the major themes in his work, and his piece here is one of many paintings, industrial-sandstone sculptures, and found-object constellations in which he explores it. *Out of Mother's Blood, the Eye,* is a symbolically loaded image that honors women for their abili-

Herbert Singleton, The House of David

Thornton Dial, Sr., Flying Free (Woman's Head)

ties to nurture the young and make sacrifices for their families, and the large eye image that dominates the composition suggests that women possess an inherent wisdom, an intuitive power that is the source of these abilities.[19]

Dial, now in his late sixties, is from an earlier generation than Holley, but he was raised in similarly disadvantaged circumstances. His mother was still in her teens when he was born; he never saw his father. Growing up in Sumter County, Alabama, during the Great Depression, he attended only the first three grades of school, after which he went to work as a field hand to help support his family. The main stabilizing influence in Dial's life during his early years was his great-aunt, Sarah Lockett, with whom he lived as a teenager. Her example no doubt was crucial in the formation of his deep respect for women, which he has visually expressed in many of his paintings, drawings, and painted assemblages, including the two works in this exhibit. Dial began making art during his youth, but for more than forty years, he allowed his creations to be seen only by his neighbors and members of his family.[20]

Like Singleton, Holley, and a number of other self-taught artists, Dial was "discovered" during the 1980s, and within a few years, he became one of the most celebrated figures in this nonacademic branch of the contemporary art world. He shares with these two artists strong feelings about social problems, and his intensely expressionistic, symbolic narrative works deal with issues such as race relations, the environment, corporate exploitation, drug abuse, religion, and sexuality. The latter subject is central to his *Love Piece: Scrambling through the Flowers,* a symbolic treatment of amorous relationships between men and women. As in many of Dial's other works, the tiger in this painted mixed-media relief functions as a symbol of masculinity. The woman's head in the upper center, meanwhile, signifies the controlling power that women are able to exert over men, especially in matters of love, emblemized by the field of flowers that surrounds this wild beast. The abilities of women to rise above their circumstances and exert their independence are celebrated in Dial's drawing *Flying Free (Woman's Head).* Here the central figure's nudity is symbolically equated with freedom from social constraints as well as with the powers of sexual attraction that Dial alludes to in *Love Piece.* It can also be inferred from these two works and others Dial has made that he sees close parallels between the sociopolitical struggles of African-Americans and those of women in this country. Through a variety of coded symbols in his art, he has repeatedly indicated his recognition that these powerfully overlapping interest groups have long been engaged in a common fight for liberation from a white-male-dominated power structure.

Bessie Harvey was herself the kind of strong, independently minded, spiritually resilient African-American woman Holley and Dial idealize in their art, and she spent most of her life in an intense personal struggle with the twin sociopolitical demons of racism and sexism. Born into a large, economically deprived family in a small Georgia town at the outset of the Great Depression, she was raised by a single mother in circumstances that necessitated she grow up fast. Before she reached her sixteenth birthday, she was married to a man who proved to be so abusive that she left him before she was twenty. She bore eleven children before she turned thirty-five, raising them largely on her own, and by the time she died at sixty-four, she had thirty grandchildren and a few great-grandchildren.[21]

Like several other artists represented in this exhibit, Harvey began making art during a period of

Bessie Ruth White Harvey, Untitled

personal crisis. Sometime around 1970, she discovered that her teenage sons apparently had gotten in-
volved in criminal activities, and the resultant anxiety and fear she felt triggered a kind of psychological
breakdown. She attributed her unsupervised recovery from this inner turmoil to divine intervention through
a series of visionary experiences, which she in turn cited as the impetus for her artistic efforts. As she
described them, these experiences involved communicating with trees and plants and seeing faces material-
ize on the interior walls of her house or from the gnarled shapes of roots and weathered tree branches that
she found nearby. In the early 1970s, Harvey began to collect these evocative natural wood fragments and
paint them to highlight the faces and figural forms they suggested to her, further embellishing them with bits
of costume jewelry, feathers, and other objects. One of her later painted sculptures of this kind, an untitled
work she made in 1986, is included here, as is a rarer drawing from a year earlier, which provides a hint of
what the mysterious faces she saw on the walls of her house might have looked like to her.

The affinities that works such as these share with traditional African art were pointed out by several
critics and other observers during the 1980s, and these comparisons weren't lost on Harvey. Although self-
taught artists are often presumed to be uninterested in art history and the work of other artists, she took
the cue and began her own investigation of African art and ritual traditions, which became a more conscious

and deliberate influence on the work she made in her last few years while reading books on these subjects. In that sense, Harvey used her art as a means of reconnecting with her cultural heritage as well as establishing contact with life's spiritual dimension. Her explorations in these areas during the last phase of her life empowered her in ways she never would have imagined possible when she had the first of those strange visionary experiences.

Harvey shared this visionary sensibility with a number of other self-taught artists, several of whom are represented in this exhibit. Notable among those who were also black southerners are "Sister" Gertrude Morgan and John B. Murry, both from an earlier generation than Harvey's. Born in Alabama at the turn of the century, Morgan evidently went through a short-lived marriage when she was young, but she never remarried, and she remained childless all her life. Instead of raising a family, she moved to New Orleans and joined an African-American missionary organization that specialized in street-preaching, singing, and dancing. Her already strong religious faith was reinforced by a vision she had when she was almost sixty years old, in which she believed she was revealed to be the bride of God. A few years before she had this startling revelation, Morgan had begun to draw, and she grew more serious in her artistic endeavors in the late 1960s, after the destruction of her missionary group's chapel in a hurricane.[22]

Many of Morgan's drawings and paintings, such as the one included here, depict scenes from the Bible, but she also created several self-portraits that refer to the mystical marriage she learned about in that

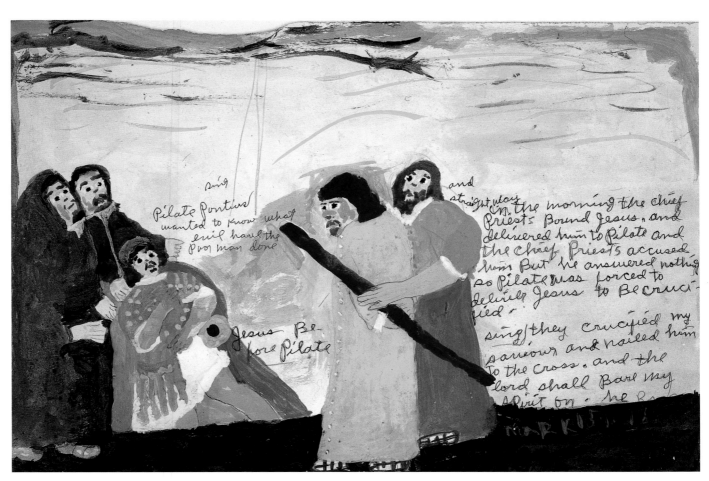

Sister Gertrude Morgan, Jesus before Pontius Pilate

pivotal visionary experience. And many of her later works from the 1970s portray scenes from the Revelation of Saint John the Divine, the extravagantly visionary book that concludes the New Testament. During these years, she began to receive some recognition for her work, and a New Orleans art dealer provided her with a place to live in exchange for her paintings. She made few drawings or paintings after 1975, though, claiming Jesus had ordered her to give up art and devote her energies to preaching. During her lifetime, her works fetched only very modest prices, and she died in poverty in 1980, but over the next few years, her creations became hot commodities in the burgeoning market for self-taught art.

J. B. Murry was born a few years after Gertrude Morgan, in 1908, in a part of rural southeast Georgia, where he continued to live until his death eighty years later. He had little or no schooling, and he worked as a sharecropper and farm laborer for most of his life. His many years of underpaid toil in the fields came to an abrupt end with a debilitating hip injury he suffered when he was about seventy years old. He evidently underwent a profound spiritual transformation in the wake of this mishap, because he started having experiences in which he believed God was using him as an instrument of visual communication. The medium for this supernatural phenomenon was a series of abstract drawings that incorporate marks and patterns reminiscent of illegible writing in an unknown language—"spirit script," as it has been called by some observers. Murry apparently believed that God actually guided his hand in making these drawings, and he claimed the ability to "read" them after the fact by viewing them through a clear jar or bottle containing water from the well in his yard. Those who knew him report that he would utter unintelligible sounds and syllables while he moved the container of water across the surfaces of the drawings, as if he were practicing glossolalia.[23]

Some scholars have compared Murry's method of visionary transcription and decipherment to traditional divination practices employed in parts of West Africa. Murry's drawings came to the attention of a few collectors of self-taught art during the 1980s, and they began providing him with paper, paints, colored-ink markers, and other supplies with which to make his drawings larger and more elaborate—not to mention more salable. As in the case of "Sister" Gertrude Morgan, Murry's death translated into dramatically increased interest in his work among collectors, and the prices of his drawings have risen accordingly. It is more than a little ironic that the works he believed to be messages from the spirit realm have been converted into art-market commodities. Murry is one of the few artists represented here who actually didn't think of his creations as art, and their appropriation by the museum and gallery world remains one of the more problematic transactions in the recent history of self-taught art. To focus on their undeniable aesthetic appeal is, ipso facto, to ignore their original context and the meaning(s) they had for their creator.

The visionary strain in self-taught art is by no means the exclusive domain of African-American artists such as Harvey, Morgan, and Murry. Artists from a variety of other cultural backgrounds have demonstrated similar preoccupations with visionary experience. This is particularly true of several Caucasian artists who live in the same region as Almon, Singleton, Holley, Dial, Harvey, Morgan, and Murry. The South's reputation as the nation's "Bible Belt" is well deserved in the sense that Protestant Christianity remains the dominant religion here, and this tradition's emphasis on individual experience of the spiritual has served as the basis

John B. ("J. B.") Murry, Untitled (Tall Figures Crowded Together)

for a receptive attitude toward the possibility of divine revelation in the form of miraculous visions, disembodied vocal messages, and other such supernatural phenomena. It is the shared belief of many southern Protestants, white and black, that contemporary Christians are capable of experiencing powerful visions like those described by the biblical prophets.

Myrtice Snead West is a white Anglo-Saxon Protestant artist from rural Alabama who shares "Sister" Gertrude Morgan's fascination with the visionary experience Saint John the Divine recalled at the conclusion of the Christian Bible. West's paintings, like the work of many other self-taught artists, represent a creative response to pain and suffering. She began drawing during the early years of her marriage, in the

1940s, after her first two pregnancies ended in miscarriages, and soon she made the transition to painting. For more than thirty years, she was content to employ her creative energies in making quaint memory paintings and images of ducks and flowers. During this period, she gave birth to her only child, a daughter named Martha Jane. But Martha Jane's life ended tragically in 1986, when she was murdered by her estranged husband. The murder brought an abrupt and devastating end to a chronically abusive relationship that had been of increasing concern to West in the years leading up to this violent final act.[24]

For spiritual guidance during this difficult period, West studied the Bible and found herself strongly drawn to "the book of Revelations," as she refers to the New Testament's closing chapter. She saw the catastrophic horrors described by Saint John of Patmos as a kind of metaphorical mirror of her own life, and she found solace in the book's ultimate message of redemption through faith. This experience inspired her to begin work on the paintings for which she has since become widely known in the self-taught art field— a series of narrative images that illustrates the extraordinary events Saint John reported having witnessed. There are fourteen paintings in the original series, and West has made additional versions of them since it was completed. Her *Song of Moses* illustrates the fourteenth through the sixteenth chapters of Saint John's Revelation, and it is remarkable, among other reasons, for the sheer amount of information West has managed to convey in it. According to the artist, these paintings are not merely illustrations of a first-century prophet's visionary experiences. She believes they also reflect her own directly received spiritual instructions. In describing her initial inspiration to make the paintings, she told one journalist, "It seemed like (the prophet) John was putting these pictures in my mind, telling me the colors to use and everything." Further, she has said, "My religious paintings give me a feeling I can't explain. There is something God wants me to get out there to the world."

West's rural Alabama background and Christian religious convictions are shared by Howard Finster, probably the world's most famous contemporary self-taught artist, whose heritage is German, Irish, and Dutch. Now living in a part of northwest Georgia not far from the small Alabama farm where he grew up, Finster was born during World War I and has followed a religious vocation since he was a teenager. For more than fifty years, he preached the Gospel at churches and old-fashioned tent revivals in several states, while also maintaining various sideline careers to help support his family. The longest-lasting of these parallel occupations has been that of visual artist—a role Finster has combined with his ministerial work in a remarkably unique way. Like West, Finster has often applied his artistic skills to the depiction of scenes from the Bible, including passages from Saint John's Revelation. But he goes one considerable step further and claims that he has himself experienced revelatory visions on the order of those received by Saint John and other biblical prophets, such as the Old Testament's Noah, Moses, and Ezekiel. According to Finster's account, he was a prodigy in this respect, divinely blessed with his first such experience when he was only three years old and his dead sister, Abbie Rose, appeared to him on a stairway to heaven. Finster has described a trip he made to hell in one of his visions and a conversation he had there with Adolf Hitler. He also tells of a visitation he had from Elvis Presley not long after the rock-and-roll star's death. And he has gone into great detail in describing his visions of traveling to different planets—"other worlds beyond the light of the sun." He insists that all of his artworks are visionarily inspired, including his elaborate

outdoor environment known as Paradise Garden and the adjacent three-tiered church that he built, both of which he has said were "blueprinted by God."[25]

Finster began his ongoing series of paintings in 1976, in response to a disembodied voice that he says commanded him to "paint sacred art." His painting in this exhibit is one of the works he made within the first year after taking on that artistic mission, before he began numbering and dating his freestanding pieces. It incorporates several of his work's signature themes and images, including a hilly landscape, biblical quotations, trumpeting angels, a historical portrait, a small self-portrait, and several of the elaborately rendered domed "mansions" that he reports having seen in his visions. The chaotically obsessive nature of Finster's art and his working habits have led some of his neighbors and other observers to question his sanity. At least one medical specialist has described him as a "borderline personality" and dismissed his visions as "hallucinations." Despite his insistence on the reality of these unconventional perceptions, Finster appears to have had no trouble distinguishing his visionary experiences from events taking place in the realm of ordinary reality, and he has negotiated the multiple responsibilities of marriage, fatherhood, providing financial support for his family in an economically depressed area, and giving spiritual guidance to the faithful—all with every indication of full mental competence. It's certainly fair to say that he's eccentric, but it's stretching a point to conclude that he verges on being psychotic.

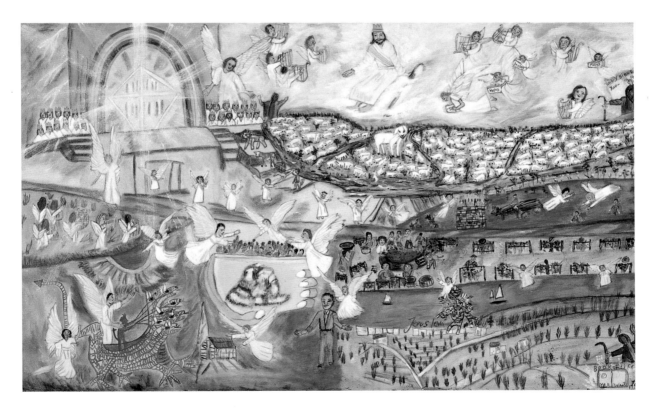

Myrtice Snead West, Song of Moses

As noted early in this essay, many of those artists whose work Jean Dubuffet originally labeled *art brut* have been clinically diagnosed with various forms of psychosis. Some fifty years later, certain creative individuals with histories of mental illness continue to draw considerable attention from aficionados of "outsider" art, and some collections are devoted exclusively to "the art of the insane." Obviously the Gordon collection has no such specialized focus, but several artists represented in it have spent time in mental institutions, and in that sense, at least, they constitute yet another of the identifiable subgroups whose works are included here. It's important to note, in this context, that definitions of mental illness have changed throughout the twentieth century (to say nothing of earlier eras), and that not everyone who has been a patient in such an institution is necessarily psychotic or mentally unstable. Unfortunately, there are numerous examples of people who were involuntarily committed to mental-health facilities for reasons other than serious mental instability.[26]

Records detailing the reasons that Dwight Mackintosh was sent to such a facility in 1922, when he was sixteen years old, have been lost or destroyed, but a court document related to his case suggests he was institutionalized because he was "unmanageable at home." Whether or not his confinement was justified, Mackintosh was locked up in California state mental hospitals for the next fifty-six years. His release in 1978 came as the result of a trend toward freeing mental patients not believed to be dangerous to themselves or others. The following year, Mackintosh was admitted into a voluntary-participation program for people in his circumstances, sponsored by the nonprofit Creative Growth Center in Oakland, California, and it was there, at age seventy-three, that he began compulsively drawing.[27]

Whatever his condition might have been on first being placed under institutional care, Mackintosh emerged from his decades of treatment in a deeply withdrawn state, and his art has since served as his only mode of communication. In that regard, his drawings are limited, despite their strong aesthetic appeal. His main pictorial subjects are male figures and cars or other wheeled vehicles, such as the yellow one that resembles a school bus in the drawing by which he is represented here. The men that appear in many of his other works are distinguished by prominent erect penises and physical abnormalities such as extra fingers. In addition to this narrow range of imagery, Mackintosh's drawings usually include lines of tightly looped flowing calligraphy, such as that which appears in the upper portion of his drawing here. This component of his work is reminiscent of the "spirit writing" in the drawings of J. B. Murry. Like Murry's visual glossolalia, Mackintosh's calligraphy is illegible to everyone except the artist himself, who evidently is unwilling or unable to share its meanings with anyone. For that reason, it lends an air of mysterious obscurity to Mackintosh's drawings, and this quality no doubt significantly enhances their appeal to collectors.

Gaetana Menna is of the same generation as Mackintosh, only six years younger, and he, too, has spent much of his life in mental institutions. Menna is a Brooklyn-born Italian-American now in his early eighties, but little is known of his early life, and he evidently is disinclined to reveal much about himself. One of the few brief biographical accounts about him that have been published since his work began to gain attention among self-taught art enthusiasts describes him simply as "cheerful but quiet." Aside from their extensive experience on the receiving end of this country's mental-health system, Menna also shares with Mackintosh a fascination with what most of us in modern Western society conceal under our clothes,

Dwight Mackintosh, Yellow Car

and this preoccupation is reflected in drawings such as the one exhibited here. Menna has made a number of variations on this same basic image, a standing male figure whose clothing has been rendered transparent. This is one of two kinds of work he produces; the other consists of rough copies he makes from reproductions of famous paintings in art-history textbooks. The latter drawings, however, aren't nearly as interesting and revealing as Menna's original figures, which carry intriguing psychological and social implications.[28]

Although no one can be sure what Menna has in mind in creating them, these drawings of isolated figures whose nakedness shows through their clothes suggest an obsessive awareness of the difference between surface appearances and fundamental reality—between the truth of the physical body and society's compulsion to cloak it in the layers of fibrous material designed to distract us from that truth. In view of the artist's reticence, one can only speculate on possible connections between this type of imagery and the events that led to Menna's institutionalization. But it's easy to imagine how such preoccupations might have led him to violate certain social taboos that were widely accepted in the early years of this century, and how that sort of an infraction could have resulted in his being declared mentally unbalanced.

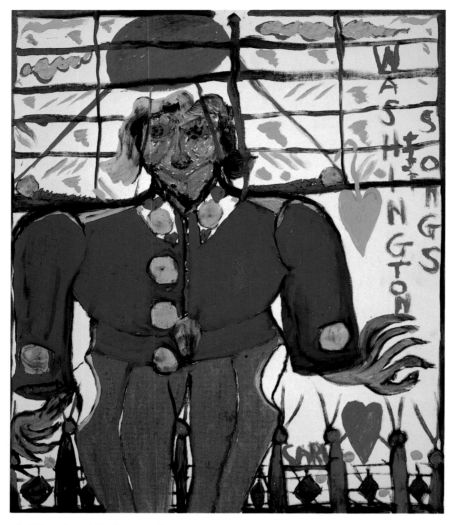

Carl Greenberg, Washington Songs

Carl Greenberg was also born in Brooklyn, about five years after Menna, and he is similarly reluctant to discuss his past. But it is known that he spent some time in a mental hospital, and there are indications that he suffered long-term emotional damage as a result of the experience. Although he is something of a recluse, his art invariably features images of flamboyantly dressed performers and other charismatic individuals who are often literally in the spotlight, standing on a stage and singing the "songs" that his titles evoke. The one here is *Washington Songs,* and it centers on a figure that probably represents George Washington standing against a decorative backdrop under what appears to be a red spotlight as he presumably performs a selection of show tunes. Greenberg's art seems to function as a vehicle for expressing aspects of his personality that he is otherwise too withdrawn to manifest. But, like Mackintosh and Menna, his range of themes and original imagery is very narrow.[29]

Freddie Brice belongs as much to the group of southern-born African-American artists whose work was discussed earlier as he does to this group of mental-institution veterans. Born in the one-time slave port of Charleston, South Carolina, Brice was nine years old when he moved with his mother to New York's Harlem district at the outset of the Great Depression. He was still a youth when his mother died, and he moved in with an aunt and uncle who also lived in New York. As an adult, he worked at a variety

of manual-labor jobs, but he had repeated run-ins with authorities, which led to sometimes lengthy periods of institutional confinement, first in reform schools and later in prisons and psychiatric facilities.[30]

Like the other former mental patients just discussed, Brice didn't start making art until late in his life, after he was introduced to painting in a psychiatric day program in New York in 1983, but his work encompasses a much wider spectrum of subject matter than theirs, including people, animals, boats, miscellaneous objects, and mythological characters. The imagery in his large-scale paintings is relatively straightforward compared to the more eccentric creations of Mackintosh, Menna, and a number of other artists with histories of psychiatric institutionalization. Here Brice is represented by a larger-than-life portrait of Christ wearing a bloody crown of thorns and a painting of a passenger in a yellow *Tug Boat,* which may have been inspired by Brice's memories of a job he once had painting ships in the Brooklyn Navy Yard. Brice is more verbally communicative than Mackintosh, Menna, or Greenberg, but his conversation apparently is quirkier than the images in his paintings. This trait is exemplified by a 1990s interview in which Brice comments on his art with observations such as the following: "When you begin to love something; when you begin to do something, a constructive something that you like and love, it becomes a hobby. It becomes regular. It becomes continuously. It becomes outrageous. It becomes magnificent. It becomes to be something that you like to do for a hobby."

Freddie Brice, Head of Christ

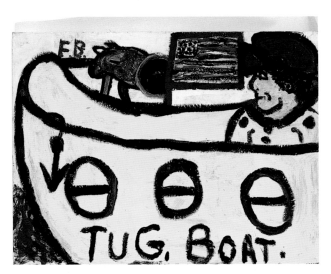

Freddie Brice, Tug Boat

Yet another artist represented in the Gordon collection who has a history of being institutionalized for treatment of mental illness is Robert Eugene Smith. The difficulties he has had as an adult seem to be at least partially rooted in his troubled childhood. Born in Saint Louis two years before the Great Depression began, Smith was only eight when his father died. Soon afterward, his mother married a man whose alcoholism created additional family problems that Smith temporarily escaped by moving to Dallas, Texas, where he remained in the care of an uncle for three years. His living circumstances remained unstable throughout his teen years, and when he was twenty-one, he joined the army. Smith's military career was very short-lived, though, because he was discharged for medical reasons after only six months in the service. About two years later, he suffered what he has described as a "nervous breakdown" and was committed to a state mental hospital in his hometown, where he was confined throughout the 1950s and most of the '60s. It was there that Smith began drawing regularly to keep himself occupied, and he continued to pursue this creative activity after his release. He has been out on his own for nearly thirty years now, and he has managed to support himself by working at a variety of menial jobs at hospitals, restaurants, and a professional sports stadium.[31]

Smith's drawings began to gain the attention of collectors and other specialists in self-taught art after he exhibited several of them at the Missouri State Fair in 1976, and over the ensuing two decades, they gradually attracted a wider audience. Except for a very brief failed marriage soon after his release from the hospital, Smith has lived alone in his postinstitutional years. Throughout this period, he has struggled with persistent financial difficulties and a shaky sense of self-esteem, but these problems seem to have fueled his oft-expressed desire to be recognized for his art. His ambition in this regard contradicts the myth that self-taught artists are unconcerned with the public response to their work. Most of his drawings feature panoramic views of outdoor scenes in which there is a lot of activity, as exemplified by the one in this exhibit. This is one of several variations Smith has made on a bird's-eye view of *Alcatraz,* the defunct island prison in San Francisco Bay, during its temporary occupation in 1969 by Native American activists who wanted the facility transformed into a study center focusing on Native American issues. Occurring as it did soon after his release from the mental hospital and during the period of his brief marriage, this rebellious action by people protesting their marginalized social status evidently made a strong impression on Smith, perhaps because he identified with the Indians' situation.

In contrast to several of the other former mental patients mentioned above, Smith seems to thrive on the opportunities his art provides for him to communicate and otherwise interact with people. Some of his drawings are inspired by things he sees on his occasional travels around the country by Greyhound bus, and many are accompanied by handwritten or audiotaped narratives that explain and elaborate on the scenes he depicts. In recent years, he has expanded the communicative dimension of his work by crossing over into the field of performance art. His one-man shows, in which he sings, displays his bicycle, and sometimes wears a purple clown wig, fulfill his early childhood dream of someday becoming a professional entertainer.

As we've seen in a number of cases cited so far in this essay, contemporary self-taught artists don't always conform so neatly to the stereotype that is promulgated by the popular press and employed by commercial galleries in the marketing of "outsider" art. Indeed, there hardly seems to be an end to the list

of exceptions to the genre's unofficial rules. Self-taught artists, for example, are often described as being unsophisticated, undereducated, isolated from mainstream culture, and indifferent to the work of other artists. But, in fact, a number of artists whose work has been enthusiastically embraced by admirers of self-taught art are highly sophisticated, keenly aware of contemporary culture, and quite conscious of their place in it.

One of several such artists represented here is Ted Gordon (no relation to the collectors). Gordon was born in Louisville, Kentucky, where he spent the first fourteen years of his life before his grandparents took him to live in Brooklyn. After graduating from high school in the early 1940s, he found work as a brickmason, and for several years, he supported himself at this trade. But he moved to San Francisco in 1951 and a few years later enrolled in San Francisco State College (now a state university), where he earned a bachelor's degree. It was during his student years that he began drawing, although not under the auspices of the school's art department.[32]

Gordon never took any art courses, but he continued to draw for his own amusement and to fill otherwise idle moments. After college, he obtained the first of several government-service jobs at veterans' hospitals and federally administered medical centers. In 1981, four years before he retired, he read two of

Robert Eugene Smith, Alcatraz

the definitive books about self-taught art—Roger Cardinal's *Outsider Art* and Michel Thevoz's *Art Brut*—and he immediately recognized a stylistic affinity between his own drawings and a number of the works reproduced in these volumes. He followed up this discovery by contacting the authors of both books and sending several of his drawings to each of them. Both responded enthusiastically, and the works Gordon sent Thevoz became part of the Collection de l'Art Brut, the institution in Lausanne, Switzerland, whose core collection was assembled by Jean Dubuffet, and of which Thevoz serves as chief curator.

The similarities between Gordon's drawings and the works that Cardinal and Thevoz define by the titles of their books have to do with the obsessively intricate patterning and endlessly repeated variations on a single basic image that are characteristic of these drawings. Not only does Gordon's work share these traits in common with art brut, but the tightly framed human faces that stare hypnotically out from the majority of these heavily worked compositions convey an unsettling psychological tension that is also common to much of the art that these two scholars surveyed in their books. As his drawing here indicates, Gordon manages to create the illusion that all the pores in the skin of these staring faces and all the cells in their hair and in the irises and pupils of their eyes are simultaneously seething and swarming like bees in a hive. Among potential viewers of this exhibit who might feel a sense of recognition on looking at these drawings are those who have ingested hallucinogenic plants or chemicals on at least one occasion, particularly if the experience involved staring into a mirror or looking closely at another person's face. Under those circumstances as well as many others of particular psychological intensity, a close face-to-face meeting—whether with oneself or with another—can be a disturbing and even terrifying experience. This fundamental personal or interpersonal encounter seems to be the recurrent theme in Ted Gordon's art.

The "discovery" of self-taught artists by members of the art cognoscenti is a staple of the outsider art myth, according to which the artist is so ignorant of or indifferent to the art world that he or she has to be "found" by the experts in order to exist within that world. But Gordon is one of a growing number of nonacademic artists who discovered themselves, in effect, by seeking out audiences for their work. The encouragement he received from Cardinal and Thevoz when he took the first step in that direction quickly led to the inclusion of Gordon's work in the first of many exhibitions and a growing number of collections. In these respects and others (such as his possession of a college degree), Gordon is an important figure in the process of reevaluation and redefinition now going on in the self-taught art field.

Another of the more obviously sophisticated artists to gain some attention within the field in recent years is Philip Travers, a native New Yorker born at the beginning of World War I. Like many of the other artists represented here, he began drawing as a child, but he is one of the few whose desire to pursue this activity was so conscious and carefully considered that he sought professional art training. While he was still in his twenties, Travers signed up for classes at the Art Students League, but his studies there didn't last long. He had a run-in with one of the teachers—none other than George Grosz, the German artist famous for his scathing visual satires on sociopolitical problems—and the experience evidently soured Travers on the formal art-education process. It seems that he declined to take part in a watercolor exercise Grosz had assigned, and the ensuing clash of wills resulted in Travers's departure before the end of the first class session. Although this conflict evidently turned him off to art school, it didn't stop him from making art

and working in fields that were at least loosely art related. He spent some time studying show card design and sign painting, and he worked in a photography studio and laboratory, in addition to many other jobs he has held that had virtually nothing to do with art.[33]

Travers is a voracious reader and has used books to educate himself on a number of subjects that hold special interest for him, such as astrology, Egyptology, and the occult. His considerable knowledge in these and other areas informs the complex series of idiosyncratic, technically proficient drawings for which he has become known. Several of these precisely rendered, elaborately text-augmented line drawings are included here, and they're part of this ongoing narrative series, which he calls the "Tut Project." The project was inspired by the blockbuster archeological exhibition *Treasures of Tutankhamen,* which came to this country in the late 1970s and gave many Americans a firsthand, once-in-a-lifetime look at objects from the tomb of a

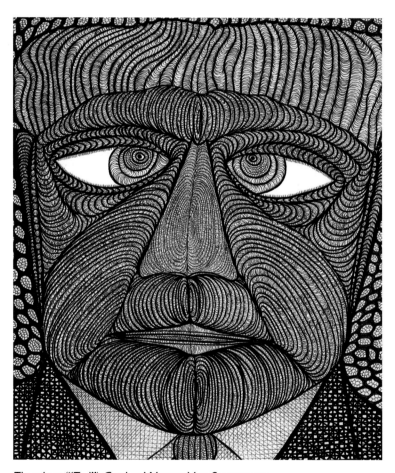

Theodore ("Ted") Gordon, Werner Von Sterngazer

Philip Travers, A Discordant Note

king who ruled Egypt some 3,400 years ago. Travers's drawings and texts recount the imaginary adventures he has after encountering a magician who enables him to travel through time and visit ancient Egypt, where he meets the Egyptian gods and angers King Tut. The king begins chasing Travers—identified in the narrative as "Mistaire Travaire"—and the pursuit extends across the centuries. Travers also manages to weave into the story various characters appropriated from *Alice's Adventures in Wonderland* and *Through the Looking Glass,* English writer Lewis Carroll's satirical fantasy novels from the late nineteenth century. Adjectives routinely used in the discourse surrounding self-taught art—such as "simple," "naive," "unsophisticated," and "illiterate"—are very much out of place in any discussion of Travers's work. And Travers's artistic activities haven't been limited to visual art, as he has performed in several New York dance and theater productions.

In addition to the impact the emergence of artists such as Travers and Ted Gordon is starting to have, the self-taught art field has lately been invigorated by the work of several young, culturally tuned-in individuals who represent a whole new generation of nonacademic artists. Their position on the field's leading edge further undermines the stereotypical view of such artists that has dominated the discussion of their work for so long. Among the most highly visible of these younger artists is Tony Fitzpatrick, in his late thirties at this writing. This Chicago painter and illustrator is another artist who began drawing during his youth. His only formal training was an art course that he failed at the Catholic high school he attended during his teen

years. While he was in his twenties he worked variously as a bouncer, bartender, boxer, construction worker, and cabdriver, but he continued to make art, and he actively pursued exhibition venues for what he made. His efforts to get his work shown began to pay off in 1987, when he had his first solo show in New York. This exhibition led to a variety of other opportunities, and his career was effectively launched.[34]

Fitzpatrick finds his subject matter in the extremes and contradictions and deep mysteries of late-twentieth-century American culture(s). He makes images of sports heroes, popular-music icons, strippers, and mass murderers, and his material also comes from horror movies, visits to places such as New Orleans and Coney Island, and his investigations into African-American spiritual traditions, notably Vodun and Santeria. His style reflects influences as diverse as comic books, pornography, and Mexican *retablo* paintings, and like a number of other self-taught artists, he takes a horror-vacui approach to composition, crowding just about every available space in his works with free-floating images and texts. A characteristic piece in this respect and others is his *Conjure Women,* rendered in chalk on an old-fashioned slate board like those used by schoolchildren in an earlier era. Collectors of his work include famous rock musicians and Hollywood film directors, through connections with whom he has pursued successful sideline careers as an illustrator and movie actor. He has created cover illustrations for several rock albums and acted in major motion pictures such as *Married to the Mob, Gladiator,* and *Mad Dog and Glory.* After several years of career success, he even opened his own gallery in Chicago—the World Tattoo Gallery—where he exhibited his own art and that of other artists, without regard to their academic backgrounds or lack thereof.

Tony Fitzpatrick, Conjure Women

Among other relatively young self-taught artists whose life experiences and levels of cultural sophistication run counter to the myth of the naive, uneducated "outsider" are Levent Isik and Melissa Polhamus, both of whom, like Fitzpatrick, are still in their thirties at this writing. Isik is a Turkish-born Canadian citizen who only began making art in 1989, after he saw works by several well-known self-taught artists who also lived in his adopted hometown of Columbus, Ohio, and set out to follow their examples. Whereas such artists are routinely described as being uninfluenced by other artists' work, Isik readily admits to being strongly affected by the art of Elijah Pierce and William Hawkins as well as that of Vincent Van Gogh, self-taught painter Morris Hirshfield, and another artist represented here—Mr. Imagination, a.k.a. Gregory Warmack. Traces of most of their influences can be found in Isik's small button-embellished nude in a box. His receptivity to these influences and his conscious decision to become a practitioner of this loosely defined art genre set him apart from most of the other artists whose work is included in the exhibit.[35]

Melissa Polhamus is more of a true original, but because of her education and other aspects of her background, she can hardly be considered the kind of pure innocent that self-taught artists are often presumed to be. Born in Germany, she is the adopted daughter of a U.S. military career serviceman and his wife, and she grew up in several different American towns as a result of her father's transfers to various East Coast military bases during her childhood. She holds an undergraduate degree in history from Virginia Polytechnic Institute and State University, and her employment history includes a job with a Wall Street

Melissa Polhamus, Kansas City

investment firm and more than three years of experience as an information analyst for a government defense contractor. She lived in New York for four years during the early 1980s, and that experience gave her plenty of exposure to contemporary visual and performing arts and other facets of "high" culture, but she made no attempt in those years to express herself creatively. She didn't start drawing, in fact, until 1990, after she was laid off from a job and suddenly found herself with a lot of spare time.[36]

Like so many other self-taught artists, Polhamus lives in the South—coastal Virginia, in her case—but her work has more in common with that of artists associated with the European *art brut* model that Dubuffet formulated. Her incongruously bright-colored linear drawings are about intense psychological distress, but unlike most of the "psychotic" artists whom Dubuffet and his followers have championed, Polhamus is quite consciously aware of the issues her work engages. A sense of menace and subconscious terror permeates her pictures. The compositions are usually overloaded and intricately fragmented, somewhat like shattered glass, and they include lots of sharp-looking jagged shapes that are often arranged in rows like so many razor-sharp teeth. Her drawings are among the toughest, most unsettling works produced by any contemporary self-taught artist, and this quality makes her one of the most promising young figures in the field. Her work is aggressively *angst*-ridden, and in that respect she is the polar opposite of someone like Levent Isik, whose art is generally sunny and upbeat. Unfortunately, the self-taught art market's bias in favor of imagery that is more whimsical and "childlike" tends to work against Polhamus, and as a

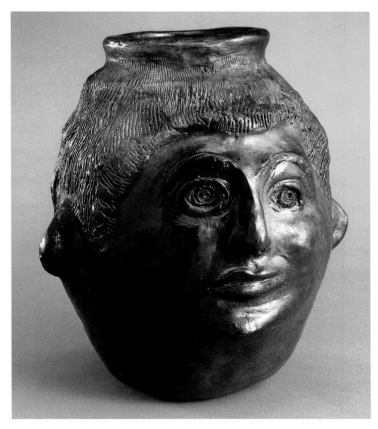

Georgia Blizzard, Ying Yang (Mae) Face Jug

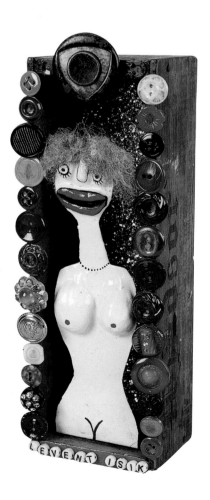

Levent Isik, Box with Nude Figure

result, her remarkable drawings haven't received the exposure they deserve. Baron and Ellin Gordon are to be commended for recognizing her work's importance early on and supporting her creative efforts by purchasing more than fifty drawings from her since 1992. This special emphasis on an artist who has yet to receive widespread attention in the self-taught art field is one of the distinctive marks of the Gordon collection.

There are many other artists represented in the collection whose art and personal histories shed further light on the issues surrounding self-taught art. In this essay, I have attempted to identify several distinct subgroups within the field in order to show something of the diversity of the social and cultural territory from which this art originates. But there are numerous other self-taught artists who don't happen to fit neatly into any of these groups. Take Georgia Blizzard, for example. Her Southern Appalachian background is hardly unique among the artists represented here, and she isn't the only potter or ceramic sculptor with work in the Gordon collection. But she doesn't specialize in the imagery of rural living, she has no African heritage, she's not a fundamentalist Christian recording divinely inspired visions, and she has never attended college or been confined in a mental institution.[37]

Blizzard's figural vessels and bas-relief plaques seem to have more in common with the engravings of eighteenth-century artist-poet William Blake and the ceramic art of pre-Columbian Mesoamerica than with the work of other contemporary self-taught artists. She sometimes incorporates biblical references into her work, but its main emphasis is in universal themes of birth, suffering, death, and rebirth. As poet Jonathan Williams has said of Blizzard's crudely fired but aesthetically sophisticated pots and sculptures, "They have nothing to do with funny folk art, and they make you think twice (at least twice) about human despair." In the same essay, Williams quotes one art dealer as commenting that "people don't know what to make of them." That seems to have been unfortunately true of most collectors specializing in self-taught art, probably because the collecting side of the field is still dominated by newcomers who have yet to develop full confidence in their personal tastes.

But collectors or anyone else who approaches this art looking for simple, easy answers and comfortingly clear definitions had best not look too closely, because they're not to be found here, at least not beyond the most superficial level. The distinction between self-taught and academically trained artists—between "outsiders" and "insiders"—has been a topic of discussion in the art world for more than a century, but it has only been in the last two or three decades that this issue has emerged into the foreground of our collective cultural consciousness. With this gradual emergence, it has become increasingly apparent that long-prevailing attitudes within the art world about self-taught art are replete with contradictions, inconsistencies, and prejudicial assumptions rooted in attitudes about race and class.

At the beginning of this essay, I pointed out that the different terminologies applied to this nonacademic art seem to reflect two mutually exclusive categories—community-based folk art as opposed to the work of isolated individual "outsiders." What I've tried to show in the subsequent discussion is that, in fact, there are many more than just two kinds of art that are habitually lumped together under these broad categories. The attempt to corral all of the artists represented in this exhibit into one or two or three classifications reflects the same kind of reductivist thinking underlying the notion that the United States is a

cultural melting pot. It ignores the sharp, fundamental differences among these artists in terms of their artistic styles, thematic concerns, cultural backgrounds, mental-health status, educational histories, and other aspects of their lives that also inform their work in significant ways. Meanwhile, the art itself flies free—so to speak—of the reductivist template that some of the specialists keep trying to superimpose on it.

Regardless of how it is grouped or classified, the work of every artist represented here maintains its own integrity and continues to assert its own singular presence. The selection may not present any sort of neat, tidy picture of contemporary nonacademic art, but that's as it should be, because any such picture would be a false one. This uncredentialed branch of the art world is as disorderly as life itself. Instead of a single overarching identity, the art in the Gordon collection represents a multiplicity of identities, a diversity of personal and communal visions, and in that respect, it is particularly American. In one way or another, it reflects virtually all of our society's strengths and weaknesses as we finish with this old, familiar century and prepare to enter a new millennium.

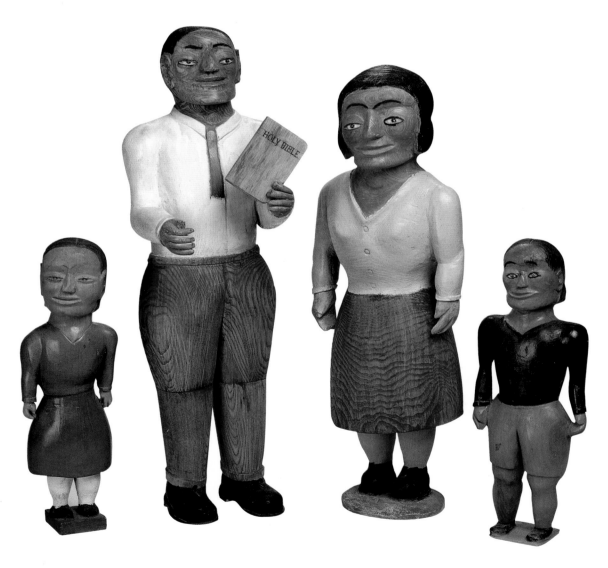

Shields Landon ("S. L.") Jones, Group of Four Family Members

NOTES

1. Roger Cardinal, *Outsider Art* (New York, 1972). Jean Dubuffet, "Art Brut Preferred to Cultural Arts" (1949), in Marc Glimcher, ed., *Jean Dubuffet: Towards an Alternative Reality* (New York, 1987), p. 104. Peter Schjeldahl, "A Walk on the Wild Side," *Artists of Vision and Purpose* (Northfield, Minn., 1994), unpaginated.

2. Walker Art Center, *Naives and Visionaries* (New York, 1974); Herbert W. Hemphill, Jr., and Julia Weissman, *Twentieth-Century American Folk Art and Artists* (New York, 1974). See also Michel Thevoz, *Art Brut,* trans. James Emmons (New York, 1976).

3. For illuminating further discussions of this semantic problem and related issues involving the classification of nonacademic art, see the following: Michael D. Hall and Eugene W. Metcalf, Jr., eds., *The Artist Outsider: Creativity and the Boundaries of Culture* (Washington, D. C., 1994); Jenifer Borum, "Term Warfare," *Raw Vision,* no. 9 (Winter 1993–1994), pp. 24–31; and Lucy R. Lippard, *Mixed Blessings: New Art in a Multicultural America* (New York, 1990).

4. Ellin Gordon and Baron Gordon, artist files.

5. Information on Minchell in this and the following paragraph is from Robert Bishop, *Folk Painters of America* (New York, 1979), pp. 176, 180; Jay Johnson and William C. Ketchum, Jr., *American Folk Art of the Twentieth Century* (New York, 1983), p. 198; Lynda Roscoe Hartigan, *Made with Passion: The Hemphill Folk Art Collection in the National Museum of American Art* (Washington, D. C., 1990), unpaginated; Chuck Rosenak and Jan Rosenak, *Museum of American Folk Art Encyclopedia of Twentieth-Century American Folk Art and Artists* (New York, 1990), pp. 214–215; Noyes Museum, *Drawing Outside the Lines: Works on Paper by Outsider Artists* (Oceanville, N. J., 1995), p. 5; unpublished biographical notes compiled by Mary Jo Toles.

6. Information on Litwak in this and the following paragraph is from unsigned essay in Galerie St. Etienne, *New York Folk: Lawrence Lebduska, Abraham Levin, Israel Litwak* (New York, 1996), unpaginated; Betty-Carol Sellen, *20th Century American Folk, Self Taught, and Outsider Art* (New York, 1993), p. 376; Sidney Janis, *They Taught Themselves: American Primitive Painters of the 20th Century* (New York, 1942).

7. Information on Birnbaum in this and the following paragraph is from Sellen, *20th Century American Folk, Self Taught, and Outsider Art,* p. 323; Anne Mai, "A Little Pepper, a Little Salt: Aaron Birnbaum," *Folk Art,* XX, no. 3 (Fall 1995), pp. 48–55; Rita Reif, "Memories Filtered through a Rosy Lens," *New York Times,* Jan. 21, 1996, Arts/Artifacts section; Chuck Rosenak and Jan Rosenak, *Contemporary American Folk Art: A Collector's Guide* (New York, 1996), pp. 35–36.

8. Information provided by Ellin Gordon; additional information from Johnson and Ketchum, *American Folk Art of the Twentieth Century,* p. 277.

9. For more information on Moses, see Chuck and Jan Rosenak, *Encyclopedia of Twentieth-Century American Folk Art and Artists,* pp. 220–221.

10. Julie Ardery, "From the Well: Eight Families of Eastern Kentucky Artists," and Tom Patterson, "Ingrained Images & Outside Influences: Recent and Current Family Art Traditions in Appalachian Kentucky," in Kentucky Art and Craft Foundation, *Generations of Kentucky: An Exhibition of Folk Art with Photographs by Guy Mendes* (Louisville, Ky., 1994), pp. 7, 8, 13, 14.

11. On Adkins and Lewis, see Kentucky Art and Craft Foundation, *Generations of Kentucky,* pp. 2, 3, 5, 7, 9, 12, 16. On Spencer, see Ramona Lampell and Millard Lampell, *O, Appalachia: Artists of the Southern Mountains* (New York, 1989), pp. 209–216; Sellen, *20th Century American Folk, Self Taught, and Outsider Art,* p. 418.

12. M. M. Jaggears, "Even an Aesthetic Praises Humble Artist's Work," *Chesapeake (Va.) Clipper,* Dec. 26–27, 1989, p. 16; Sellen, *20th Century American Folk, Self Taught, and Outsider Art,* p. 332.

13. Information on Jones in this and the following paragraph is from Lampell, *O, Appalachia,* pp. 30–33; Chuck and Jan Rosenak, *Encyclopedia of Twentieth-Century American Folk Art and Artists,* pp. 166–168.

14. Information on Aiken in this and the following paragraph is from Sellen, *20th Century American Folk, Self Taught, and Outsider Art,* p. 315; Gayleen Aiken, "An Autobiography," in Peter Gallo, *Rooms and Rooms: The Art of Gayleen Aiken* (West Glover, Vt., 1993), unpaginated; Noyes Museum, *Drawing Outside the Lines,* p. 3.

15. Information on Farmer in this and the following paragraph is from Chuck and Jan Rosenak, *Encyclopedia of Twentieth-Century American Folk Art and Artists,* pp. 116–118; Regenia Perry, "Elijah Pierce and the African American Tradition of Wood Carving," in Columbus Museum of Art, *Elijah Pierce: Woodcarver* (Columbus, Ohio, 1992), pp. 48–50.

16. Information on Pierce in this and the following paragraph is from Jane Livingston and John Beardsley, *Black Folk Art in America, 1930–1980* (Jackson, Miss., 1982), pp. 116–121; Chuck and Jan Rosenak, *Encyclopedia of Twentieth-Century American Folk Art and Artists,* pp. 240–241; Columbus Museum of Art, *Elijah Pierce: Woodcarver;* Gerald L. Davis, "Elijah Pierce, Woodcarver: Doves and Pain in Life Fulfilled," in Hall and Metcalf, *The Artist Outsider,* pp. 290–311.

17. Chuck and Jan Rosenak, *Encyclopedia of Twentieth-Century American Folk Art and Artists,* pp. 29–30; Leroy Almon, Sr., "Speakeasy," *New Art Examiner,* XIX, no. 1 (Sept. 1991), pp. 13–14; Wake Forest University Fine Arts Gallery, *Diving in the Spirit* (Winston-Salem, N. C., 1992), pp. 32–33; Perry, "Elijah Pierce," pp. 56–59.

18. Information on Singleton in this and the following paragraph is from Chuck and Jan Rosenak, *Encyclopedia of Twentieth-Century American Folk Art and Artists,* pp. 279–280; Wake Forest Univ. Fine Arts Gallery, *Diving in the Spirit,* pp. 5, 12–13, 24–25; Perry, "Elijah Pierce," pp. 59–62; Tom Patterson, *Not by Luck: Self-Taught Artists in the American South* (Milford, N. J., 1993), pp. 22–25; Regenia Perry, "Herbert Singleton," in Gail Andrews Trechsel, ed., *Pictured in My Mind: Contemporary American Self-Taught Art from the Collection of Dr. Kurt Gitter and Alice Rae Yelen* (Birmingham, Ala., 1995), pp. 182–187.

19. INTAR Latin American Gallery, *Another Face of the Diamond: Pathways through the Black Atlantic South* (New York, 1988), pp. 10–12, 17–18, 34, 36, 40–41, 63–64, 66; Chuck and Jan Rosenak, *Encyclopedia of Twentieth-Century American Folk Art and Artists,* pp. 158–159; Miriam Rogers Fowler, comp., *Outsider Artists in Alabama* (Montgomery, Ala., 1991), p. 27; Wake Forest Univ. Fine Arts Gallery, *Diving in the Spirit,* pp. 11–12, 16, 34–35; Judith McWillie, "Lonnie Holley's Moves," *Artforum,* XXX, no. 8 (Apr. 1992), pp. 80–84; Tom Patterson, *'Ashe: Improvisation & Recycling in African-American Visionary Art* (Winston-Salem, N. C., 1993), pp. 9, 10, 21, 26, 29, 31; Patterson, *Not by Luck,* pp. 2, 3, 8–9.

20. Information on Dial in this and the following paragraph is from INTAR Lat. Am. Gallery, *Another Face of the Diamond*, pp. 10, 25–27, 39, 62; Southern Queens Park Association, Inc., *Thornton Dial: Strategy of the World* (Jamaica, N.Y., 1990); Chuck and Jan Rosenak, *Encyclopedia of Twentieth-Century American Folk Art and Artists*, pp. 100–102; Fowler, *Outsider Artists in Alabama*, pp. 18–21; Amiri Baraka [LeRoi Jones] and Thomas McEvilley, *Thornton Dial: Image of the Tiger* (New York, 1993); Patterson *'Ashe*, pp. 9, 20, 25–27.

21. Information on Harvey in this and the following two paragraphs is from INTAR Lat. Am. Gallery, *Another Face of the Diamond*, pp. 19, 27, 36, 42, 44; Chuck and Jan Rosenak, *Encyclopedia of Twentieth-Century American Folk Art and Artists*, p. 152; Wake Forest Univ. Fine Arts Gallery, *Diving in the Spirit*, pp. 9–10, 12, 36–37; Patterson, *'Ashe*, pp. 12, 15, 23–24, 31; Patterson, *Not by Luck*, pp. 50–51; Tom Patterson, "Bessie Harvey (1929–1994)," *Art Papers*, XVIII, no. 6 (Nov.–Dec. 1994), p. 57.

22. Information on Morgan in this and the following paragraph is from Chuck and Jan Rosenak, *Encyclopedia of Twentieth-Century American Folk Art and Artists*, pp. 219–220; Regenia Perry, "Sister Gertrude Morgan," in Trechsel, *Pictured in My Mind*, pp. 140–145.

23. Information on Murry in this and the following paragraph is from INTAR Lat. Am. Gallery, *Another Face of the Diamond*, pp. 9, 10, 19, 65; Chuck and Jan Rosenak, *Encyclopedia of Twentieth-Century American Folk Art and Artists*, pp. 222–223; Regenia Perry, "John B. Murry," in Trechsel, *Pictured in My Mind*, pp. 150–153.

24. Information on West in this and the following paragraph is from Fowler, *Outsider Artists in Alabama*, p. 55; Kathy Kemp, "Heartache Reveals Creative Soul," *Birmingham (Ala.) Post-Herald*, Nov. 15, 1993, sec. B, pp. 1, 4; unpublished videotaped interview with the artist conducted by Rollin Rigg, 1993.

25. Information on Finster in this and the following paragraph is from Howard Finster and Tom Patterson, *Howard Finster, Stranger from Another World: Man of Visions Now on This Earth* (New York, 1989); J. F. Turner, *Howard Finster, Man of Visions: The Life and Work of a Self-Taught Artist* (New York, 1989), pp. 210–212; Robert Peacock with Annibel Jenkins, *Paradise Garden: A Trip through Howard Finster's Visionary World* (San Francisco, 1996).

26. See Allen S. Weiss, *Art Brut: Madness and Marginalia*, Art & Text, no. 27 (Dec. 1987–Feb. 1988); see also John M. MacGregor, *The Discovery of the Art of the Insane* (Princeton, N. J., 1989).

27. Information on Mackintosh in this and the following paragraph is from John M. MacGregor, *Dwight Mackintosh: The Boy Who Time Forgot* (Oakland, Calif., 1990); Frank Maresca and Roger Ricco, *American Self-Taught: Paintings and Drawings by Outsider Artists* (New York, 1993), p. 133; Sellen, *20th Century American Folk, Self Taught, and Outsider Art*, p. 378; Noyes Museum, *Drawing Outside the Lines*, p. 5; Chuck and Jan Rosenak, *Contemporary American Folk Art*, pp. 288–289.

28. Information on Menna in this and the following paragraph is from Elizabeth Marks and Thomas Klocke, *The HAI Collection of Outsider Art, 1980–1990: Selected Works Created by Mentally Ill Artists in New York City from the Hospital Audiences, Inc., Art Workshop Program* (New York, 1990), p. 18; Sellen, *20th Century American Folk, Self Taught, and Outsider Art*, pp. 385–386; Hospital Audiences, Inc. (HAI), *Outsider Artists of Hospital Audiences, Inc. (HAI)* (New York, 1996), p. 19.

29. Marks and Klocke, *HAI Collection*, p. 14; Sellen, *20th Century American Folk, Self Taught, and Outsider Art*, p. 354; Hospital Audiences, *Outsider Artists*, pp. 10–11.

30. Information on Brice in this and the following paragraph is from Artists Space, *Art's Mouth* (New York, 1991), unpaginated; Maresco and Ricco, *American Self-Taught*, p. 24; Sellen, *20th Century American Folk, Self Taught, and Outsider Art*, p. 327; Noyes Museum, *Twentieth Century Self-Taught Artists from the Mid-Atlantic Region* (Oceanville, N. J., 1994), p. 4.

31. Information on Smith in this and the following two paragraphs is from Didi Barrett, *Muffled Voices: Folk Artists in Contemporary America* (New York, 1986), p. 30; "Robert E. Smith," *Folk Art Finder*, IX, no. 3 (July–Sept. 1988), p. 13; Chuck and Jan Rosenak, *Encyclopedia of Twentieth-Century American Folk Art and Artists*, pp. 285–286; Crystal Payton, "Portrait of Robert Eugene Smith," *Maine Antique Digest*, Oct. 1993, sec. C, pp. 8–10; Gary J. Schwindler, "Robert Eugene Smith," in Trechsel, *Pictured in My Mind*, pp. 194–195.

32. Information on Gordon in this and the following three paragraphs is from Barrett, *Muffled Voices*, p. 19; Chuck and Jan Rosenak, *Encyclopedia of Twentieth-Century American Folk Art and Artists*, pp. 142–143; Milwaukee Art Museum, *Common Ground/Uncommon Vision: The Michael and Julie Hall Collection of American Folk Art* (Milwaukee, Wis., 1993), p. 314.

33. Information on Travers in this and the following paragraph is from Artists Space, *Art's Mouth*, unpaginated; Sellen, *20th Century American Folk, Self Taught, and Outsider Art*, p. 423; Noyes Museum, *Drawing Outside the Lines*, p. 7; Chuck and Jan Rosenak, *Contemporary American Folk Art*, p. 61.

34. Information on Fitzpatrick in this and the following paragraph is from Jonathan Demme, "Forward," in Tony Fitzpatrick, *The Hard Angels: Drawings and Poems* (Philadelphia, 1988), pp. 7–8; Elizabeth Snead, "Drawing on His Talents: Tony Fitzpatrick, Painter and Actor," *USA Today*, Aug. 19, 1991, Life section.

35. Sellen, *20th Century American Folk, Self Taught, and Outsider Art*, p. 363; Chuck and Jan Rosenak, *Contemporary American Folk Art*, p. 212.

36. Information on Polhamus in this and the following paragraph is from a telephone interview with her, conducted by the author on Sept. 20, 1996, and from Chuck and Jan Rosenak, *Contemporary American Folk Art*, pp. 108–109.

37. Information on Blizzard in this and the following paragraph is from Roger Manley, "Visionary Clay by Georgia Blizzard" (privately distributed essay, 1986); Jo Woestendiek, "Art from Adversity: Georgia Blizzard Takes Her Art from a Hard Life," *Winston-Salem (N. C.) Journal*, Aug. 10, 1986, sec. C, pp. 1, 6; Chuck and Jan Rosenak, *Encyclopedia of Twentieth-Century American Folk Art and Artists*, pp. 52–53; Patterson, *Not by Luck*, pp. 46–49; Jonathan Williams, "Rattler on the Ledge: Georgia Blizzard and Her Pottery Vessels," *Georgia Blizzard: Cleansing Vessels* (Winston-Salem, N. C., 1996), unpaginated.

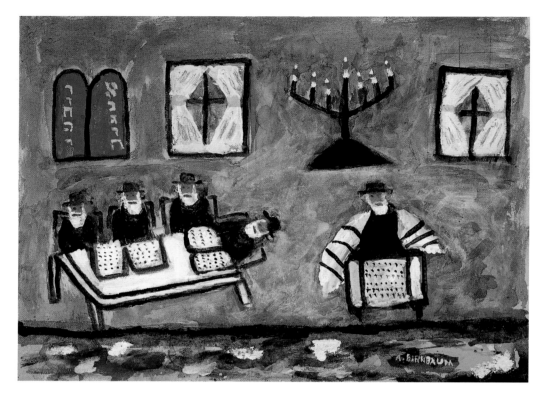

Aaron Birnbaum, Rabbis

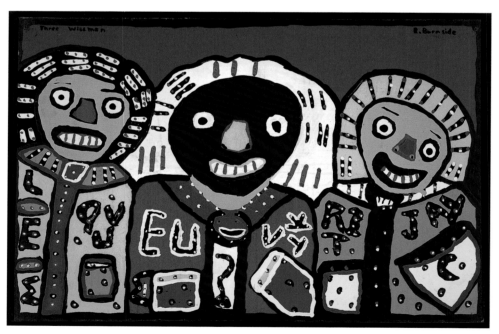

Richard Burnside, Three Wise Men

Victor Joseph ("Joe") Gatto, Georgia

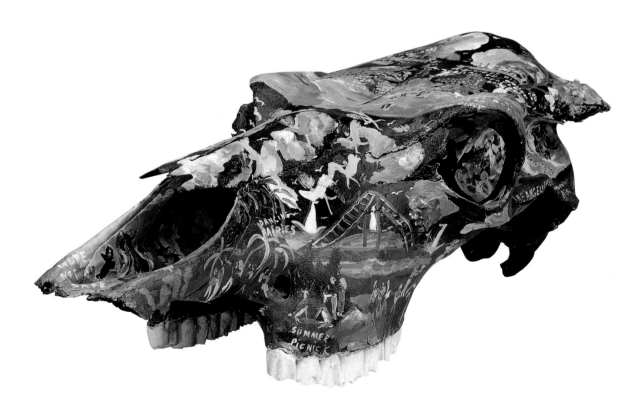

Jessie Farris Dunaway Cooper, The Eyes of the World Are on You

Victor Joseph ("Joe") Gatto, The Lorelei

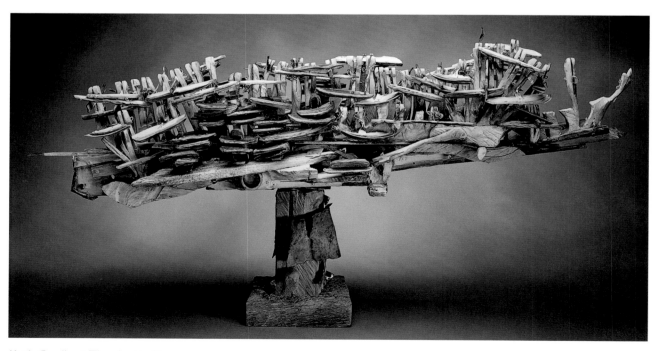

Keith Goodhart, The Arctic Slip

Ray Hamilton, Owl/Eagle

Oscar E. Hadwiger, Eiffel Tower

Anderson Johnson, Abraham Lincoln

81

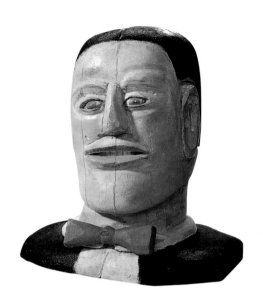

Shields Landon ("S. L.") Jones, Head of a Man

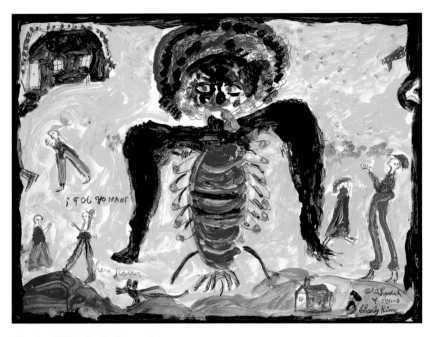

Charles ("Charley") Kinney, Haint

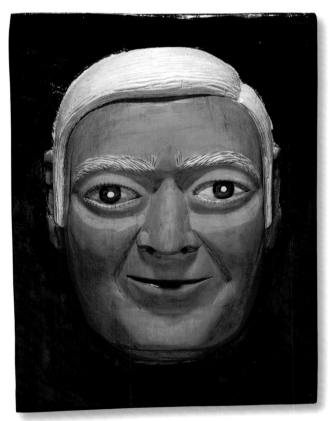

Tim Lewis, Head of Baron Gordon

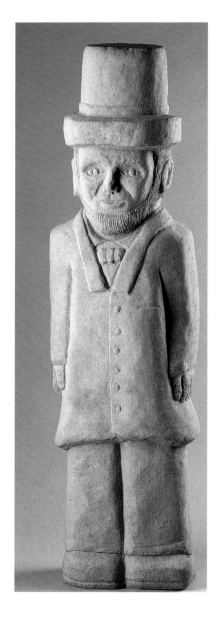

Tim Lewis, Abraham Lincoln

Justin McCarthy, Miss America/1946

Justin McCarthy, Racing Sailboats

"PRINCESS"
"GRACE"
"GRACE,"
"KELLY"
"Movie Star"

"THE WEDDING,"
AT
"MONACO,"
FRANCE!"

"By MONTAGUE
"SURF"
MANOR"
1986.

Frances ("Lady Shalimar") Montague, Princess Grace

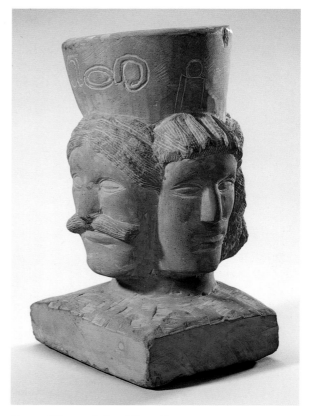

Ernest ("Popeye") Reed, Four Faces

Norman Scott ("Butch") Quinn, MX Missile Taking Off,
Going into the Heavens to Deity

Anthony Joseph ("Tony Joe") Salvatore, Luke V:29

Paulina Santiliz, Figure/"Zip 10025"

Jon Serl, The Blue Barrel

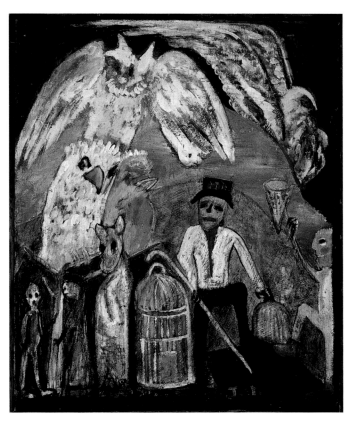

Jon Serl, The Collector

Vollis Simpson, Ice Cream Scoop Sculpture

Jimmy Lee Sudduth, House

Nelson Tygart, Tiger

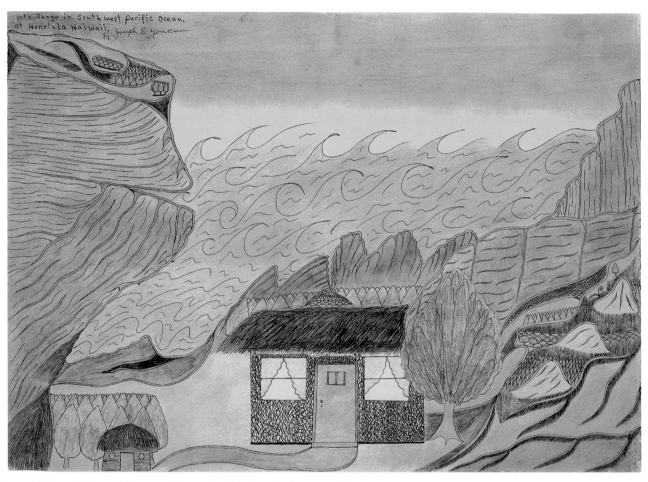

Joseph Elmer Yoakum, Mountain Range in S.W. Pacific Ocean at Honalula

John Vivolo, Man in Green

Minnie Adkins

b. 1934 in Isonville, Kentucky

Currently living in Isonville, Kentucky

Adkins spent much of her youth on her father's tobacco farm, located not too far from her present home. She assisted with all chores there and whittled and carved whenever free moments arose. At age sixteen, she met her husband. After their marriage, the couple moved to Ohio, where they lived for many years. Though Adkins sold small carvings at a local flea market to supplement their income, she did not start to carve full-time until the couple returned to Kentucky in the early 1980s. Her early work consists of small birds and animals. Her more recent pieces are larger and focus on childhood memories and biblical subjects.

In addition, Adkins creates quilts using the same animal motifs as her sculptures. Her husband also enjoys carving, and the two often work side by side on many projects, though Adkins is responsible for painting the works. Both Adkinses are credited with inspiring and encouraging many local artists, including Tim, Leroy, and Junior Lewis and Linvel and Lillian Barker.

Sources consulted:

Gordon, Ellin, and Baron Gordon. Artist files.

Huntington Museum of Art. *Figural Quilts: Minnie Adkins & Sarah Mary Taylor.* Huntington, W. Va.: Huntington Museum of Art, 1991.

Kentucky Art and Craft Foundation. *Generations of Kentucky: An Exhibition of Folk Art with Photographs by Guy Mendes.* Louisville, Ky.: Kentucky Art and Craft Foundation, 1994.

Lampell, Ramona, and Millard Lampell. *O, Appalachia: Artists of the Southern Mountains.* New York: Stewart, Tabori & Chang, 1989.

Trechsel, Gail Andrews, ed. *Pictured in My Mind: Contemporary American Self-Taught Art from the Collection of Dr. Kurt Gitter and Alice Rae Yelen.* Birmingham, Ala.: Birmingham Museum of Art, 1995.

Aghassi George Aghassian

b. ca. 1904 in Armenia

d. 1985 in Saint Clair, Michigan

Aghassian immigrated to New York City in 1921 with the intention of studying architecture. He worked at a variety of jobs from cabin boy to waiter and moved often between 1936 and the early 1960s. He finally settled in Memphis, Michigan, where he and his wife opened a restaurant in 1965. Aghassian grew ill in 1970 and began to draw during his recovery. His work reflects his strong interest in architecture.

Sources consulted:

Gordon, Ellin, and Baron Gordon. Artist files.

Beverly ("Gayleen") Aiken

b. 1934 in Barre, Vermont

Currently living in Barre, Vermont

Aiken's hometown is also the site of Rock of Ages Quarries, Inc., a granite quarry that serves as one of many subjects depicted by the artist. Other subjects include the home where she grew up, the Vermont landscape, and musical instruments. Aiken's artistic career is said to have begun at the age of two, when her father sawed off a piece of joinery that featured one of her drawings. She speaks often of her childhood, a time when family camping excursions were frequent, although she remembers most of her youth as a time spent alone. At age nine, she invented the Raimbilli family, which consists of twenty-four imaginary cousins. She keeps the family alive today in the form of life-size cutouts. Aiken maintains an interest in other childhood hobbies and uses them as subjects in combination with the lighthearted Raimbilli family as the core of her work.

Aiken's favorite activities include writing comic books; playing instruments and creating songs; building in stone, cardboard, and wood; and collecting photographs of nickelodeons and granite quarries. She did not, however, focus seriously on her art until the early 1980s, when her mother grew ill. Aiken's fantasy drawings reflect her early childhood memories and are nostalgic representations of not only her youth but a life she wished to have led.

Sources consulted:
Aiken, Gayleen. "An Autobiography by Gayleen Aiken."
G.R.A.C.E. News (Fall 1995), p. 1.
Gallo, Peter. *Rooms and Rooms: The Art of Gayleen Aiken.* West Glover, Vt.: Grass Roots Arts & Community Efforts, 1993.
Rosenak, Chuck, and Jan Rosenak. *Museum of American Folk Art Encyclopedia of Twentieth-Century American Folk Art and Artists.* New York: Abbeville Press, 1990.
Sunseri, Don. "Some Notes on Gayleen." *G.R.A.C.E. News* (Fall 1995), p. 3.

Leroy ("Lee") Almon, Sr.

b. 1938 in Tallapoosa, Georgia

Currently living in Tallapoosa, Georgia

When he was seven, Almon moved with his family to Cincinnati, Ohio. In 1961, he was a member of the United States Army for a brief period, then he worked at a variety of sales jobs until he was offered employment with the Coca-Cola Company in Columbus, Ohio. Soon after Almon's arrival in Columbus, he became acquainted with folk carver Elijah Pierce, and in 1979, Almon became a full-time apprentice to the ninety-one-year-old woodcarver. He also acted as curator of Pierce's gallery.

In 1982, Almon moved back to Tallapoosa and obtained work as a radio dispatcher for the local police department, where he worked until 1994, when he retired. He now devotes his full time to his art. Almon creates colorful bas-reliefs using a pocketknife and chisel. His subjects depict aspects of contemporary life—racism, drugs, and materialism—and historical and biblical scenes.

Sources consulted:

Almon, Leroy, Sr. "Speakeasy." *New Art Examiner,* XIX, no. 1 (September 1991), 13–14.

Columbus Museum of Art. *Elijah Pierce: Woodcarver.* Columbus, Ohio: Columbus Museum of Art, 1992.

Gordon, Ellin, and Baron Gordon. Artist files.

Rosenak, Chuck, and Jan Rosenak. *Museum of American Folk Art Encyclopedia of Twentieth-Century American Folk Art and Artists.* New York: Abbeville Press, 1990.

Wake Forest University Fine Arts Gallery. *Diving in the Spirit.* Winston-Salem, N. C.: Wake Forest University Fine Arts Gallery, 1992.

Leroy Ramon Archuleta

b. 1949 in Tesuque, New Mexico

Currently living in Tesuque, New Mexico

The son and student of a well-known Hispanic woodcarver, Felipe Archuleta (1910–1991), Leroy continues in the tradition of his father but also incorporates his own style. He did not always carve; it was not until the age of twenty that he first learned his father's woodworking skills, and it was not until years later that he practiced what he had learned.

After high school, Archuleta moved to Denver and worked miscellaneous jobs; various sources cite a tree service, chemical company, soda factory, and arsenal. He grew tired of urban life and returned home to work with his father. He now carves one-of-a-kind wooden animals.

Sources consulted:

Art Museum of South Texas. *Lions and Tigers and Bears, Oh My!: New Mexican Folk Carvings from the Collection of Christine and Davis Mather.* Corpus Christi, Tex.: Art Museum of South Texas, 1986.

Everts-Boehm, Dana. "New Mexican Hispano Animal Carving in Context." *Clarion,* XVI, no. 2 (Summer 1991), pp. 34–36.

Museum of American Folk Art. *Ape to Zebra: A Menagerie of New Mexican Woodcarvings, the Animal Carnival Collection of the Museum of American Folk Art.* New York: Museum of American Folk Art, 1985.

Rosenak, Chuck, and Jan Rosenak. *Museum of American Folk Art Encyclopedia of Twentieth-Century American Folk Art and Artists.* New York: Abbeville Press, 1990.

Lillian and Linvel Barker

b. 1930 in Roscoe, Kentucky; d. 1977 in Elliott County, Kentucky

b. 1929 in Crockett, Kentucky; currently living in Isonville, Kentucky

After their marriage, the Barkers moved to Indiana, where they resided for roughly thirty years. Linvel worked as a maintenance technician at a local steel mill, and Lillian worked as a production inspector at an auto-parts manufacturer. Both were employed until 1983, when the couple retired and moved back to Kentucky. After his relocation, Linvel assumed the role of preacher to a nondenominational congregation but had difficulty adjusting to retirement from full-time work. Lillian found enjoyment in a new career as a painter of biblical scenes and, with the help of Minnie Adkins, encouraged her husband also to create. Until Lillian's death, the couple collaborated on Linvel's stylized animal carvings. Lillian sawed the wood in preparation for Linvel's carving and then finished his form by sanding.

Sources consulted:

Barker, Lillian. Telephone conversation with Ellin Gordon. August 11, 1996.

Gordon, Ellin, and Baron Gordon. Artist files.

Kentucky Art and Craft Foundation. *Generations of Kentucky: An Exhibition of Folk Art with Photographs by Guy Mendes*. Louisville, Ky.: Kentucky Art and Craft Foundation, 1994.

Owensboro Museum of Fine Art. *Kentucky Spirit: The Naive Tradition*. Owensboro, Ky.: Owensboro Museum of Fine Art, 1991.

Rosenak, Chuck, and Jan Rosenak. *Contemporary American Folk Art: A Collector's Guide*. New York: Abbeville Press, 1996.

Sellen, Betty-Carol. *20th Century American Folk, Self Taught, and Outsider Art*. New York: Neal-Schuman Publishers, 1993.

Swain, Adrian. Telephone conversation with Barbara R. Luck. January 30, 1997.

Geneva Beavers

b. 1913 near Durham, North Carolina

Currently living in Chesapeake, Virginia

Beavers is the youngest of twelve children. She spent much of her childhood watching and playing with the animals on her parents' North Carolina farm. As a youth, she enjoyed drawing, but her parents discouraged her. In 1941, Beavers moved with her husband to Norfolk, Virginia, where he was employed by the Norfolk Naval Shipyard. Beavers spent thirty years as a housewife and began painting in 1973, when her twenty-five-year-old son was killed in a motorcycle accident. Almost twenty-five years later, Beavers still focuses on painting as a means of obtaining peace. In addition to her canvases, she also paints plaster sculptures and decorates furniture. Throughout, her main subject matter is animals.

Sources consulted:

Abby Aldrich Rockefeller Folk Art Center. Artist files.

Jaggears, M. M. "Even an Aesthete Praises Humble Artist's Work." *Chesapeake (Va.) Clipper*, December 26–27, 1989, Seniors section.

Sellen, Betty-Carol. *20th Century American Folk, Self Taught, and Outsider Art*. New York: Neal-Schuman Publishers, 1993.

Aaron Birnbaum

b. 1895 in Skola, Poland (then Austria-Hungary)

Currently living in Brooklyn, New York

Birnbaum was born to two Polish tailors. When Birnbaum was young, his father left the family to go to America, and his mother started a tailoring business of her own. At age thirteen, Birnbaum apprenticed in the same trade. In his late teens, his family was reunited in Brooklyn, New York, where at age twenty-four, Birnbaum attended design school and studied clothing manufacture and design. He was employed as a tailor until age sixty-five, when he began to paint. One source suggests he turned to art after his wife's ten-year struggle with cancer and subsequent death. Birnbaum's work is impressionistic and uninhibited, drawing on childhood memories of Poland and New York and his observations on the human condition. Evidence of his design training and tailoring career is reflected in his use of templates.

Sources consulted:

Mai, Anne. "A Little Pepper, a Little Salt: Aaron Birnbaum." *Folk Art*, XX, no. 3 (Fall 1995), pp. 48–55.

Reif, Rita. "Memories Filtered through a Rosy Lens." *New York Times*, January 21, 1996, Arts/Artifacts section.

Sellen, Betty-Carol. *20th Century American Folk, Self Taught, and Outsider Art*. New York: Neal-Schuman Publishers, 1993.

Georgia Blizzard

b. 1919 in Saltville, Virginia

Currently living near Glade Springs, Virginia

Blizzard began handcrafting clay figures at the age of eight. She and her sister spent much time at a nearby creek, where they watched crayfish and played with their nests. The girls filled these mud holes with water, making "fairy houses," and created dolls and animals out of the creek mud. Their clay dolls were decorated with flour, berries, and pieces of discarded quilts. Today, Blizzard continues to fashion objects of clay in the form of figures and caricatures.

Blizzard held various jobs with the National Youth Administration, a munitions factory, and a local mill, spending more than twenty years in the latter until a forced retirement in the late 1960s. After the death of her husband, Blizzard's work intensified under the economic necessity of being unemployed. A dealer suggested that she focus on replicas of Native American pottery and encouraged her to start experimenting with firing techniques and reproductions. Sources cite her father's Apache Indian ancestry as an influence in her work. Though her early works were simple pipes, pots, and masks, her art today has expanded to include a variety of wares—fertility figures, effigy pots, and bas-relief plaques.

Sources consulted:
Patterson, Tom. *Not by Luck: Self-Taught Artists in the American South.* Milford, N. J.: Lynne Ingram Southern Folk Art, 1993.
Rosenak, Chuck, and Jan Rosenak. *Museum of American Folk Art Encyclopedia of Twentieth-Century American Folk Art and Artists.* New York: Abbeville Press, 1990.
Sieveking, Brian. *Georgia Blizzard: Southern Visionary Artist.* Danville, Va.: Danville Museum of Fine Arts & History, 1993.

Freddie Brice

b. 1920 in Charleston, South Carolina

Currently living in New York City

Brice was still young when his father left the family, leaving Brice's mother to support the family by working in a cotton mill. After her death, Brice went to live with an aunt and uncle. In 1929, he moved to Harlem, New York, where he was employed as a stoker, laundryman, elevator operator, and ship painter between periods of institutionalization in jails, psychiatric hospitals, and reform schools. In the early 1980s, Brice was introduced to art while attending a psychiatric day program. His works depict a wide range of subjects, such as clocks, animals, room interiors, and devils.

Sources consulted:
Artists Space. *Art's Mouth.* New York: Artists Space, 1991.
Maresca, Frank, and Roger Ricco. *American Self-Taught: Paintings and Drawings by Outsider Artists.* New York: Alfred A. Knopf, 1993.
Sellen, Betty-Carol. *20th Century American Folk, Self Taught, and Outsider Art.* New York: Neal-Schuman Publishers, 1993.

Richard Burnside

b. 1944 in Baltimore, Maryland

Currently living in Pendleton, South Carolina

When Burnside was five, his family relocated to Anderson County, South Carolina. For seven years, he worked at an S & H Green Stamp store in Greenville. He spent the same amount of time in the army in Charlotte, North Carolina, then took a job as a hotel chef. In 1980, Burnside began to paint. In 1983, after cooking in North Carolina for nine years, he moved back to South Carolina and focused on his painting. He works on a variety of found objects from paper bags to gourds to furniture, and his subjects depict religious themes as well as African kings and queens.

Sources consulted:

Gordon, Ellin, and Baron Gordon. Artist files.

Rosenak, Chuck, and Jan Rosenak. *Museum of American Folk Art Encyclopedia of Twentieth-Century American Folk Art and Artists.* New York: Abbeville Press, 1990.

Wake Forest University Fine Arts Gallery. *Diving in the Spirit.* Winston-Salem, N. C.: Wake Forest University Fine Arts Gallery, 1992.

David Butler

b. 1898 in Saint Mary Parish, Louisiana

Currently living in Morgan City, Louisiana

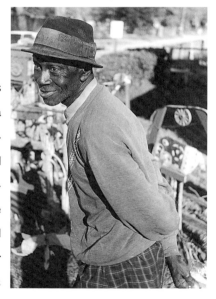

The eldest of eight children, Butler assumed responsibility for his siblings upon his mother's death and immediately went to work at a variety of jobs in a sawmill and sugarcane fields to support them. As a youth and young adult, however, he found time to draw contemporary subjects and to whittle animals and boats. In the early 1960s, Butler was forced into retirement because of a partially disabling accident. The window screens that he made to protect his home led to his discovery as an artist. Through sheets of weathered tin, Butler punched ventilation holes in decorative patterns. Thereafter, many biblical and secular creations were made to ornament his house and yard. Butler has said that his images came to him in the form of dreams and that upon receiving the vision, he immediately went to work forming sculptures and assemblages. In the early 1980s, Butler was discouraged from pursuing his artwork because of vandalism, and in 1984, he ceased art production entirely upon entering a nursing home.

Sources consulted:

Gasperi, Richard. Telephone conversation with Laura E. Pass. August 14, 1996.

Kaufman, Barbara Wahl, and Didi Barrett. *A Time to Reap: Late Blooming Folk Artists.* South Orange, N. J.: Seton Hall University; New York: Museum of American Folk Art, 1985.

Livingston, Jane, and John Beardsley. *Black Folk Art in America, 1930–1980.* Jackson, Miss.: University Press of Mississippi and the Center for the Study of Southern Culture for the Corcoran Gallery of Art, 1982.

New Orleans Museum of Art. *David Butler.* New Orleans, La.: New Orleans Museum of Art, 1976.

Newark Museum. *A World of Their Own: Twentieth-Century American Folk Art.* Newark, N. J.: Newark Museum, 1995.

Rosenak, Chuck, and Jan Rosenak. *Museum of American Folk Art Encyclopedia of Twentieth-Century American Folk Art and Artists.* New York: Abbeville Press, 1990.

Trechsel, Gail Andrews, ed. *Pictured in My Mind: Contemporary American Self-Taught Art from the Collection of Dr. Kurt Gitter and Alice Rae Yelen.* Birmingham, Ala.: Birmingham Museum of Art, 1995.

University Art Museum. *Baking in the Sun: Visionary Images from the South, Selections from the Collection of Sylvia and Warren Lowe.* Lafayette, La.: University of Southwestern Louisiana, 1987.

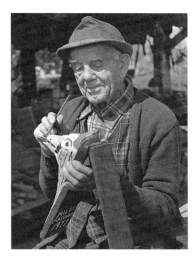

Miles Burkholder Carpenter

b. 1889 near Brownstown, Pennsylvania

d. 1985 in Waverly, Virginia

Carpenter's Pennsylvania German Mennonite family moved to Waverly, Virginia, when he was three years old. He assisted on his father's farm and sawmill until the age of twenty-three, when he began his own lumber business. Other endeavors included operating an icehouse and an outdoor movie theater. During World War II, Carpenter started to carve animals, but he stopped when the lumber business picked up toward the end of the war. He did not return to woodworking until his retirement from the lumber business in 1955, when he devoted himself to his icehouse and a vegetable, fruit, and soda stand. Looking for ways to advertise his business, Carpenter carved three-dimensional trade signs for his roadside stand. After the death of his wife in 1966, he focused increasingly on his woodworking and expanded his work to include larger carvings. Carpenter's art is seen as social commentary expressed through carved root figures of animals, friends, and imaginary creatures. He has received national and international acclaim for his work; in 1981, he visited the White House to present a politically inspired sculpture created for then-President Ronald Reagan.

Sources consulted:

Abby Aldrich Rockefeller Folk Art Center. *Folk Art USA since 1900 from the Collection of Herbert Waide Hemphill, Jr.* New York: Publishing Center for Cultural Resources, 1980.

Flossie Martin Gallery. *Miles Carpenter: A Second Century.* Radford, Va.: Radford University, 1989.

Gordon, Ellin, and Baron Gordon. Artist files.

Gregson, Chris. "Miles Carpenter: The Man and His Art." *Folk Art Messenger,* II, no. 3 (Spring 1989), pp. 1, 3.

Hand Workshop. *Miles B. Carpenter, Centennial Exhibition.* Richmond, Va.: Hand Workshop, 1989.

Horwitz, Elinor Lander. *Contemporary American Folk Artists.* Philadelphia: J. B. Lippincott Co., 1975.

Henry Ray Clark

b. 1936 in Bottley, Texas

Currently living in Huntsville, Texas

From the age of three onward, Clark spent his youth in Houston's infamous Third Ward district. Though he tried his hand at a variety of jobs from plumbing to warehouse work, Clark spent most of his time on the street hustling, pimping, and gambling. Such activities earned him the nickname the "Magnificent Pretty Boy." Jailed twice previously for attempted murder and drug possession, Clark's third offense in 1988 landed him a sentence of thirty years. While behind bars, Clark produced some sixty drawings, having been introduced to art while in prison in 1977. Though he was released in 1991 and did some drawing on his own, Clark primarily creates while incarcerated. As of this writing, he is in prison.

Sources consulted:

Artists' Alliance. *It'll Come True: Eleven Artists First and Last.* Lafayette, La.: Artists' Alliance, 1992.

Maresca, Frank, and Roger Ricco. *American Self-Taught: Paintings and Drawings by Outsider Artists.* New York: Alfred A. Knopf, 1993.

Rosenak, Chuck, and Jan Rosenak. *Contemporary American Folk Art: A Collector's Guide.* New York: Abbeville Press, 1996.

———. *Museum of American Folk Art Encyclopedia of Twentieth-Century American Folk Art and Artists.* New York: Abbeville Press, 1990.

Steen, William. Telephone conversation with Barbara R. Luck. January 7, 1997.

———. Telephone conversation with Laura E. Pass. January 14, 1997.

Raymond Coins

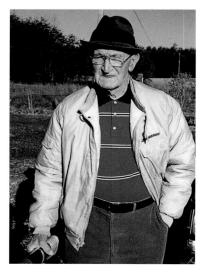

b. 1904 in Stuart, Virginia

Currently living in Westfield, North Carolina

Born to subsistence farmers, Coins spent much of his youth and adult life in the fields. He worked as a hired farmhand until the 1950s, when he and his wife bought a farm of their own. Coins performed tobacco-related tasks until 1968, when he retired. Some sources say that his first inspiration for carving came when he plowed up Native American artifacts in a neighbor's field. Upon returning home, he learned that these relics were worth money, so he found local river stone and tried to reproduce the forms himself. Coins carved stone and sometimes wooden dolls in the round, bas-relief animals, and stelae based on imagery in his dreams. Unfortunately, he has not produced anything since 1990.

Sources consulted:

Manley, Roger. *Signs and Wonders: Outsider Art inside North Carolina.* Raleigh, N. C.: North Carolina Museum of Art, 1989.

"Raymond Coins." *Folk Art Finder,* IX, no. 2 (April–June 1988), p. 7.

Rosenak, Chuck, and Jan Rosenak. *Contemporary American Folk Art: A Collector's Guide.* New York: Abbeville Press, 1996.

Trechsel, Gail Andrews, ed. *Pictured in My Mind: Contemporary American Self-Taught Art from the Collection of Dr. Kurt Gitter and Alice Rae Yelen.* Birmingham, Ala.: Birmingham Museum of Art, 1995.

University Art Museum. *Baking in the Sun: Visionary Images from the South, Selections from the Collection of Sylvia and Warren Lowe.* Lafayette, La.: University of Southwestern Louisiana, 1987.

Jessie Farris Dunaway Cooper

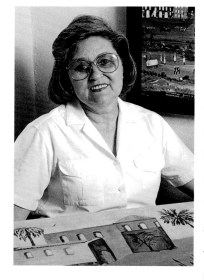

b. 1932 in Muses Mills, Kentucky

Currently living in Flemingsburg, Kentucky

Cooper has drawn and painted since her youth. In 1949, she married Ronald Cooper, and the two ran a country store for many years until financial difficulties drove them north. In 1968, they moved to Ohio, where they spent almost fifteen years before moving back home. In 1984, Cooper tried sculpting, but by 1987, her efforts to interest her convalescing husband in making wooden cutouts had rekindled her enthusiasm for painting. Cooper started working on paper and canvas but quickly abandoned traditional surfaces and now paints on animal skulls and furniture. Her work is religious and autobiographical. See also the separate entry for Cooper's husband, Ronald.

Sources consulted:

Gordon, Ellin, and Baron Gordon. Artist files.

Kentucky Art and Craft Foundation. *Generations of Kentucky: An Exhibition of Folk Art with Photographs by Guy Mendes.* Louisville, Ky.: Kentucky Art and Craft Foundation, 1994.

Lehigh University. *Natural Scriptures: Visions of Nature and the Bible.* Bethlehem, Pa.: Lehigh University Art Galleries, 1990.

Rosenak, Chuck, and Jan Rosenak. *Museum of American Folk Art Encyclopedia of Twentieth-Century American Folk Art and Artists.* New York: Abbeville Press, 1990.

Sellen, Betty-Carol. *20th Century American Folk, Self Taught, and Outsider Art.* New York: Neal-Schuman Publishers, 1993.

Sunseri, Don. "Ronald and Jessie Cooper." *Folk Art Finder,* XII, no. 4 (October–December 1991), pp. 10–11.

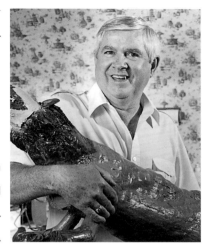

Ronald Everett Cooper

b. 1931 in Plummers Landing, Kentucky

Currently living in Flemingsburg, Kentucky

Cooper and his older brother Calvin spent much of their youth working in their father's grocery store. After his marriage to Jessie Dunaway, Cooper started a store of his own, where the couple worked for many years until financial difficulties forced them to abandon the business. Sources disagree on whether Cooper left for Ohio alone or with his wife. Regardless, Cooper was joined by his wife in Marion, Ohio, at some point. There, he survived two heart attacks and a serious auto accident. The couple then moved back home to Kentucky, where he recuperated, aided by his intense religious beliefs and wood projects. Today, Cooper focuses his full attention and efforts on his wooden sculptures of heaven and hell. See also the separate entry for Cooper's wife, Jessie.

Sources consulted:

Gordon, Ellin, and Baron Gordon. Artist files.

Kentucky Art and Craft Foundation. *Generations of Kentucky: An Exhibition of Folk Art with Photographs by Guy Mendes.* Louisville, Ky.: Kentucky Art and Craft Foundation, 1994.

Lehigh University. *Natural Scriptures: Visions of Nature and the Bible.* Bethlehem, Pa.: Lehigh University Art Galleries, 1990.

Morehead State University. *Local Visions: Folk Art from Northeast Kentucky.* Morehead, Ky.: Folk Art Collection, Morehead State University, 1990.

Oppenhimer, Ann. *Unto the Hills: Folk Art of Eastern Kentucky.* Richmond, Va.: Marsh Gallery, University of Richmond, 1989.

Rosenak, Chuck, and Jan Rosenak. *Museum of American Folk Art Encyclopedia of Twentieth-Century American Folk Art and Artists.* New York: Abbeville Press, 1990.

Sellen, Betty-Carol. *20th Century American Folk, Self Taught, and Outsider Art.* New York: Neal-Schuman Publishers, 1993.

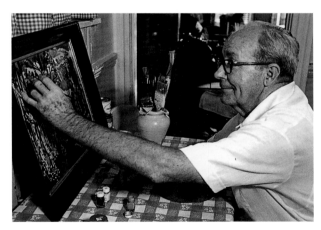

John William ("Uncle Jack") Dey

b. 1912 in Phoebus (now Hampton), Virginia

d. 1978 in Richmond, Virginia

When Dey was eleven, his parents separated, leaving Dey and his sister in their mother's care. Dey held several jobs as a janitor and a paperboy in an effort to augment the family's finances. He also made toys, such as World War I planes, guns, and swords, that he sold to his friends. Beginning in 1932, Dey spent two years in Maine as a trapper and lumberjack. Following his stint up north, he moved to Richmond, Virginia, where he married and worked as a barber. In 1943, he joined the Richmond police force, earning the name "Uncle Jack" from the neighborhood children because he repaired their bicycles and toys.

From as early as 1935, Dey practiced decorative painting on various objects, such as glass jars and doorstops. He turned to two-dimensional painting after he retired from the force in 1955. Dey's work consists of multiple layers of enamel-based model paint on canvas, cardboard, or wood. Often, he predeter-

mined the size of his paintings according to the availability and selection of secondhand frames that he had collected. Much of Dey's art is based on memories of the experiences he had as a young adult in Maine.

Sources consulted:

Horwitz, Elinor Lander. *Contemporary American Folk Artists*. Philadelphia: J. B. Lippincott Co., 1975.

Kaufman, Barbara Wahl, and Didi Barrett. *A Time to Reap: Late Blooming Folk Artists*. South Orange, N. J.: Seton Hall University; New York: Museum of American Folk Art, 1985.

Meadow Farm Museum. *Life and Legend: Folk Paintings of "Uncle Jack" Dey*. Richmond, Va.: Meadow Farm Museum, 1989.

Wright, R. Lewis, Jeffrey T. Camp, and Chris Gregson. "'Uncle Jack': John William Dey." *Clarion*, XVII, no. 1 (Spring 1992), pp. 34–40.

Thornton Dial, Sr.

b. 1928 in Emelle, Alabama

Currently living in Bessemer, Alabama

Dial spent most of his childhood in the care of various female relatives. By the time he was thirteen, he and his two brothers were living in Bessemer, Alabama. In 1952, Dial obtained a job with a railroad-car manufacturing company, Pullman Standard, where he worked with steel for more than thirty years. During this same period, he also worked for thirteen years at the Bessemer Water Works during layoffs from Pullman Standard. Other jobs included various types of construction work and the operation of local cafes on vacant community lots; Dial raised the animals and grew the crops for these restaurants. After he retired from Pullman Standard in the early 1980s, Dial devoted himself to creating objects such as fishing lures and assemblages out of found objects and materials ranging from recycled carpet to scrap metal. He subsequently buried many of these early works because he thought a license was needed to make them, and the interred pieces were eventually destroyed by a flood. In 1984, Dial's two sons opened a small business, Dial Metal Patterns, making metal patio furniture in their father's backyard. In 1987, Dial started painting and began to pursue his art full-time.

Sources consulted:

Baraka, Amiri [LeRoi Jones], and Thomas McEvilley. *Thornton Dial: Image of the Tiger*. New York: Harry N. Abrams Inc., in association with the Museum of American Folk Art, the New Museum of Contemporary Art, and the American Center, 1993.

Borum, Jenifer P. "Strategy of the Tiger: The World of Thornton Dial." *Folk Art,* XVIII, no. 4 (Winter 1993–1994), pp. 34–40.

Gaver, Eleanor E. "Inside the Outsiders." *Art & Antiques* (Summer 1990), pp. 72–86, 159–163.

Southern Queens Park Association, Inc. *Thornton Dial: Strategy of the World*. Jamaica, N.Y.: Southern Queens Park Association, Inc., 1990.

Trechsel, Gail Andrews, ed. *Pictured in My Mind: Contemporary American Self-Taught Art from the Collection of Dr. Kurt Gitter and Alice Rae Yelen*. Birmingham, Ala.: Birmingham Museum of Art, 1995.

Josephus Farmer

b. 1894 near Trenton, Tennessee

d. 1989 in Joliet, Illinois

The son of a former slave, Farmer was born into poverty and spent most of his childhood farming. By age twelve, he was employed as a cotton picker. In his spare time, he carved, often making his own toys. In 1917, he moved with his brother to East Saint Louis, Illinois, where he was employed for some time with the Armour Packing Company. In 1922, Farmer's life changed dramatically when he was directed by God to join the church and to preach. He was ordained as a Pentecostal minister and began to

spread religious messages through word and song as a street preacher. Nine years later, he founded El Bethel Apostolic Church in South Kinlock, Missouri, and in 1947, he moved his family to Milwaukee, Wisconsin, where he opened a storefront church. In addition to his religious work, Farmer worked for the federal government in construction during the 1930s and 1940s. In the early 1950s, he gained employment as a porter in a nearby hotel. During this time, he also began making banners, wooden reliefs, and dioramas based on standard theological charts, using them as visual aids to his preaching. In 1960, Farmer retired from most secular work, though he farmed for a brief period, and he devoted his time to ministry and carving. His carvings, relief panels, and tableaux depict American historical themes as well as his religious beliefs and are influenced by popular culture and his memories of the South.

Sources consulted:

Columbus Museum of Art. *Elijah Pierce: Woodcarver.* Columbus, Ohio: Columbus Museum of Art, 1992.

Cubbs, Joanne. *The Gift of Josephus Farmer.* Milwaukee, Wis.: Milwaukee Art History Gallery, University of Wisconsin, 1982.

Milwaukee Art Museum. *Common Ground/Uncommon Vision: The Michael and Julie Hall Collection of American Folk Art.* Milwaukee, Wis.: Milwaukee Art Museum, 1993.

Rosenak, Chuck, and Jan Rosenak. *Museum of American Folk Art Encyclopedia of Twentieth-Century American Folk Art and Artists.* New York: Abbeville Press, 1990.

Yelen, Alice Rae. *Passionate Visions of the American South: Self-Taught Artists from 1940 to the Present.* New Orleans, La.: New Orleans Museum of Art, 1993.

Howard Finster

b. 1915 near Valley Head, Alabama

Currently living in Summerville, Georgia

The self-described "Man of Visions" received his first message from God at the age of three. By 1923, the eight-year-old Finster was receiving religious instruction and attending revivals, and by age sixteen, he had been told by God to preach. Though Finster did not begin to pastor until 1941, once started in his ministry, he continued over the next thirty-five years in more than a dozen churches. In the late 1940s, Finster moved to Trion, Georgia, where he constructed his first outdoor museum/environment in his backyard. This premier effort contained small

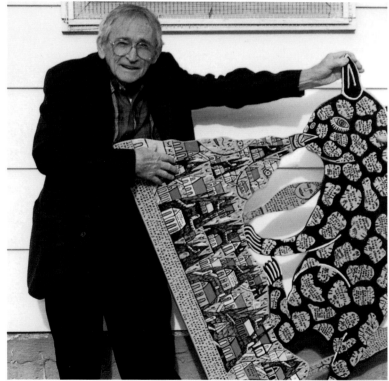

monuments, buildings, and a pond. Finster also was employed at the local mill for some time but quit because of a Sunday work requirement, deciding to focus his attention on a variety of other businesses from screen-door and -window contracting to small-machinery repair. He spent the next years preaching and working in various locations but settled in Pennville, Georgia, in 1961.

Finster spent much of his time restoring and constructing his Plant Farm Museum (later referred to as "Paradise Garden"), which was located on a two-and-one-half-acre swamp that had been a garbage dump. He renovated existing springs and collected discarded objects to decorate his garden. In 1965, he quit the

ministry and devoted fifteen years to developing his outdoor environment and to painting, building, and repairing objects. In 1976, Finster received a message from God telling him to paint sacred art. Sources disagree on whether he received the message by dream or vision, but nonetheless, he has been creating his biblical, historical, and popular culture figures and objects ever since.

In the late 1970s, Finster began to number his artwork. He started with a system that recorded the hours spent on each creation and eventually developed a chronological dating and numbering system. As of this writing, he has completed approximately forty thousand works of art. In 1982, Finster bought an abandoned building adjacent to his Plant Farm Museum property and converted it to a chapel he named the World's Folk Art Church, using found objects and art as decoration. His outdoor museum, Paradise Garden, still exists, though large portions have been removed. In the early 1990s, Finster moved yet again to the nearby county seat, Summerville, where he currently resides.

Sources consulted:

Finster, Howard. *Howard Finster: Man of Visions*. Atlanta, Ga.: Peachtree Publications, 1989.

Finster, Howard, and Tom Patterson. *Howard Finster, Stranger from Another World: Man of Visions Now on This Earth*. New York: Abbeville Press, 1989.

Oppenhimer, Ann Frederick, and Susan Hankla, eds. *Sermons in Paint: A Howard Finster Folk Art Festival*. Richmond, Va.: University of Richmond, 1984.

Patterson, Tom. Telephone conversation with Laura E. Pass. August 9, 1996.

Philadelphia Art Alliance. *Howard Finster: Man of Visions, the Garden and Other Creations*. Philadelphia, Pa.: Philadelphia Art Alliance, 1984.

Rosenak, Chuck, and Jan Rosenak. *Contemporary American Folk Art: A Collector's Guide*. New York: Abbeville Press, 1996.

Turner, J. F. *Howard Finster, Man of Visions: The Life and Work of a Self-Taught Artist*. New York: Alfred A. Knopf, 1989.

Wilson, Cynthia. Telephone conversation with Laura E. Pass. September 6, 1996.

Tony Fitzpatrick

b. 1958 in Chicago, Illinois

Currently living in Chicago, Illinois

Artist, poet, and actor Tony Fitzpatrick spent his youth attending Catholic schools. Though he painted as a child, he kept his work to himself by hiding it in his girlfriend's locker. Despite failing his art classes, Fitzpatrick continued to draw after high school while working a variety of jobs from boxer to cabdriver. In 1987, he traveled to Haiti to study painting with Andre Pierre. Upon returning to the United States, he landed a one-man show of his work in New York City. Today, Fitzpatrick continues to create, expressing his concerns for the degradation of humanity and the indifference of Americans. His inspirations are horror films and mass murders, New Orleans and Coney Island; in addition, recurring themes of the Crucifixion and redemption appear in his art. He has acted in major box-office movies, been published in magazines and books of his own, and can be heard on Chicago radio.

Sources consulted:

Cavin, Shari. Telephone conversation with Laura E. Pass. August 30, 1996.

Fitzpatrick, Tony. *The Hard Angels: Drawings and Poems*. Philadelphia: Janet Fleisher Gallery, 1988.

Snead, Elizabeth. "Drawing on His Talents: Tony Fitzpatrick, Painter and Actor." *USA Today*, August 19, 1991, Life section.

Victor Joseph ("Joe") Gatto

b. 1893 in New York City

d. 1965 in Miami, Florida

Following his mother's death when he was five, Gatto and his siblings were placed in an orphanage. Three years later, they joined their father and stepmother in New York City. Gatto recollected a visit from President Theodore Roosevelt to his school—and the latter's comment that eight-year-old Gatto was the most talented draftsman in the school. This experience left a lasting impression on him, though he did not begin to paint until age forty-five.

In 1913, Gatto became a lightweight boxer and fought for six years. Between 1920 and 1930, he spent time in prison for a crime he claimed he did not commit. He worked at a variety of jobs from movie extra to steamfitter; he was laid off from the latter because of an injury. In 1938, Gatto began to take his art more seriously. During the next decade, he reached the height of his career. Though living amid an active contemporary art scene, Gatto made an effort not to learn from neighboring artists, because he feared that knowledge would lessen his authenticity as a "primitive" artist.

Gatto often wintered in Miami and summered in New York, but eventually he remained in the South. Themes of his early work include jungle scenes, war, peace, and loneliness. In the late 1940s, he expanded his subject matter to depict an even wider range of subjects, from dog races to natural disasters to biblical scenes.

Sources consulted:

Abby Aldrich Rockefeller Folk Art Center. *Folk Art USA since 1900 from the Collection of Herbert Waide Hemphill, Jr.* New York: Publishing Center for Cultural Resources, 1980.

Epstein, Gene. "The Art and Times of Victor Joseph Gatto." *Clarion,* XIII, no. 2 (Spring 1988), pp. 56–63.

Sargeant, Winthrop. "Joe Gatto, Primitive." *Life* (November 8, 1948), pp. 5–6, 76, 78, 80.

Trechsel, Gail Andrews, ed. *Pictured in My Mind: Contemporary American Self-Taught Art from the Collection of Dr. Kurt Gitter and Alice Rae Yelen.* Birmingham, Ala.: Birmingham Museum of Art, 1995.

"Victor Joseph Gatto Dies at 71; Plumber-Boxer Became Artist." *New York Times,* May 27, 1965, Obituary section.

Keith Goodhart

b. 1956 in Philadelphia, Pennsylvania

Currently living in Montana

At age seventeen, Goodhart read Jack Kerouac and was motivated to travel west to San Francisco. Disliking California, he headed eastward, getting as far as Montana. He briefly attended the University of Montana and worked as cowboy during the summers. In the winter, he worked odd jobs on a ranch, eventually saving enough money to purchase his own spread, where he lives today. Goodhart started creating with wood at night while he was a cowboy and a ranch hand. His interests in current events are reflected in his work. Prevalent themes include the attitude of people and the role of money in the destruction and overpopulation of the land. Goodhart uses nontraditional materials and constructs artworks from found objects.

Sources consulted:

Cavin, Shari. Telephone conversation with Laura E. Pass. July 10, 1996.

Hines, Jack. "Creative Process." *Southwest Art* (August 1995), pp. 43–44.

Hoffberger, Rebecca, Roger Manley, and Colin Wilson. *Tree of Life.* Baltimore, Md.: American Visionary Art Museum, 1996.

Denzil Goodpaster

b. 1908 in Deniston, Kentucky

d. 1995 in West Liberty, Kentucky

The son of a tobacco farmer, Goodpaster was raised on his grandfather's farm. He worked there most of his life until 1968, when he retired from farm work and leased out much of the tobacco operation. Goodpaster created small objects in wood as a hobby, but he did not focus on this work until after he retired. His artistic endeavors began in 1970, when he reacted to a cane his neighbor had made by carving a more impressive one.

Goodpaster's early work consisted of unpainted animal carvings on cane handles and shafts, but by 1976, his carving encompassed the entire length of his canes. He also created freestanding sculptures, though his specialty was walking sticks. Goodpaster's subjects are whimsical and imaginative and take a variety of forms from reptiles to celebrities.

Sources consulted:

Goodpaster, Lexie. Telephone conversation with Laura E. Pass. August 12, 1996.

Meyer, George H. *American Folk Art Canes: Personal Sculpture.* Bloomfield Hills, Mich.: Sandringham Press in association with the Museum of American Folk Art and the University of Washington Press, 1992.

Rosenak, Chuck, and Jan Rosenak. *Museum of American Folk Art Encyclopedia of Twentieth-Century American Folk Art and Artists.* New York: Abbeville Press, 1990.

Swain, Adrian. "Denzil Goodpaster: Kentucky Folk Artist." *Folk Art Messenger,* XXI, no. 1 (Spring 1996), pp. 8–9.

Theodore ("Ted") Gordon

b. 1924 in Louisville, Kentucky

Currently living in Laguna Hills, California

Gordon spent his youth in Kentucky until 1938, when his grandparents' business failed and the family moved north to Brooklyn. In the early 1950s, he headed west to San Francisco, and by 1958, he was married and had received a degree in social welfare from San Francisco State College. At some point during this time, he began doodling on three-by-five-inch pieces of paper. He later expanded his work onto pieces of poster board. From 1961 to 1985, Gordon worked as a hospital file clerk and receptionist. In 1981, he discovered two art books with drawings similar to his and sent examples of his art to the authors. He has been working full-time on his drawings since his retirement in 1986. His work is mainly portraits consisting of thousands of concentric and spiraling lines. As of 1990, he had created more than four hundred pieces.

Sources consulted:

Barrett, Didi. *Muffled Voices: Folk Artists in Contemporary America.* New York: Museum of American Folk Art at the Paine Webber Art Gallery, 1986.

Milwaukee Art Museum. *Common Ground/Uncommon Vision: The Michael and Julie Hall Collection of American Folk Art.* Milwaukee, Wis.: Milwaukee Art Museum, 1993.

Rosenak, Chuck, and Jan Rosenak. *Museum of American Folk Art Encyclopedia of Twentieth-Century American Folk Art and Artists.* New York: Abbeville Press, 1990.

Carl Greenberg

b. 1917 in Brooklyn, New York

Currently living in Brooklyn, New York

Greenberg's past includes many years of institutionalization. It is unknown when he began painting, but he continues today as his health permits. Most of his works include the word "song" in their titles, and they usually relate to some part of a song or tune. He depicts footlights and a proscenium in most instances and attaches a theatrical relationship to whatever subject he might be painting. The subjects of his art are rich in detail, and his work is colorfully painted in yellow, orange, red, and/or green. He enjoys exhibiting his work, though he declines invitations to attend showings of his pieces.

Sources consulted:

Hospital Audiences, Inc. (HAI). *Outsider Artists of Hospital Audiences, Inc. (HAI)*. New York: Capital Cities/ABC, Inc., 1996.

Marks, Elizabeth, and Thomas Klocke. *The HAI Collection of Outsider Art, 1980–1990: Selected Works Created by Mentally Ill Artists in New York City from the Hospital Audiences, Inc., Art Workshop Program*. New York: Hospital Audiences, Inc., 1990.

Marks, Elizabeth. Telephone conversation with Laura E. Pass. August 14, 1996.

Sellen, Betty-Carol. *20th Century American Folk, Self Taught, and Outsider Art*. New York: Neal-Schuman Publishers, 1993.

Oscar E. Hadwiger

b. 1890 [in Colorado?]

d. 1989 in Pueblo, Colorado

Hadwiger was born into woodworking; both his father and grandfather created in the medium. At age five, Hadwiger contracted scarlet fever, which left him 40 percent deaf in both ears and eventually forced him to leave school. As a youth, he spent his spare time at home working on mechanical projects. As a young adult, he taught woodworking classes for two years, and he was a founder of the Pueblo [Colorado] Junior College, a training school for war workers. Hadwiger, however, worked most of his life by himself at his machine shop and foundry, making such things as stairs and patterns for iron casting. He also had an interest in inventions. Among other creations, he invented the bearing puller for the United States Air Command in 1942, and he credited himself with the invention of the hearing aid one year later. It is unknown when he started to create the inlaid wood pieces by which he is best known today, but by the 1950s and 1960s, Hadwiger was selling this type of work at a roadside stand.

Sources consulted:

Gordon, Ellin, and Baron Gordon. Artist files.

Hoffberger, Rebecca, Roger Manley, and Colin Wilson. *Tree of Life*. Baltimore, Md.: American Visionary Art Museum, 1996.

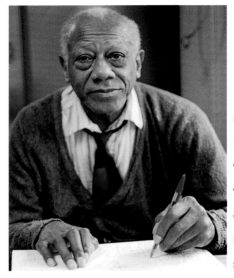

Ray Hamilton

b. 1919? in Williamston, South Carolina?

d. 1996 in Brooklyn, New York

Sources disagree on the place and date of Hamilton's birth; published statements range in date from 1919 to 1920 and in place from North Carolina to South Carolina. He and his twelve siblings were raised on a farm. Hamilton was always interested in drawing but did not begin to create until the 1980s, when he was admitted to a Brooklyn health care facility. He served in the navy during World War II and afterwards continued to address other men as "Sir." Later, he often added the title to his signature on his artwork. After the service, Hamilton moved to New York City and worked with a railroad company until the late 1970s, when a stroke forced him into an adult home.

Hamilton was inspired to draw when a hospital worker introduced him to ballpoint pens. In 1989, a second stroke paralyzed his dominant hand, but he quickly recovered by switching to the other. The subjects of his work varied from themes in his environment to farm animals recollected from his childhood to imaginative subjects, such as semihumans. An unusual aspect of his work is the incorporation of dense columns of words, letters, and numbers in the backgrounds of some of his compositions.

Sources consulted:

Artists Space. *Art's Mouth.* New York: Artists Space, 1991.

Hospital Audiences, Inc. (HAI). *Outsider Artists of Hospital Audiences, Inc. (HAI).* New York: Capital Cities/ABC, Inc., 1996.

Marks, Elizabeth, and Thomas Klocke. *The HAI Collection of Outsider Art, 1980–1990: Selected Works Created by Mentally Ill Artists in New York City from the Hospital Audiences, Inc., Art Workshop Program.* New York: Hospital Audiences, Inc., 1990.

"Miniatures." *Folk Art,* XXI, no. 2 (Summer 1996), p. 24.

Noyes Museum. *Drawing Outside the Lines: Works on Paper by Outsider Artists.* Oceanville, N. J.: Noyes Museum, 1988.

Rosenak, Chuck, and Jan Rosenak. *Contemporary American Folk Art: A Collector's Guide.* New York: Abbeville Press, 1996.

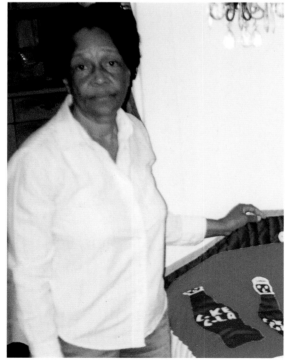

O'Tesia ("O.T.") Harper

b. 1925 in Yazoo County, Mississippi

Currently living in Yazoo City, Mississippi

As a child, Harper watched her grandmother quilt. It was not until she received a quilt as a wedding gift, however, that she began to quilt herself. She has been sewing since then but has only pursued quilting full-time since she retired in 1988. Harper's work is inspired by illustrated children's Bibles and depicts subjects such as Adam and Eve and Noah's ark. She also portrays patriotic subjects, such as the Statue of Liberty, as well as themes from popular culture, such as Coca-Cola.

Sources consulted:

Gordon, Ellin, and Baron Gordon. Artist files.

Harper, O'Tesia. Telephone conversation with Laura E. Pass. August 29, 1996.

Bessie Ruth White Harvey

b. 1928 in Dallas, Georgia

d. 1994 in Alcoa, Tennessee

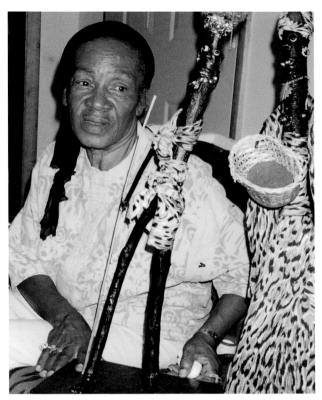

Born the seventh of thirteen children, Harvey was only a young child when her father died. In 1944, she married and moved to her husband's hometown of Buena Vista, Georgia. Over the next decade, she bore eleven children. Marital problems developed, and Harvey took her children and left her husband. She then worked at a variety of service jobs. In 1968, she gained employment as a housekeeper's aide in an Alcoa, Tennessee, hospital, remaining there until she retired in 1983.

Different accounts exist as to why Harvey started creating artwork. One says that in 1972, she dug up a piece of metal with a spiritual face on it that inspired her. Another gives drug and crime problems with her children as the reason she began sculpting, maintaining that Harvey saw spiritual faces as she prayed and meditated about her family problems. Regardless of the origins of her visions, it is clear that in the early 1970s, Harvey started to depict in wood the faces she saw. She sculpted tree limbs and roots in the forms of her many visions and then decorated the pieces with paint, glitter, beads, human hair, and other objects.

Because some associated her works with voodoo, Harvey destroyed many of her early creations. In 1978, however, she received positive recognition for her artwork after she entered pieces in an art show at the hospital. Her other creations include masks and drawings based on African-American mythology, rituals, and traditions. Harvey devoted her full time to her art after she retired from the hospital.

Sources consulted:

Carr, Simon, et al., eds. *Portraits from the Outside: Figurative Expression in Outsider Art.* New York: Groegfeax Publishing, 1990.

Milwaukee Art Museum. *Common Ground/Uncommon Vision: The Michael and Julie Hall Collection of American Folk Art.* Milwaukee, Wis.: Milwaukee Art Museum, 1993.

Morris, Shari Cavin. "Bessie Harvey: The Spirit in the Wood." *Clarion,* XII, no. 2–3 (Spring–Summer 1987), pp. 44–49.

Patterson, Tom. *Not by Luck: Self-Taught Artists in the American South.* Milford, N. J.: Lynne Ingram Southern Folk Art, 1993.

Rosenak, Chuck, and Jan Rosenak. *Museum of American Folk Art Encyclopedia of Twentieth-Century American Folk Art and Artists.* New York: Abbeville Press, 1990.

Trechsel, Gail Andrews, ed. *Pictured in My Mind: Contemporary American Self-Taught Art from the Collection of Dr. Kurt Gitter and Alice Rae Yelen.* Birmingham, Ala.: Birmingham Museum of Art, 1995.

University Art Museum. *Baking in the Sun: Visionary Images from the South, Selections from the Collection of Sylvia and Warren Lowe.* Lafayette, La.: University of Southwestern Louisiana, 1987.

Yelen, Alice Rae. *Passionate Visions of the American South: Self-Taught Artists from 1940 to the Present.* New Orleans, La.: New Orleans Museum of Art, 1993.

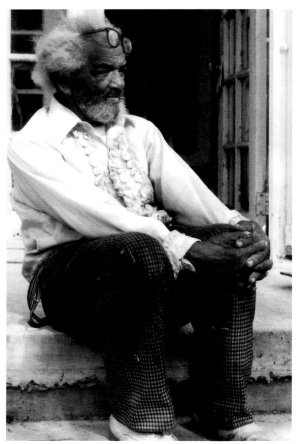

William Lawrence Hawkins

b. 1895 in Union City, Kentucky

d. 1990 in Columbus, Ohio

After his mother's death, two-year-old Hawkins was sent to live on his maternal grandparents' farm. He spent most of his youth there learning every aspect of farming, from running machines to raising livestock. At age sixteen, he moved to Columbus, Ohio, where he worked in construction until he entered the military in 1918. In the 1920s, he obtained employment with the Buckeye Steel Casting Company. At different points in his life, Hawkins took jobs ranging from horse training to house painting to plumbing. He often supplemented his income by selling scrap and photographic portraits.

From childhood, Hawkins had an interest in painting and drawing, and in the 1930s and 1940s, he began his artistic career by selling small works. It was not until his retirement in the late 1970s, however, that his art became his primary interest. His early paintings referred to popular media advertisements and illustrations and were executed in monochromatic tones. In 1981, his work changed to memory paintings and expanded in both size and palette. By 1986, he was working on collages and mixed-media constructions utilizing recycled items. Hawkins continued to create until November 1989, when he suffered a stroke; he died two months later.

Sources consulted:

Columbus Museum of Art. *Popular Images, Personal Visions: The Art of William Hawkins, 1895–1990.* Columbus, Ohio: Columbus Museum of Art, 1990.

Hartigan, Lynda Roscoe. *Made with Passion: The Hemphill Folk Art Collection in the National Museum of American Art.* Washington, D. C.: Smithsonian Institution Press for the National Museum of American Art, 1990.

Kraskin, Sandra. *Black History and Artistry: Work by Self-Taught Painters and Sculptors from the Blanchard-Hill Collection.* New York: Sidney Mishkin Gallery, Baruch College, CUNY, 1993.

Milwaukee Art Museum. *Common Ground/Uncommon Vision: The Michael and Julie Hall Collection of American Folk Art.* Milwaukee, Wis.: Milwaukee Art Museum, 1993.

Newark Museum. *A World of Their Own: Twentieth-Century American Folk Art.* Newark, N. J.: Newark Museum, 1995.

Ricco, Roger, and Frank Maresca. *William L. Hawkins, 1895–1990.* New York: Ricco/Maresca Gallery, 1990.

Rosenak, Chuck, and Jan Rosenak. *Museum of American Folk Art Encyclopedia of Twentieth-Century American Folk Art and Artists.* New York: Abbeville Press, 1990.

Schwindler, Gary J. "William Hawkins: Master Storyteller." *Raw Vision,* IV (Spring 1991), pp. 40–45.

Trechsel, Gail Andrews, ed. *Pictured in My Mind: Contemporary American Self-Taught Art from the Collection of Dr. Kurt Gitter and Alice Rae Yelen.* Birmingham, Ala.: Birmingham Museum of Art, 1995.

Lonnie Bradley ("Sandman") Holley

b. 1950 in Birmingham, Alabama

Currently living in Birmingham, Alabama

Born the seventh of twenty-seven children, Holley claims he was traded for a pint of alcohol on the night of his birth. He lived with his adoptive parents until he fled from abuse at age six. Upon his escape, Holley was injured in an automobile accident and was hospitalized for several months. He spent the next few years running away from various foster homes until age nine, when he escaped to New Orleans, Louisiana, by train. After he was located by authorities, Holley was sent to an Alabama juvenile delinquent center, where he resided until his natural

grandmother adopted him at age fourteen. Holley later moved to Florida with his brother and found work as a short-order cook. In the 1970s, he moved back to Birmingham, where he gained employment at a local restaurant.

In 1979, Holley's sister's children were killed in a domestic fire. Heavily affected by the tragedy, Holley attempted suicide. He turned to God for guidance and was encouraged to create art as a means of overcoming his grief. Holley decided to make grave markers, his first works of art, for his deceased nieces and nephews. He collected discarded pipe fittings from a nearby steel mill, utilizing portions of the sandstone castaway molds for his sculptures. Holley continued to create tombstones and eventually relief and three-dimensional figures and animals. These later forms are also made of found and discarded materials. In the mid–1980s, Holley began to paint. His works incorporate his interest in contemporary and ancestoral African figures, Egyptian and pre-Columbian sculpture, philosophy, and spiritualism and focus on contemporary issues, such as the importance of family, children, and art. Holley paints, sculpts, and creates found-object assemblages and environmental art.

Sources consulted:

Fowler, Miriam Rogers, comp. *Outsider Artists in Alabama*. Montgomery, Ala.: Alabama State Council on the Arts, 1991.

Kemp, Kathy. *Revelations: Alabama's Visionary Folk Artists*. Birmingham, Ala.: Crane Hill Publishers, 1994.

Montgomery Museum of Fine Arts. *1992 Montgomery Biennial: In/Outsiders from the American South*. Montgomery, Ala.: Montgomery Museum of Fine Arts, 1992.

McWillie, Judith. "Lonnie Holley's Moves." *Artforum*, XXX, no. 8 (April 1992), pp. 80–84.

Murphy, Jay. "Cultural Recycling: The Work of Lonnie Holley." *Raw Vision*, VII (Summer 1993), pp. 20–24.

Patterson, Tom. *Not by Luck: Self-Taught Artists in the American South*. Milford, N. J.: Lynne Ingram Southern Folk Art, 1993.

Rosenak, Chuck, and Jan Rosenak. *Museum of American Folk Art Encyclopedia of Twentieth-Century American Folk Art and Artists*. New York: Abbeville Press, 1990.

Weber, Marcia. Telephone conversation with Laura E. Pass. October 11, 1996.

Robert Howell

b. 1934 in Powhatan, Virginia

Currently living in Powhatan, Virginia

Not much is known about Howell's early life. He began creating in the early 1970s. At that time, he was employed in Richmond, Virginia, working in general maintenance for a condominium unit. Howell utilizes found objects, wood, cloth, and various other materials in his whirligigs and other assembled sculptures. The subjects of his work include people, flying machines, and animals, the latter being a favorite theme. Howell's large-scale wind sculptures and flying creations decorate the environment beside his home, a former roadside grocery built by his brother. His smaller works are kept inside.

Sources consulted:

Gordon, Ellin, and Baron Gordon. Artist files.

Howell, Robert. Telephone conversation with Laura E. Pass. August 21, 1996.

Rosenak, Chuck, and Jan Rosenak. *Contemporary American Folk Art: A Collector's Guide.* New York: Abbeville Press, 1996.

Billy Ray Hussey

b. 1955 in Robbins, North Carolina

Currently living in Robbins, North Carolina

At the age of ten, Hussey started working for the Owens Pottery under his great-uncle, M. L. Owens. Owens taught Hussey the basics of his business, including his personal formulas for glazes. They worked on projects together, the elder creating the bodies of the face jugs and the younger adding the facial characteristics. Hussey continues making face jugs today, but he also creates animals, figurines, and teapots in both stone- and earthenware. Although he has transformed his trade into a contemporary art, Hussey still utilizes the traditional methods that were taught to him, such as wheel throwing, wood-burning kiln firing, and using his great-uncle's formulas for glazes. Hussey also often seeks historical prototypes for his work. As early as 1977, he sculpted replicas of lions made at the nineteenth-century Shenandoah Valley Bell family pottery. The Rosenaks call him the "most innovative of nonacademic North Carolina potters today." He is also president of the more than six-hundred-member Southern Folk Pottery Collector's Society.

Sources consulted:

Hussey, Billy Ray. Telephone conversation with Laura E. Pass. August 15, 1996.

Rosenak, Chuck, and Jan Rosenak. *Contemporary American Folk Art: A Collector's Guide.* New York: Abbeville Press, 1996.

Sellen, Betty-Carol. *20th Century American Folk, Self Taught, and Outsider Art.* New York: Neal-Schuman Publishers, 1993.

University Center Gallery. *Vernacular Pottery of North Carolina: 1982–1986, from the Collection of Leonidas J. Betts.* Raleigh, N. C.: University Center Gallery, N. C. State University, 1987.

Levent Isik

b. 1961 in Istanbul, Turkey

Currently living in Columbus, Ohio

At the age of five, Isik immigrated to Montreal, Canada. In 1981, he moved to Columbus, Ohio, where he currently lives as a legal alien, since he has retained his Canadian citizenship. Isik began painting in Columbus in 1989, having been inspired by Elijah Pierce and William Hawkins, the latter a close friend. His work also has been influenced by Gregory Warmack ("Mr. Imagination") and by the paintings created by Vincent Van Gogh and Morris Hirshfield. The colorful, highly patterned, and romantic images in Isik's paintings derive from both his and his girlfriend's subconsciouses. The subjects include cityscapes, superwomen, and angels. Some of his creations are reliefs with raised shapes, either cut from paper or built from putty, that he has attached to the painting surface. Isik also creates putty borders around some of his works, painting these frames with bold designs or patterns and adding objects such as buttons and bottle caps to their surfaces. See also the separate entries on Elijah Pierce, William Hawkins, and Gregory Warmack.

Sources consulted:

Constable, Lesley. "Childlike Sense of Wonder Pops Out Merrily at Exhibit." *Columbus (Ohio) Dispatch,* August 11, 1991.

————. "Isik Conveys Warmly Human, Humorous Visions." *Columbus (Ohio) Dispatch*, September 13, 1992.

————. "State Fair: Breadth, Excellence Reign at This Winning Art Exhibit." *Columbus (Ohio) Dispatch,* August 4, 1991, Visual Arts section.

Rosenak, Chuck, and Jan Rosenak. *Contemporary American Folk Art: A Collector's Guide.* New York: Abbeville Press, 1996.

Sellen, Betty-Carol. *20th Century American Folk, Self Taught, and Outsider Art.* New York: Neal-Schuman Publishers, 1993.

Anderson Johnson

b. 1915 in Lunenberg County, Virginia

Currently living in Newport News, Virginia

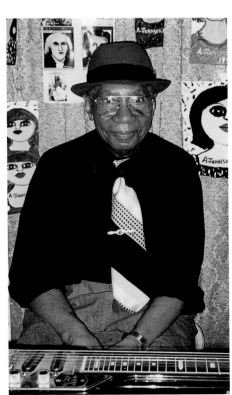

The son of a sharecropper, Johnson was working in the fields when he received his first message from God. At age eight, he was asked to preach, but he waited until he was sixteen to become the pastor of a small New Jersey church. Johnson spent the next fifty years moving from congregation to congregation and preaching on the streets in a variety of locations from New York City to Los Angeles to Miami. In addition to his preaching, he began to play the guitar and piano, incorporating music into his sermons. Johnson also maintained a childhood interest in art by sketching chalk drawings on the backs of wallpaper rolls, an inexpensive replacement for canvas, and sold these works to cover his preaching expenses. (One source cites medical expenses as motivating his wallpaper drawing.)

In 1985, Johnson moved to Newport News after an accident left him partially paralyzed. He regained his strength, despite refusing his doctor's rec-

ommendations, and attributed his recovery to God's intervention. He converted the first floor of his home to a church called the Faith Mission and decorated the environment with colorful signs and paintings addressed to the faithful. In 1993, Johnson was forced out of his home because of an urban renewal project. His wall murals were saved, however, and today, he is resettled in a new home in the same city. The subjects of his work include biblical, historical, political, and visionary portraits as well as landscapes, figures, and birds.

Sources consulted:

Erickson, Mark St. John. "Vivid Visions: Preacher's Chapel Packed with Lively, Colorful Folk Art." *Newport News (Va.) Daily Press*, August 13, 1989, Arts & Leisure section.

Gordon, Ellin, and Baron Gordon. *Virginia Originals*. Virginia Beach, Va.: Virginia Beach Center for the Arts, 1994.

Merritt, Robert. "Human Form's Gracefulness Highlighted in Exhibit at UR." *Richmond (Va.) Times-Dispatch*, January 14, 1991, sec. C, p. 5.

Rosenak, Chuck, and Jan Rosenak. *Contemporary American Folk Art: A Collector's Guide*. New York: Abbeville Press, 1996.

Wake Forest University Fine Arts Gallery. *Diving in the Spirit*. Winston-Salem, N. C.: Wake Forest University Fine Arts Gallery, 1992.

Yelen, Alice Rae. *Passionate Visions of the American South: Self-Taught Artists from 1940 to the Present*. New Orleans, La.: New Orleans Museum of Art, 1993.

Shields Landon ("S. L.") Jones

b. 1901 in Indian Mills, West Virginia

Currently living in Pine Hill, West Virginia

One of thirteen children born to a sharecropper (another source says a tenant farmer), Jones spent much of his early life traveling from one farm to another until 1905–1906, when his father was able to purchase his own land. In 1918, Jones lied about his age to obtain work with the Chesapeake and Ohio Railroad. He spent forty-six years with the railroad, working his way up to construction foreman by his retirement in 1967. Though Jones was interested in whittling and carving from childhood, it was not until the death of his first wife in 1969 that he took an art class at the local YMCA and began carving.

Jones started with unpainted carvings but had expanded his work to include painted, stained, and decorated effects by the early 1970s. Around this time, he remarried and traveled extensively in Greece, Egypt, and South America. Possibly these travels influenced his work. By 1975, Jones was creating life-size busts and tabletop groups of figures; his subjects are often family and friends. In the early 1990s, Jones suffered a stroke, and though he still carves today, he does so in a limited capacity, preferring to concentrate on drawing.

Sources consulted:

Hartigan, Lynda Roscoe. *Made with Passion: The Hemphill Folk Art Collection in the National Museum of American Art*. Washington, D. C.: Smithsonian Institution Press for the National Museum of American Art, 1990.

Lampell, Ramona, and Millard Lampell. *O, Appalachia: Artists of the Southern Mountains*. New York: Stewart, Tabori & Chang, 1989.

Philadelphia College of Art. *Transmitters: The Isolate Artist in America*. Philadelphia, Pa.: Philadelphia College of Art, 1981.

Rosenak, Chuck, and Jan Rosenak. *Museum of American Folk Art Encyclopedia of Twentieth-Century American Folk Art and Artists*. New York: Abbeville Press, 1990.

Rosenak, Chuck. "A Person Has to Have Some Work to Do." *Goldenseal*, VIII, no. 1 (Spring 1982), pp. 47–52.

Sellen, Betty-Carol. *20th Century American Folk, Self Taught, and Outsider Art*. New York: Neal-Schuman Publishers, 1993.

Charles ("Charley") Kinney

b. 1906 near Vanceburg, Kentucky

d. 1991 near Vanceburg, Kentucky

Kinney spent most of his life in the same location, moving before the age of six merely a tenth of a mile down the road from his birthplace. As a youth, he raised corn and tobacco on the family farm, learning all the basics of subsistence farming, but he was limited to light labor because of a birth defect. As a young adult, Kinney moved away from home to work on a nearby farm, but he returned in the 1950s to assist his brother Noah after the two brothers inherited the family property. In the 1970s, after Noah had a heart attack, both brothers decided to retire and lease the farm. Kinney maintained his childhood interest in art throughout his life but concentrated on his creativity only after retirement. In addition to making clay objects, baskets, puppets, and paintings, he was also an avid storyteller and musician. Kinney incorporated his stories—myths, legends, and folktales—into religious scenes and other subjects in his paintings. He also sculpted animal and human figures.

Sources consulted:

Lampell, Ramona, and Millard Lampell. *O, Appalachia: Artists of the Southern Mountains*. New York: Stewart, Tabori & Chang, 1989.

"Miniatures." *Clarion*, XVI, no. 3 (Fall 1991), p. 18.

Morehead State University. *Local Visions: Folk Art from Northeast Kentucky*. Morehead, Ky.: Folk Art Collection, Morehead State University, 1990.

Rosenak, Chuck, and Jan Rosenak. *Museum of American Folk Art Encyclopedia of Twentieth-Century American Folk Art and Artists*. New York: Abbeville Press, 1990.

Sunseri, Don. "Slow Time: The Art of Charley, Noah and Hazel Kinney." *Folk Art Finder*, XVI, no. 3 (July–September 1995), pp. 8–11.

Swain, Adrian. Telephone conversation with Laura E. Pass. August 12, 1996.

Trechsel, Gail Andrews, ed. *Pictured in My Mind: Contemporary American Self-Taught Art from the Collection of Dr. Kurt Gitter and Alice Rae Yelen*. Birmingham, Ala.: Birmingham Museum of Art, 1995.

Tim Lewis

b. 1952 in Eddrich, Kentucky

Currently living in Isonville, Kentucky

Lewis's father and grandfather were quite accomplished in woodworking and carpentry. Lewis, however, was not always interested in wood. After six years in the army, he worked at a variety of jobs, such as making and wiring radios, logging, farming, and strip mining. When Lewis wrecked his cousin's coal truck, he forced the business to close. He then turned to carving wooden canes in 1988. A year later, he began stone sculpting. His canes combine both painting and sculpture, focusing on varied themes from popular culture and including motifs ranging from fanciful mermaids to skulls and animals. The subjects of his stone carvings are

more often biblical but also focus on history and animals. Lewis was recently commissioned to create for the 1996 Atlanta Olympics.

Sources consulted:
Gordon, Ellin, and Baron Gordon. Artist files.
Kentucky Art and Craft Foundation. *Generations of Kentucky: An Exhibition of Folk Art with Photographs by Guy Mendes.* Louisville, Ky.: Kentucky Art and Craft Foundation, 1994.
————. *Sticks: Historical and Contemporary Kentucky Canes.* Louisville, Ky.: Kentucky Art and Craft Foundation, 1988.
Laffal, Jules. "The Life and Art of Walking Sticks and Staffs." *Folk Art Finder,* XIII, no. 2 (April–June 1992), pp. 4–7.
Meyer, George H. *American Folk Art Canes: Personal Sculpture.* Bloomfield Hills, Mich.: Sandringham Press in association with the Museum of American Folk Art and the University of Washington Press, 1992.
Rosenak, Chuck, and Jan Rosenak. *Contemporary American Folk Art: A Collector's Guide.* New York: Abbeville Press, 1996.
Sellen, Betty-Carol. *20th Century American Folk, Self Taught, and Outsider Art.* New York: Neal-Schuman Publishers, 1993.

Israel Litwak

b. 1868 in Odessa, Russia

d. 1960 in Brooklyn, New York

Litwak spent over half of his life in Brooklyn, New York, as a furniture maker and restorer. Raised in Russia, Litwak apprenticed to a cabinetmaker at age eleven. Between the ages of twenty-one and twenty-five, he served in the Russian army, and in 1903, Litwak and his family immigrated to the United States. Upon his arrival, Litwak gained employment in cabinetry, working until his retirement in 1936. Litwak was sixty-eight years old when he began to draw, though he was familiar with art from many visits to local museums. Three years after he began his artistic career, he was offered a show at the Brooklyn Museum. Litwak's early works were pencil and crayon drawings on board. He employed a creative technique in executing his work—he traced his drawings from paper to cardboard, filled in the pressed design with crayon, and then applied fixative and shellac onto the final surface. He also created bold and colorful designs in watercolor and oil.

Sources consulted:
Bachert, Hildegard. Telephone conversation with Laura E. Pass. August 20, 1996.
Galerie St. Etienne. *New York Folk: Lawrence Lebduska, Abraham Levin, Israel Litwak.* New York: Galerie St. Etienne, 1996.
Sellen, Betty-Carol. *20th Century American Folk, Self Taught, and Outsider Art.* New York: Neal-Schuman Publishers, 1993.

Dwight Mackintosh

b. 1906 in Hayward, California

Currently living in Berkeley, California

Since the age of sixteen, Mackintosh has lived in either institutional or managed-care facilities. Mentally retarded, he spent some fifty years under the state's care until 1978, when it was decided that he should be placed in a nursing home. He began to draw the following year, at which time he received much encouragement from Creative Growth, a nonprofit organization that promotes self-expression through the visual arts. One author suggests that Mackintosh's self-image may be similar to that of an eight-year-old. His work is autobiographical, detailing the early years of his life.

Mackintosh's first renderings are characterized by his obsession with transportation vehicles, particularly buses. In 1988, his work shifted, and both line and color became more evident in his drawings. More recently, Mackintosh's work consists of fragmented and frenzied calligraphic markings that dominate the picture plane.

Sources consulted:
MacGregor, John M. *Dwight Mackintosh: The Boy Who Time Forgot.* Oakland, Calif.: Creative Growth Art Center, 1990.
Rosenak, Chuck, and Jan Rosenak. *Contemporary American Folk Art: A Collector's Guide.* New York: Abbeville Press, 1996.

Mona McCalmon

b. 1926 in Arkansas

Currently living in Temple City, California?

McCalmon was born to a large family and reared in rural Arkansas. At some point, she moved to Missouri. A single mother, she raised two daughters while pursuing an engineering degree. In addition, McCalmon held managerial jobs at an animal shelter and a supper club. She began to carve in her sixties while "semi-stranded" on Vancouver Island. Upon her retirement, she relocated to California, where it is assumed that she currently resides and works full-time as an artist. Her sculptures and canes are made of driftwood collected during various travels, and her work is influenced by her past. McCalmon incorporates her insight, humor, and observations on society into the wide range of her work.

Sources consulted:
Gordon, Ellin, and Baron Gordon. Artist files.

Justin McCarthy

b. 1891 or 1892 in Weatherly, Pennsylvania

d. 1977 in Tucson, Arizona

McCarthy was born into an affluent family. His father was the editor of the Hazleton, Pennsylvania, paper and also was involved in politics as a congressional campaign manager and as the private secretary to a congressman. By 1905, because of wise investments in stocks, McCarthy's father was thought to be the wealthiest man in town. In 1907, McCarthy's younger brother died, and the remaining family went to Europe. There, McCarthy was inspired to paint and spent much time at the Louvre. In 1908, his father died; it is suspected that he committed suicide because of financial ruin.

In 1911, McCarthy entered law school, but

within three years, he suffered a nervous breakdown and was put into a private institution. One source suggests that his institutionalization was due to having failed his law school exams. He spent 1915–1920 in a state mental hospital, where he began to draw and paint. He lived with his mother in the family mansion during the next two decades, supporting them both through the sale of produce and liniment. Following his mother's death in 1940, McCarthy worked at various jobs until World War II, when he gained employment with the Bethlehem Steel Company in Lehigh, Pennsylvania. Working as a machinist's helper, he completed his first oil painting (a steel company subject). It was not until the 1960s, however, that he was recognized as an artist. His works, which depict nature (fruits, vegetables, animals, and birds), people (particularly celebrities), sports, and religion, were influenced by the popular media.

Sources consulted:

Abby Aldrich Rockefeller Folk Art Center. Artist files.

Rosenak, Chuck, and Jan Rosenak. *Museum of American Folk Art Encyclopedia of Twentieth-Century American Folk Art and Artists.* New York: Abbeville Press, 1990.

Stebich, Ute. *Justin McCarthy.* Allentown, Pa.: Allentown Art Museum, 1984.

Trechsel, Gail Andrews, ed. *Pictured in My Mind: Contemporary American Self-Taught Art from the Collection of Dr. Kurt Gitter and Alice Rae Yelen.* Birmingham, Ala.: Birmingham Museum of Art, 1995.

J. T. ("Jake") McCord

b. 1945 in Thomson, Georgia

Currently living in Thomson, Georgia

McCord lived and worked on his family farm for more than thirty years. In the 1970s, he cut grass in the summer and drove a truck in the winter. In 1984, he bought an old cafe and converted it into his home. He was inspired to paint after witnessing a group of women at an art class. His work consists of images of houses, buildings, people, and animals painted on plywood. Bright colors occupy the backgrounds of his paintings and serve as outlines of his subjects. McCord is inspired by television and his childhood. He works in his front yard, and when he completes a work, he leaves it there to dry and to advertise itself and his home.

Sources consulted:

Gordon, Ellin, and Baron Gordon. Artist files.

Rosenak, Chuck, and Jan Rosenak. *Museum of American Folk Art Encyclopedia of Twentieth-Century American Folk Art and Artists.* New York: Abbeville Press, 1990.

Sellen, Betty-Carol. *20th Century American Folk, Self Taught, and Outsider Art.* New York: Neal-Schuman Publishers, 1993.

Kenny McKay

b. 1941 in Mount Vernon, New York

Currently living in Queens, New York

From an early age, McKay had learning disabilities that eventually led to more than twenty-five years of institutionalization in a state mental hospital. He has been creating art for at least the past decade, though his initial work was apparently ignored until he became involved in an art therapy program. His earliest source of inspiration was a coffee cup, a motif he continues to utilize today. McKay is also interested in Renaissance art. After a trip to the Cloisters Museum, he began to incorporate knights and armor into his drawings. Other subjects include animals, birds, beasts, people, and humanoid forms. As of 1990, McKay has been adding written jokes to his watercolors. In addition, he has recently begun portraying contemporary subjects and popular icons, such as Mickey Mouse and Marilyn Monroe.

Sources consulted:

Hospital Audiences, Inc. (HAI). *Outsider Artists of Hospital Audiences, Inc. (HAI)*. New York: Capital Cities/ABC, Inc., 1996.

Maresca, Frank, and Roger Ricco. *American Self-Taught: Paintings and Drawings by Outsider Artists*. New York: Alfred A. Knopf, 1993.

Marks, Elizabeth. Telephone conversation with Laura E. Pass. August 14, 1996.

Marks, Elizabeth, and Thomas Klocke. *The HAI Collection of Outsider Art, 1980–1990: Selected Works Created by Mentally Ill Artists in New York City from the Hospital Audiences, Inc., Art Workshop Program*. New York: Hospital Audiences, Inc., 1990.

Larry McKee

b. 1941 in McCreary County, Kentucky

Currently living in South Central area, Kentucky

McKee has carved and whittled since his youth, learning the trade from his father, who made canes and dancing dolls. Though currently not working because of a disability, McKee spent many years employed with the lumber industry. It is believed that he has been carving canes for at least ten years. McKee uses native Kentucky woods, mainly cedar, for his canes and frequently adds paint and shellac to the finished forms. The subject matter is varied, including skeletons, animals, birds, reptiles, flowers, cards, and dice. McKee is also a member of the local Masonic lodge and occasionally depicts Masonic symbols on his canes.

Sources Consulted:

Hackley, Larry. Telephone conversation with Laura E. Pass. September 6, 1996.

Kentucky Art and Craft Foundation. *Sticks: Historical and Contemporary Kentucky Canes*. Louisville, Ky.: Kentucky Art and Craft Foundation, 1988.

Lavitt, Wendy. *Animals in American Folk Art*. New York: Alfred A. Knopf, 1990.

Meyer, George H. *American Folk Art Canes: Personal Sculpture*. Bloomfield Hills, Mich.: Sandringham Press in association with the Museum of American Folk Art and the University of Washington Press, 1992.

Gaetana ("Thomas") Menna

b. 1912 in Brooklyn, New York

Currently living in Brooklyn, New York

Not much is known about Menna's early life beyond the fact that he spent many years in a state mental hospital. He creates two basic types of artworks in watercolor and pencil: male figures and copies of paintings by old masters. The first are executed in a simple manner, whereas Menna's detailed interpretations of early European paintings not only follow the existing composition closely but also add unique aspects of his own. In his interpretation of Van Eyck's *Arnolfini Wedding Portrait,* for example, Menna transformed Arnolfini's shoes into angels. Menna uses focal points in planning the position of his figures, then incorporates these dots as skeletal joints in the subjects. When executing his works, he starts on the right side of the paper, painting and drawing that entire section of the support before moving to the left. Once Menna reaches the left side, his work is complete.

Sources consulted:

Hospital Audiences, Inc. (HAI). *Outsider Artists of Hospital Audiences, Inc. (HAI).* New York: Capital Cities/ABC, Inc., 1996.

Marks, Elizabeth. Telephone conversation with Laura E. Pass. August 14, 1996.

Marks, Elizabeth, and Thomas Klocke. *The HAI Collection of Outsider Art, 1980–1990: Selected Works Created by Mentally Ill Artists in New York City from the Hospital Audiences, Inc., Art Workshop Program.* New York: Hospital Audiences, Inc., 1990.

Peter J. Minchell

b. 1889 in Treves (now Trier), Germany

d. 1984 in West Palm Beach, Florida

From 1903 to 1906, Minchell attended a German trade school, where he produced and exhibited small watercolors. This early work depicted scenes of Europe and also included architectural studies. In 1906, Minchell left Europe for America and entered preparatory seminary in New Orleans, Louisiana. After three years, he attended major seminary at Saint Mary's in Baltimore, Maryland, returning to New Orleans in 1911 by way of Florida and the Gulf of Mexico. Contrary to written sources, Minchell did not move to Florida until the late 1920s. By this time, he had left the priesthood, married, and fathered three children. Upon his arrival in Florida, Minchell obtained employment in the building trade.

It is assumed that Minchell continued to paint and sketch until the late 1940s, because during the years 1949–1967, he did not produce art. He resumed his creative endeavors in the late 1960s. This period of Minchell's artwork is characterized by his interest in the surrounding Florida habitat. In the early 1970s, he created a series of illustrations of natural disasters entitled *Geological Phenomena*. Other works that followed include a series entitled *Comet X* and *Planet Perfection* as well as other paintings based on the jungle and the Bible. Minchell was methodical in the execution of his work, often sketching the entire design on paper before painting. He sometimes included a commentary on the bottom margin of a work.

Sources consulted:

Gordon, Ellin, and Baron Gordon. Artist files.

Hartigan, Lynda Roscoe. *Made with Passion: The Hemphill Folk Art Collection in the National Museum of American Art.* Washington, D. C.: Smithsonian Institution Press for the National Museum of American Art, 1990.

Rosenak, Chuck, and Jan Rosenak. *Museum of American Folk Art Encyclopedia of Twentieth-Century American Folk Art and Artists.* New York: Abbeville Press, 1990.

Toles, Mary Jo. Telephone conversation with Laura E. Pass. October 7, 1996.

Frances ("Lady Shalimar") Montague

b. 1905 in Paris, France

d. 1996 in Brooklyn, New York

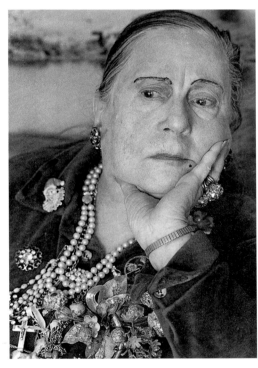

Born backstage at the Paris Opera House, Montague claimed a glamorous lifestyle on the European and American stage as a ballerina and actress. She also worked with the Barnum and Bailey Circus for fifteen years. Montague began painting in an adult home through an art program sponsored by Hospital Audiences, Inc., a nonprofit organization that encourages mentally ill patients to create art. She continued to work after moving to a managed health care facility. The subjects of her paintings include circus, opera, and ballet performers. These figures, whom she identified as herself, are highly decorated in costumes of applied glitter, pins, and sequins. Montague worked them on white backgrounds that included the titles of her works.

Sources consulted:

Gordon, Ellin, and Baron Gordon. Artist files.

Hospital Audiences, Inc. (HAI). *Outsider Artists of Hospital Audiences, Inc. (HAI).* New York: Capital Cities/ABC, Inc., 1996.

Marks, Elizabeth, and Thomas Klocke. *The HAI Collection of Outsider Art, 1980–1990: Selected Works Created by Mentally Ill Artists in New York City from the Hospital Audiences, Inc., Art Workshop Program.* New York: Hospital Audiences, Inc., 1990.

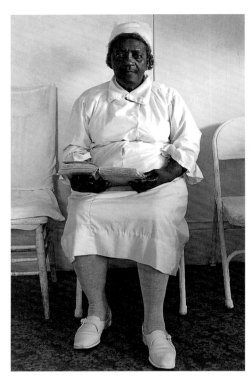

Sister Gertrude Morgan

b. 1900 in Lafayette, Alabama

d. 1980 in New Orleans, Louisiana

When the young Morgan was not in her Lafayette Baptist church, she was drawing with branches in the sand. As a young adult, she lived in Columbus, Georgia, where she had a short-lived marriage, and in 1934, she received a command to preach from God. After joining a fundamentalist sect, she embarked on a series of missionary trips, working in different cities as a street preacher. In 1939, she moved to New Orleans, where she concentrated full-time on her missionary work; she joined others in building an orphanage, child-care facility, runaway shelter, and chapel. Within the next few years, she adopted the title "Sister."

In 1956, Morgan received two more revelations: that she was the bride of Christ and that she was the bride of Jehovah. She discarded her black habit and thereafter dressed only in white. At that time, she also began painting religious figures on canvas. In 1965, she transformed her small home into a chapel called the Everlasting Gospel Mission and painted everything inside the building, including the furniture, white. Though no longer on the streets, Morgan continued to preach the Gospel, using a cut plastic bleach bottle for a megaphone. She also continued to make religious paintings, which adorned the white walls of her chapel. Her early works were executed in wax crayon and inexpensive paints, then she turned to acrylics. She painted on a variety of objects from jelly jars to pillowcases to toilet-paper rolls. All of her works were biblically inspired, and many contain self-portraits and religious messages.

Sources consulted:

Abby Aldrich Rockefeller Folk Art Center. Artist files.

Horwitz, Elinor Lander. *Contemporary American Folk Artists*. Philadelphia: J. B. Lippincott Co., 1975.

Livingston, Jane, and John Beardsley. *Black Folk Art in America, 1930–1980*. Jackson, Miss.: University Press of Mississippi and the Center for the Study of Southern Culture for the Corcoran Gallery of Art, 1982.

Rosenak, Chuck, and Jan Rosenak. *Contemporary American Folk Art: A Collector's Guide*. New York: Abbeville Press, 1996.

Trechsel, Gail Andrews, ed. *Pictured in My Mind: Contemporary American Self-Taught Art from the Collection of Dr. Kurt Gitter and Alice Rae Yelen*. Birmingham, Ala.: Birmingham Museum of Art, 1995.

John B. ("J. B.") Murry

b. 1908 near Sandersville, Georgia

d. 1988 near Sandersville, Georgia

From the age of six, Murry worked on various farms as a laborer until his forced retirement in the late 1970s. During this time, he received a vision from God explaining that he was to become a spiritual mediator between God and the people. Murry's first artistic creations were letters that contained coded messages, or "spirit script." He claimed that whenever he received this mystical inspiration, it would flow through his pen, moving the utensil

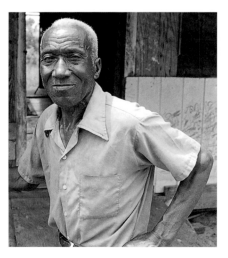

back and forth, right to left and left to right, similar to a computer printer. He distributed pages of this script to church members and embellished a variety of found objects to place outdoors. Murry asserted that only true believers could decode his messages and that they could do so only by looking through a "lens" consisting of a glass bottle of water from his well.

Murry became intensely vocal about his religious beliefs and was both jailed and hospitalized for brief periods. Soon after, he expanded his artwork to include nonrepresentational drawings. His later works consist of ghostlike images in elongated, linear forms and sometimes include the coded messages.

Sources consulted:

Carr, Simon, et al., eds. *Portraits from the Outside: Figurative Expression in Outsider Art*. New York: Groegfeax Publishing, 1990.

Gordon, Ellin, and Baron Gordon. Artist files.

INTAR Latin American Gallery. *Another Face of the Diamond: Pathways through the Black Atlantic South*. New York: INTAR Latin American Gallery, 1988.

Noyes Museum. *Drawing Outside the Lines: Works on Paper by Outsider Artists*. Oceanville, N. J.: Noyes Museum, 1995.

Rosenak, Chuck, and Jan Rosenak. *Museum of American Folk Art Encyclopedia of Twentieth-Century American Folk Art and Artists*. New York: Abbeville Press, 1990.

Trechsel, Gail Andrews, ed. *Pictured in My Mind: Contemporary American Self-Taught Art from the Collection of Dr. Kurt Gitter and Alice Rae Yelen*. Birmingham, Ala.: Birmingham Museum of Art, 1995.

University Art Museum. *Baking in the Sun: Visionary Images from the South, Selections from the Collection of Sylvia and Warren Lowe*. Lafayette, La.: University of Southwestern Louisiana, 1987.

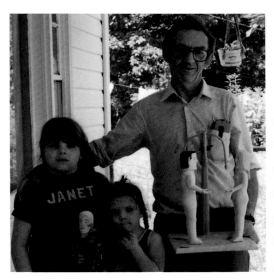

Earnest Patton

b. 1935 in Holly Creek, Kentucky

Currently living near Campton, Kentucky

The son of a tobacco farmer and the eldest child in a large family, Patton quit school to assist his father in the fields. He started carving in his youth, depicting animals and farm tools and equipment, such as shovels, pitchforks, and wagons. In 1963, Patton married and began sharecropping for a neighboring farmer. In addition to his farmwork, he supplemented his income by driving a bus and working as a mechanic. He started to carve seriously after seeing examples of Edgar Tolson's work displayed in a doctor's office. Patton felt he could replicate the sculptures and devoted himself to carving in the late 1960s, though he continued to farm. His early work was mainly small animals, but after his encounter with Tolson's work, he began to include biblically inspired human figures. His later creations are human-animal hybrids based on mythology.

Since 1987, both Patton's art- and farmwork have been limited because of arthritis, yet he still creates carved subjects on broad themes ranging from rural life to patriotism. The human figure is the dominant form in Patton's work.

Sources consulted:

Morehead State University. *Local Visions: Folk Art from Northeast Kentucky*. Morehead, Ky.: Folk Art Collection, Morehead State University, 1990.

Oppenhimer, Ann. *Unto the Hills: Folk Art of Eastern Kentucky*. Richmond, Va.: Marsh Gallery, University of Richmond, 1989.

Patton, Betty. Telephone conversation with Laura E. Pass. August 20, 1996.

Rosenak, Chuck, and Jan Rosenak. *Museum of American Folk Art Encyclopedia of Twentieth-Century American Folk Art and Artists*. New York: Abbeville Press, 1990.

Elijah Pierce

b. 1892 in Baldwyn, Mississippi

d. 1984 in Columbus, Ohio

Born to an intensely religious farmer, Pierce began to create while young, carving animals and names on tree trunks at age eight. Not long after, he made his first walking stick. Pierce learned to barber at a young age because he did not want to farm, and from 1908 to 1916, he was employed in that trade, in addition to a variety of other jobs.

After his first wife's death in 1915, Pierce traveled throughout the country while working for the railroad. In 1920, he was issued a license to preach, though he did not begin preaching consistently until the 1930s and 1940s. He remarried in 1923, moved to Columbus, Ohio, and again began work as a barber. In Columbus, he created the first of many animal carvings, continuing to make wooden biblical scenes through the next decade. His early art consists of small, three-dimensional carvings mounted to cardboard; this form eventually evolved into wooden reliefs. In 1932, Pierce completed what is revered today as his masterpiece—a book of thirty-three wood carvings, each representing a scene in Christ's life.

In 1954, Pierce built his own barbershop. It had two rooms—one for cutting hair and the other for carving wood—and by 1969, the woodshop officially had become Pierce's gallery. Pierce retired from barbering in 1978, devoting himself to his art. By his death in 1984, Pierce and his religiously inspired carvings had become known internationally through exhibits, articles, awards, and a documentary.

Sources consulted:

Columbus Museum of Art. *Elijah Pierce: Woodcarver.* Columbus, Ohio: Columbus Museum of Art, 1992.

Horwitz, Elinor Lander. *Contemporary American Folk Artists.* Philadelphia: J. B. Lippincott Co., 1975.

"Sermons in Wood." *Ebony* (July 1974), pp. 67–74.

Melissa Polhamus

b. 1957 in Ludwigsburg, Germany

Currently living in Virginia Beach, Virginia

At eighteen months, Polhamus immigrated with her family to America. She was reared on the East Coast and has worked at a variety of jobs, from greenkeeper to information analyst. Polhamus began to draw in 1990 after a forced retirement. She continues to create today in between sporadic periods of employment. Her early work was executed in pen and ink, and her more recent pieces include crayon, watercolor, and colored ink. Polhamus's style incorporates fragmented, colored, and highly detailed patterns that often suggest anguish and struggle.

Sources consulted:

Gordon, Ellin, and Baron Gordon. Artist files.

————. *Virginia Originals.* Virginia Beach, Va.: Virginia Beach Center for the Arts, 1994.

Rosenak, Chuck, and Jan Rosenak. *Contemporary American Folk Art: A Collector's Guide.* New York: Abbeville Press, 1996.

Smith, Mike. "Melissa Polhamus." *Folk Art Finder,* XIV, no. 3 (July–September 1993), p. 13.

Norman Scott ("Butch") Quinn

b. 1939 in Oil City, Pennsylvania

Currently living in Oil City, Pennsylvania

At fifteen, Quinn's mother died, leaving him in the care of his alcoholic father. Today, Quinn continues to lead a lifestyle of hardship and poverty, even though he achieved artistic recognition in the late 1970s. One source suggests that he has lived in the same three-bedroom apartment, without insulation or heat, since 1975. Because of ill health, Quinn has difficulty finding employment; he often supports himself on the street and through public assistance.

Quinn has always been aware of the art in his environment, but it was a high school mechanical-drawing class that fostered his interest in creating and provided him with technique. Quinn resisted traditional representation and concentrated on abstraction in his drawings at that time. He began to paint in 1974. By 1978, his work had begun to receive attention. Quinn paints canvases and makes assemblages by incorporating found objects, from rubber bands to chair springs to his refrigerator. The subjects of Quinn's work—animals, people, birds, and farmscapes—are commonplace, but he depicts everyday objects in unusual combinations with elements of fantasy and reality. He is influenced by popular science magazines, comic books, church stained-glass windows, and popular radio music.

Sources consulted:
Abby Aldrich Rockefeller Folk Art Center. Artist files.
Gordon, Ellin, and Baron Gordon. Artist files.
Lavitt, Wendy. *Animals in American Folk Art*. New York: Alfred A. Knopf, 1990.
Quinn, Fred. Telephone conversation with Laura E. Pass. August 14, 1996.

David E. ("Dave") Rawlings

b. 1917 in Washington, D. C.

Currently living in Roanoke, Virginia

After serving in World War II, Rawlings attended the University of Maryland, from which he graduated with a degree in zoology. He obtained work with the Maryland Forestry Service and remained there for thirty years. During that time, he lived near both the Chesapeake Bay and the Potomac River. Rawlings has always had a deep interest in the outdoors, and upon his retirement in 1979, he began to carve walking sticks devoted to such subject matter. In late 1986, he and his wife moved to the Blue Ridge Mountains of Virginia, where they currently reside. His canes depict mostly reptiles and birds, such as snakes, alligators, and owls.

Sources consulted:
Rawlings, Mr. and Mrs. David E. Telephone conversation with Laura E. Pass. July 12, 1996.

Ernest ("Popeye") Reed

b. 1919 in Jackson, Ohio

d. 1985 in Fort Jackson, South Carolina

Reed had both Native American and Irish ancestors. He began to carve at the age of seven or eight, whittling small animals and reptiles. By age fourteen, he had left home to work in a sawmill and a cabinet shop. In 1964, he divorced and moved into a trailer, for which he made all of his own furniture. At this time, he started making and selling Native American objects. One source suggests that he was motivated to enter the tourist trade by selling a fake Daniel Boone bowl as a genuine artifact. He continued to work in wood, making objects such as friezes, small animals, Indians, and mythological figures (some of which are life-size). He was inspired by popular media and interested in Greek mythology and his Native American ancestry. In 1968, he concentrated on stone, utilizing local sand- and limestone in both sculpture-in-the-round and relief.

Sources consulted:

Barrett, Didi. *Muffled Voices: Folk Artists in Contemporary America.* New York: Museum of American Folk Art at the Paine Webber Art Gallery, 1986.

Lavitt, Wendy. *Animals in American Folk Art.* New York: Alfred A. Knopf, 1990.

Ricco, Roger, and Frank Maresca. *American Primitive: Discoveries in Folk Sculpture.* New York: Alfred A. Knopf, 1988.

Rosenak, Chuck, and Jan Rosenak. *Museum of American Folk Art Encyclopedia of Twentieth-Century American Folk Art and Artists.* New York: Abbeville Press, 1990.

Ron Steve Rodriguez

b. 1968 in Santa Fe, New Mexico

Currently living in Santa Fe, New Mexico

Rodriguez has been carving since he was eight years old. The grandson of Felipe Archuleta (1910–1991) and the nephew of Leroy Archuleta (b. 1949; see also the separate entry in this catalog), Rodriguez used to spend the summers in Tesuque, New Mexico, assisting the two in their shop. He credits both relatives with providing a strong influence of

traditional Hispanic art. Rodriguez's work, however, transcends tradition, incorporating a variety of materials from baling wire to bottle caps. Though he has previously created pottery and jewelry and has carved faces, he prefers to concentrate on his painted wood carvings of reptiles and animals.

Sources consulted:

Museum of American Folk Art. *Ape to Zebra: A Menagerie of New Mexican Woodcarvings, the Animal Carnival Collection of the Museum of American Folk Art.* New York: Museum of American Folk Art, 1985.

DeBouzek, Jeanette. "Animal Woodcarvers in Northern New Mexico Speak about Their Art in Dana Everts-Boehm's 'New Mexican Hispano Animal Carving in Context.'" *Clarion,* XVI, no. 2 (Summer 1991), pp. 36–40.

Anthony Joseph ("Tony Joe") Salvatore

b. 1938 in Youngstown, Ohio

d. 1994 in Youngstown, Ohio

Salvatore was the son of a Roman Catholic Italian immigrant. His father owned a grocery store and enjoyed masonry and cement work as a hobby, drawing and creating colorful designs on sidewalks. From a young age, Salvatore was interested in art, and during his junior high school years, he pursued art classes there and at the Butler Institute of Art.

Salvatore claimed that God spoke to him at age nine. This experience led him to use his artistic talents to spread the Gospel. At age sixteen, he quit school and devoted himself to religious interests. At twenty, he joined a Pentecostal sect. In 1973, after undergoing several spinal operations because of an auto accident, he began to concentrate on his art. From 1975 to 1981, he took correspondence classes from a bible college and was ordained by 1981. (One source suggests that he began to paint after a series of illnesses confined him to a nursing home, and that he then attended Youngstown State University, taking classes in art, philosophy, and religion while also working in a laundry.)

Nonetheless, Salvatore's interest in his art gradually became more intense, especially in 1979, when he discovered the Lamsa Bible, an English translation of the Aramaic Bible. Salvatore's work is highly symbolic and religious. Though he sketches the initial images onto the support himself, he depends on God to guide the rest of the painting. Working on linen canvas or paper, he uses acrylics, oil pastels, and multiple layers of wax.

Sources consulted:

Akron Art Museum. *Pillar of Fire: The Visionary Art of Anthony Joseph Salvatore.* Akron, Ohio: Akron Art Museum, n.d.

Horwitz, Elinor Lander. *Contemporary American Folk Artists.* Philadelphia: J. B. Lippincott Co., 1975.

Maresca, Frank, and Roger Ricco. *American Self-Taught: Paintings and Drawings by Outsider Artists.* New York: Alfred A. Knopf, 1993.

Milwaukee Art Museum. *Common Ground/Uncommon Vision: The Michael and Julie Hall Collection of American Folk Art.* Milwaukee, Wis.: Milwaukee Art Museum, 1993.

"Miniatures." *Folk Art,* XX, no. 1 (Spring 1995), pp. 25–26.

Rosenak, Chuck, and Jan Rosenak. *Museum of American Folk Art Encyclopedia of Twentieth-Century American Folk Art and Artists.* New York: Abbeville Press, 1990.

Helen Salzberg

b. 1923 in New York City

Currently living in New York City

Salzberg has had varied exposure to academic art. She has always been interested in art, but as a young adult, her family did not feel a career in the arts was suitable for her. She consequently obtained her undergraduate and graduate degrees in business at New York University, but she participated in evening art classes to satisfy her interest in creativity. Salzberg has also taken a number of studio classes at local art centers and institutions. She conducts her own art demonstrations and has a special interest in instructing the elderly. She uses a variety of mediums and techniques, such as paint, clay, paper, collage, graphics,

and mixed media, to create religious scenes. In addition to her artwork, she designs covers for brochures and has illustrated books for various organizations on the East Coast. Currently, Salzberg concentrates on painting recycled furniture.

Sources consulted:
Gordon, Ellin, and Baron Gordon. Artist files.

Paulina Santiliz

b. 1925 in Puerto Rico

d. 1987 in New York City

Santiliz did not begin creating artwork until late in life, but once started, she was devoted. She began drawing while participating in a Manhattan art workshop and continued to work on her own. She sometimes drew throughout the night. Santiliz was apparently extremely proud of her dedication to her art and her accomplishments. She often showed people the calluses formed on her hands from drawing. She preferred to use colored pencils; the densely applied color sometimes gives her work the appearance of oil pastels. In addition to her interest in art, Santiliz performed in a community theater as a singer and dancer.

Sources consulted:
Gordon, Ellin, and Baron Gordon. Artist files.
Schuss, Kerry. Telephone conversation with Laura E. Pass. July 10, 1996, and August 8, 1996.

John ("Jack") Savitsky

b. 1910 in Silver Creek (now New Philadelphia), Pennsylvania

d. 1991 in Coaldale, Pennsylvania

Self-named "Coal Miner Jack," Savitsky was born to a coal-mining family. He left school at age twelve to gain employment cracking coal. Despite claims to the contrary, he did not work as a slate picker. In 1932, he married and continued working in the mines as a mucker (the person responsible for removing mine waste). At that time, he also continued his childhood interest in art and supplemented his income by painting signs and murals for local bars. In addition, he often exchanged his services for alcohol. By the 1940s, he had become a contract miner. Savitsky worked until 1959, when the mine closed. Because of poor health, he was encouraged to retire, and later that year, he began to paint. His early works were mostly landscapes, until local patron Sterling Strauser suggested he portray

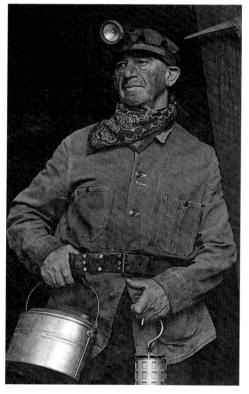

events that related to his own experiences. Savitsky adapted his subject matter to incorporate what he is best known for—the life of a coal miner. In 1984, Savitsky turned away from oil painting on his doctor's

advice and focused on drawing until his death. Today, his work serves an important role in documenting the Pennsylvania coal mines of the first half of the twentieth century.

Sources consulted:

Abby Aldrich Rockefeller Folk Art Center. Artist files.

Maresca, Frank, and Roger Ricco. *American Self-Taught: Paintings and Drawings by Outsider Artists.* New York: Alfred A. Knopf, 1993.

Rosenak, Chuck, and Jan Rosenak. *Contemporary American Folk Art: A Collector's Guide.* New York: Abbeville Press, 1996.

Savitt, Mary Lou, and Jack Savitt. "Jack Savitsky (1910–1991)." *Folk Art Finder,* XIII, no. 2 (April–June 1992), cover, p. 2.

———. Telephone conversation with Laura E. Pass, August 14, 1996.

Trechsel, Gail Andrews, ed. *Pictured in My Mind: Contemporary American Self-Taught Art from the Collection of Dr. Kurt Gitter and Alice Rae Yelen.* Birmingham, Ala.: Birmingham Museum of Art, 1995.

Jon Serl

b. 1894 in Olean, New York

d. 1993 in Lake Elsinore, California

Born to a family of vaudeville performers, Serl spent most of his years traveling throughout the country. By age ten, he had joined his parents on stage as a singer and dancer. Sources are inconsistent regarding the next few years of his life. It appears that he left his family in Texas in 1913 and fled to Mexico to escape World War I. Soon after, he reunited with his family in New York City, where they remained until 1915, when they moved to Denver, Colorado. During this time, Serl performed as a female impersonator.

In the early 1930s, Serl moved to Hollywood to pursue a career in film. While there, he acted, danced, sang, and, later, wrote and produced books and screenplays. He also adopted several names, from Joseph Searles (said to be his birth name) to Jerry Palmer. At the time of World War II, he is thought to have fled to British Columbia, where he may have started to create small objects. In 1949, he moved south and worked as a gardener and general repairman in Laguna Beach, California, moving in the early 1960s to San Juan Capistrano. He started painting in the latter locale because he could not afford to buy a painting for the wall of his home. In 1971, Serl moved to his final residence, in Lake Elsinore, California, where he spent his remaining years painting reflections of the past, people from the present, and visions of the future. Serl's works often incorporated salvaged and found materials.

Sources consulted:

Art Galleries of Ramapo College. *Jon Serl: Painter.* Mahwah, N. J.: Ramapo College of New Jersey, 1986.

"Jon Serl, 98, Painter; Used Scraps as Canvas." *New York Times,* July 1, 1993, Obituary section.

McKenna, Kristine. "Inside the Mind of an Artistic Outsider." *Los Angeles Times,* November 12, 1989, Calendar section.

Rosenak, Chuck, and Jan Rosenak. *Museum of American Folk Art Encyclopedia of Twentieth-Century American Folk Art and Artists.* New York: Abbeville Press, 1990.

Trechsel, Gail Andrews, ed. *Pictured in My Mind: Contemporary American Self-Taught Art from the Collection of Dr. Kurt Gitter and Alice Rae Yelen.* Birmingham, Ala.: Birmingham Museum of Art, 1995.

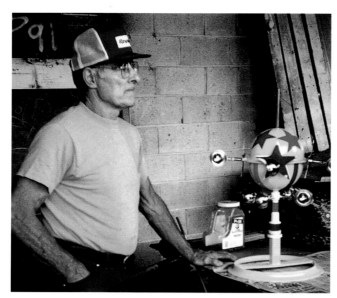

Vollis Simpson

b. 1919 in Lucama, North Carolina

Currently living in Lucama, North Carolina

Simpson has spent most of his life surrounded by farm equipment. He was drafted during World War II and devoted four years to the United States Army Air Corps in the Mariana Islands. While there, he built a windmill to power his washing machine. After the war, Simpson returned home and worked as a mechanic and also moved heavy machinery and homes with both large trucks and adapted equipment. He continued his interest in wind power and designed and built a windmill to heat his home. In 1952, he opened his own machinery shop that repaired mainly farm equipment.

By the late 1960s, Simpson had started to create things from the leftover machine parts that he had collected over the years. The discovery of an old bicycle frame inspired him to create large-scale windmills and whirligigs. In 1985, Simpson retired from his house-moving business. Today, he continues to build creations up to forty feet high from discarded materials, such as scrap metal, fiberglass, industrial parts, machines, and donated highway reflectors. Recently, Simpson created a commission for the 1996 Atlanta Olympics.

Sources consulted:

Joel, Jane M. "Vollis Simpson: The Don Quixote of East-Central North Carolina." *Folk Art Messenger,* IX, no. 3 (Spring 1996), pp. 1, 3.

Manley, Roger. *Signs and Wonders: Outsider Art inside North Carolina.* Raleigh, N. C.: North Carolina Museum of Art, 1989.

Patterson, Tom. *Not by Luck: Self-Taught Artists in the American South.* Milford, N. J.: Lynne Ingram Southern Folk Art, 1993.

"Vollis Simpson." *Folk Art Finder,* IX, no. 2 (April–June 1988), pp. 4–5.

Herbert Singleton

b. 1945 in New Orleans, Louisiana

Currently living in New Orleans, Louisiana

In his youth, Singleton spent much of his time on the banks of the Mississippi River, creating snakes from mud and driftwood. He was the oldest of eight children. His father left the family when Singleton was ten years old; a few years later, Singleton dropped out of school and started to spend time on the streets. By 1975, he had begun to carve ax handles into canes with the hope of selling or exchanging them

for drugs. They were called "Killer Sticks" after someone was beaten to death with one. Between the years 1967 and 1986, Singleton was arrested on drug charges and sentenced to prison for thirteen years. Upon his

release, he decided to record his life events on found wood, such as driftwood and discarded furniture, carving in 3-D and relief. His work reflects his deep interest in contemporary and historical African-American life as well as social, political, and religious themes.

Sources consulted:

Columbus Museum of Art. *Elijah Pierce: Woodcarver*. Columbus, Ohio: Columbus Museum of Art, 1992.

Patterson, Tom. *Not by Luck: Self-Taught Artists in the American South*. Milford, N. J.: Lynne Ingram Southern Folk Art, 1993.

Wake Forest University Fine Arts Gallery. *Diving in the Spirit*. Winston-Salem, N. C.: Wake Forest University Fine Arts Gallery, 1992.

Robert Eugene Smith

b. 1927 in Saint Louis, Missouri

Currently living in Springfield, Missouri

Though Smith enjoyed art at a young age, his primary aspiration was to be a singer. After the death of his father in 1935, Smith went to live with an uncle instead of with his mother and alcoholic stepfather. He remained with his uncle until 1939. Smith is said to have moved in search of employment quite often throughout his life. The jobs he has held include positions at a publishing company, a restaurant, and a hospital. In 1948, he joined the army but was medically discharged because of a heart infection. In the 1950s, side effects from his drug treatment prevented him from working. While under the care of his mother, Smith was admitted to a local mental hospital, which provided less expensive treatment than home care. During the sixteen years he spent in that institution, he is said to have developed institutional behavior patterns that reflect his long-term hospitalization. These patterns are evident in his paintings. His cartoonlike paintings and drawings represent elements of both reality and fantasy, though they are often autobiographical. Upon his release, Smith gained employment with the hospital, where he provided menial labor for the next seven years.

Sources conflict as to when Smith began painting, but he exhibited his work at the Missouri State Fair in the 1970s. His chosen medium is acrylic and watercolor on poster board, paper, and sometimes wooden furniture that he has constructed himself. Smith considers himself an instrumentalist, a performance artist, and a poet in addition to a visual artist, and he often complements his art with accompanying stories. In addition, he published a book of his poems in 1987.

Sources consulted:

Barrett, Didi. *Muffled Voices: Folk Artists in Contemporary America*. New York: Museum of American Folk Art at the Paine Webber Art Gallery, 1986.

Payton, Crystal. "Portrait of Robert Eugene Smith." *Maine Antique Digest*, October 1993, sec. C, pp. 8–10.

Prince, Dan. *Passing in the Outsider Lane: Art from the Heart of Twenty-One Self-Taught Artists*. Boston, Mass.: Charles E. Tuttle Co., Journey Editions, 1995.

"Robert E. Smith." *Folk Art Finder*, IX, no. 3 (July–September 1988), cover, p. 13.

Rosenak, Chuck, and Jan Rosenak. *Museum of American Folk Art Encyclopedia of Twentieth-Century American Folk Art and Artists*. New York: Abbeville Press, 1990.

Oscar Lipscomb ("O. L.") Spencer

b. 1908 in Franklin County, Virginia

d. 1993 in Blue Ridge, Virginia

Born and raised in a family of anthracite miners, Spencer continued in the tradition of his family and entered the mines at age eighteen. At age twenty, he lost his leg in an accident, thus ending his mining career quite early. He then worked as a housepainter and rabbit breeder. He was inspired to create during a hunting trip, after he encountered a copperhead snake that bit his artificial leg. Spencer went home and bent a crowbar into the shape of the snake, carved a wooden head and tail for it, and covered it with black rubber. He placed his creation in the grass to surprise his wife, who mistook it for a real snake, thus beginning his artistic career. Spencer focused on realistic portrayals of indigenous Virginia snakes; his flea-market friends called him "Old Snake." He combed the woods for branches that naturally conformed to a snake's shape, then carved them, removing the knots and adorning the forms with glass beads, plastic wire, and sometimes rattlesnake rattles. In addition, Spencer often used a handmade tool of his own devising to create the appearance of scales.

Sources consulted:

Gordon, Ellin, and Baron Gordon. *Virginia Originals.* Virginia Beach, Va.: Virginia Beach Center for the Arts, 1994.

Lampell, Ramona, and Millard Lampell. *O, Appalachia: Artists of the Southern Mountains.* New York: Stewart, Tabori & Chang, 1989.

Wimmer, Martha. Telephone conversation with Ellin Gordon. August 30, 1996.

Jimmy Lee Sudduth

b. 1910 in Caines Ridge, Alabama

Currently living in Fayette, Alabama

One story recounts that Sudduth began creating at the age of four, when he molded mud in the shape of a dog onto a recently cut stump. His partly Native American mother later noticed that the image was still intact and encouraged him to create, regarding it as a good sign. Another version of Sudduth's artistic origins is that when he was ten years old, he painted mud images on the side of his home. After the rain, his pictures disappeared until he combined molasses from a nearby sorghum mill with the mud, thus prolonging the works' existence.

Sudduth has painted throughout his life, even as he worked as a gardener and at other odd jobs for money. His early work consists of homemade paint on found objects. This paint was a concoction of dirt, sugar, and a variety of vegetable matter, such as berries and tree buds, extracted for color. He also used axle grease and lawnmower exhaust deposits. His basic subject matter is local buildings and cityscapes, although in the mid-1980s, he broadened it to include native Alabamian animals, historical events, and people. He

also began using house paint, the medium he now prefers. In addition, Sudduth depicts transportation vehicles, from trains to bikes to farm carts.

Sources consulted:
Fayette County (Ala.) Broadcaster, September 23, 1971.
Gordon, Ellin, and Baron Gordon. Artist files.
Hood, John. "Jimmy Lee Sudduth." *Folk Art,* XVIII, no. 4 (Winter 1993–1994), pp. 47–51.
Maresca, Frank, and Roger Ricco. *American Self-Taught: Paintings and Drawings by Outsider Artists.* New York: Alfred A. Knopf, 1993.
Patterson, Tom. *Not by Luck: Self-Taught Artists in the American South.* Milford, N. J.: Lynne Ingram Southern Folk Art, 1993.
Sellen, Betty-Carol. *20th Century American Folk, Self Taught, and Outsider Art.* New York: Neal-Schuman Publishers, 1993.
Trechsel, Gail Andrews, ed. *Pictured in My Mind: Contemporary American Self-Taught Art from the Collection of Dr. Kurt Gitter and Alice Rae Yelen.* Birmingham, Ala.: Birmingham Museum of Art, 1995.

Moses Earnest ("Mose") Tolliver

b. 1921 in Montgomery County, Alabama

Currently living in Montgomery, Alabama

One of twelve children born to farm laborers, Tolliver left school at the age of eight or nine to work as a produce truck farmer and possibly a launderer. In the 1930s, his father died; his family then moved to the city, where Tolliver helped support them with various jobs in gardening and general maintenance. In the early 1940s, Tolliver married and served in the army for a brief stint, provoking a discharge so he could return home. For the next twenty-five years, he earned a living through routine yard- and housework for the McLendon family, and he was also employed at the McLendon's Furniture Company. In the late 1960s, Tolliver suffered a disabling injury when a forklift dropped a crate of marble on him, and he was forced to stop working.

One story maintains that after a slow recovery and a period of depression, Tolliver was encouraged to paint by his previous shop manager. Another source states that he began to create on his own initiative after viewing works by the manager. Tolliver's early work used an odd assortment of colors because he was limited to donated paints. He depicted birds and flowers on a variety of surfaces, from metal trays to plywood packing crates, until the 1980s, when he expanded his subject matter to include animals, reptiles, and people, including self-portraits. Since then, his medium has changed from oil paint to water-based latex paint, and though his palette has remained limited, he now selects his own colors. Tolliver paints on plywood and found objects and is inspired by his childhood, African culture, and southern folklore. Some of his figural paintings are erotic, emphasizing awkward positions and including phallic objects, but most of them incorporate his characteristic open-mouthed people.

Sources consulted:
Abby Aldrich Rockefeller Folk Art Center. Artist files.
Fowler, Miriam Rogers, comp. *Outsider Artists in Alabama.* Montgomery, Ala.: Alabama State Council on the Arts, 1991.
Haart, Anton. "Mose Tolliver Goes to Washington." *Raw Vision,* XII (Summer 1995), pp. 22–29.
Kemp, Kathy. *Revelations: Alabama's Visionary Folk Artists.* Birmingham, Ala.: Crane Hill Publishers, 1994.
Kogan, Lee. "Mose Tolliver: Picture Maker." *Folk Art,* XVIII, no. 3 (Fall 1993), pp. 44–56.
Patterson, Tom. *Not by Luck: Self-Taught Artists in the American South.* Milford, N. J.: Lynne Ingram Southern Folk Art, 1993.

Philip Travers

b. 1914 in New York City

Currently living in New York City

Travers has been drawing since his youth. He participated in classes at the Art Students League but refused to use watercolor and dropped out of a particular session taught by the American painter George Grosz. He has been employed in a variety of positions, such as nurse and research chemist, and he has experience with sign painting, show card design, and photographic lab work. He is interested in the occult, astrology, science fiction, and Egyptian antiquities, all of which are reflected in his work. Since 1984, Travers has drawn a series of works entitled the "Tut Project," a narrated journey in which he (referring to himself as "Mistaire Travaire"), King Tut, and Alice in Wonderland are participants. His drawings are created in a cartoonlike manner and include lengthy narratives.

Sources consulted:
Artists Space. *Art's Mouth.* New York: Artists Space, 1991.
Rosenak, Chuck, and Jan Rosenak. *Contemporary American Folk Art: A Collector's Guide.* New York: Abbeville Press, 1996.

Nelson Tygart

b. 1961 in Auburn, California

Currently living near Oakland, California

Nothing is known about Tygart's youth or young-adult life before 1983. Since then, he has participated in art programs sponsored by Creative Growth Industries of Oakland, California. He works part-time at a custodial job with Ace Hardware and spends the rest of his time on his art. Tygart's work always depicts animals, yet it seems to change depending on his medication: the stronger the prescription, the tamer his animals appear. His forms of expression vary from printmaking to drawing, but all reflect his energy and enthusiasm.

Sources consulted:
Creative Growth Art Center. Faxes. June 24, 1996, and June 28, 1996. Now in Abby Aldrich Rockefeller Folk Art Center files.

John Vivolo

b. 1886 in Accri, Italy

d. 1987 in Hartford, Connecticut

The son of a farm laborer, Vivolo spent much of his youth assisting his family with animals and doing field work. By the time he was fourteen, his parents had sent him to the United States, where he gained employment in the West Virginia coal mines. In 1903, Vivolo worked in railroad construction, then moved north to New York City. He worked briefly for a bakery, migrated up-state to work in a butcher shop, then returned to Italy at age twenty. He mar-

ried abroad. Soon after, the couple moved to Hartford, Connecticut, where in 1907, Vivolo worked in construction. He saved enough money to purchase his own land in 1910, and in 1916, he built two homes, as the first was destroyed by fire. In 1931, his wife died, leaving him totally responsible for seven children. While Vivolo worked as a mason, the children assisted financially with odd jobs. In 1950, Vivolo built his third home after the previous one was damaged by a flood. He retired in his early seventies and began to carve. His representational figures (or "wooden children," as he called them) range in height from fourteen to thirty-six inches, and his subject matter includes musicians, astronauts, and animal riders. His figures typically reach out with open arms.

Sources consulted:

Laffal, Ken. *Vivolo and His Wooden Children*. Essex, Conn.: Gallery Press, Inc., 1976.

Rosenak, Chuck, and Jan Rosenak. *Museum of American Folk Art Encyclopedia of Twentieth-Century American Folk Art and Artists*. New York: Abbeville Press, 1990.

Inez Stedman Nathaniel Walker

b. 1911 in Sumter, South Carolina

d. 1990 in Willard, New York

By her teenage years, Walker had lost both her parents, married, and borne four children. In the 1930s, she moved to Philadelphia, where she obtained factory work. She remained there until 1949, when she moved to upstate New York. Walker was employed as a migrant worker until 1971, when she was sentenced to prison for murder. During her first year in prison, she began to draw; her early work was done on the back of prison newspapers and was first noticed by her English teacher. Sources disagree on the length of Walker's imprisonment, but in 1975, she remarried and returned to field work. In 1980, she withdrew from society, and in 1986–1990, she lived sporadically in a psychiatric center, where she later died. Walker's works depict her prison years. Her subjects focus on the women she encountered there, though they do not represent anyone in particular. Her drawings are characterized by close attention to detail, and her creative process was particular, as she started each work with the face of her subject, using the eyes as focal points, then worked down the body to finish at the feet or the bottom of the paper.

Sources consulted:

Horwitz, Elinor Lander. *Contemporary American Folk Artists*. Philadelphia: J. B. Lippincott Co., 1975.

Livingston, Jane, and John Beardsley. *Black Folk Art in America, 1930–1980*. Jackson, Miss.: University Press of Mississippi and the Center for the Study of Southern Culture for the Corcoran Gallery of Art, 1982.

"Outsider Artist Inez Walker Dies." *Antiques and the Arts Weekly*, August 17, 1990, p. 54.

Rosenak, Chuck, and Jan Rosenak. *Museum of American Folk Art Encyclopedia of Twentieth-Century American Folk Art and Artists*. New York: Abbeville Press, 1990.

Hubert Walters

b. 1931 in Kingston, Jamaica

Currently living in Troutman, North Carolina

Walters's father died when the artist was two and one-half years old, leaving him in the care of his Jamaican grandparents. During his youth, he spent much time with his grandfather, learning carpentry and masonry. In his twenties, he worked as a fisherman, built his own boat, and eventually owned a boat-rental business. Walters also tried his hand at canvas painting during this time. A few years later, at age thirty, Walters became active with the Jehovah's Witnesses, and by 1971, he had immigrated to America to marry a woman from New York City. The couple lived in Harlem while he worked in a cabinet shop until the mid–1970s, when they moved to North Carolina. There, Walters gained employment in a textile mill and furniture factory.

In the late 1980s, Walters moved back to New York for work. There, he experimented with making three-dimensional objects in metal, wood, and auto putty. During his previous stay, Walters had begun making miniature replicas of Jamaican fishing boats. But after his second visit (of only one and one-half year's duration), it was necessary to rent a vehicle in order to transport all of his art when he moved back to North Carolina. His work expanded to include subjects and materials such as people from his past, birds, animals, and clocks. His three-dimensional clocks include both faux-painted and battery-operated dials, and the people he portrays are characteristically humorous, often depicted from the waist up. Walters's work is usually painted white with few details.

Sources consulted:

Gordon, Ellin, and Baron Gordon. Artist files.

Rosenak, Chuck, and Jan Rosenak. *Contemporary American Folk Art: A Collector's Guide.* New York: Abbeville Press, 1996.

Trechsel, Gail Andrews, ed. *Pictured in My Mind: Contemporary American Self-Taught Art from the Collection of Dr. Kurt Gitter and Alice Rae Yelen.* Birmingham, Ala.: Birmingham Museum of Art, 1995.

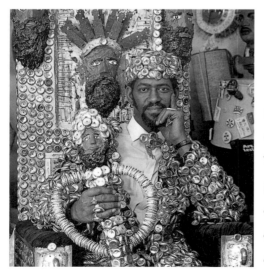

Gregory Warmack ("Mr. Imagination" or "Mr. I")

b. 1948 in Chicago, Illinois

Currently living in Chicago, Illinois

Warmack has always been artistic and was encouraged by his mother to pursue his creative instincts from an early age. His mother commissioned his first work, which was a sign for their church. Warmack also collected found objects, made jewelry and hats, and painted on cardboard. Throughout his life, he has worked in a variety of professions, from food service to construction. In addition to his own artistic endeavors, Warmack has encouraged neighborhood children to create alongside him, and in the 1970s, he held an art show for the neighborhood, displaying everyone's efforts.

Warmack worked part-time on the porch of his home, at first creating jewelry and handicrafts to be

sold on the street. After he was assaulted and injured in 1978, he began to create full-time. In 1980, he began using leftover industrial sandstone, carving themes of African and Egyptian royalty. In 1988, Warmack's work shifted to include bottle caps after he received donated bucketfuls. He created an entire bottle-cap outfit, including a hat and staff. He has also used other found objects, such as nails and cardboard cylinders, which became the foundation of a 1992 totem pole series. In 1993, he expanded the makeup of his totem poles to include discarded paintbrushes and brooms in the form of three-dimensional figures and faces. In 1995, assisted by neighborhood children, Warmack completed a grotto made of cement, found objects, seashells, and mosaics. The grotto is one portion of a sculpture garden adorned and created by various artists for the Chicago Youth Center, Bronzville Youth Park. Warmack calls himself "Mr. Imagination" or "Mr. I" because of his creative visions.

Sources consulted:

Clark, Leslie. Telephone conversation with Laura E. Pass. August 21, 1996.

Dallas Museum of Art. *Black Art—Ancestral Legacy: The African Impulse in African-American Art.* Dallas, Tex.: Dallas Museum of Art, 1989.

Hobbs, Karen, with Chris Ruys and Christin Crampton. "Chicago Youth Center Sculpture Park." *Folk Art Finder,* XV, no. 4 (October–December 1994), pp. 4–9.

Patterson, Tom. *Reclamation and Transformation: Three Self-Taught Chicago Artists.* Chicago, Ill.: Terra Museum of American Art, 1994.

Myrtice Snead West

b. 1923 in Cherokee County, Alabama

Currently living in Centre, Alabama

Born and reared on a farm, West pursued artistic endeavors such as sewing, drawing, painting, and creating paper cutouts when she was not working in the fields. Some of her first works consisted of fingernail polish or paint made from water-soaked crepe paper on pasteboard. She continued to create after her marriage at age seventeen, but after a miscarriage in 1948, she changed her artistic focus from genre subjects such as boats and ducks to images of Christ. Over the years, West increasingly sought therapy in her religious work. Despite another miscarriage four years later and a series of surgeries, West gave birth to a daughter in 1957.

During World War II, West worked in the cotton fields to support an interest in photography. A photography class in her early twenties introduced her to the art of hand-coloring. West also participated in a painting class held at a local college, where she learned the basic principles of paint application and color. Before these courses, West did not know what paintbrushes, canvas, or oil paints were.

In the 1970s, West's daughter married an abusive boyfriend, and they relocated with their children to Japan. During this time, West began having nightmares about her daughter's safety. She also awoke one Sunday to find herself standing in the pulpit of an unfamiliar church. West recalls that a congregation member who knew her encouraged her to paint her biblical beliefs onto canvas. West had been studying the Bible until this point; after these events, she was motivated to paint her apocalyptic visions. A portrait of

Christ descending from the clouds executed on an old screen window and couch cover marks the first of fourteen original canvases devoted to the Book of Revelations in the Bible.

In the mid-1980s, West's daughter left her husband, moving back to the United States with her children, but was killed by him in 1986. Again, West focused on the painting of biblical stories as a means of surviving the traumatic incident. She has been painting ever since, and as of this writing, has finished two sets of Revelations paintings and twenty-one canvases illustrating the Book of Ezekiel. West has also recently completed her ninth painting devoted to the chapter of Daniel. West's work is detailed and literally transcribed from the Bible, taking months of preparation before the canvas is painted.

Sources consulted:

Fowler, Miriam Rogers, comp. *Outsider Artists in Alabama*. Montgomery, Ala.: Alabama State Council on the Arts, 1991.

Hoffberger, Rebecca, Roger Manley, and Colin Wilson. *Tree of Life*. Baltimore, Md.: American Visionary Art Museum, 1996.

Kemp, Kathy. *Revelations: Alabama's Visionary Folk Artists*. Birmingham, Ala.: Crane Hill Publishers, 1994.

West, Myrtice Snead. Telephone conversations with Laura E. Pass. October 23, 1996, October 31, 1996, and November 5, 1996.

Joseph Elmer Yoakum

b. 1886 or 1888 near Window Rock, Arizona

d. 1972 in Chicago, Illinois

Sources disagree on where Yoakum was born; the artist, however, was quoted as saying he was born in Arizona on land that was subsequently developed as a Navajo and Apache reservation. Yoakum claimed he was a full-blooded Native American and refuted assertions that he was African-American, although various sources say that he called himself an "old black man." He appears to have been skeptical of advertising any African-American heritage, fearing that if he did so, his art would become less desirable. At an early age, Yoakum moved east to Missouri with his family. From ages sixteen to twenty-five, he worked in various circus-related capacities, traveling extensively through Europe, China, Australia, and Canada with different performing groups. After his employment subsided, Yoakum continued to travel to places as far away as South and Central America and Mexico. During World War I, he was stationed in France; afterwards, he moved frequently, working at jobs ranging from a porter to a baseball player. Yoakum eventually settled in Chicago, Illinois, where he retired in the late 1950s.

At age seventy-six, Yoakum began to draw after receiving a vision from God. He moved in 1966, utilizing the location of his new home for his business needs by advertising his pictures on a clothesline in the storefront window. In 1971, he was hospitalized because of an illness and eventually entered a nursing home, where he died in late 1972.

Yoakum created both portraits and landscapes, although he is better known for the latter. His landscapes are based on his travels, his imagination, and inspiration from God, though there is skepticism over

how much of his work is based on actual experiences versus printed material. His early pieces contain little color; by 1964, however, Yoakum was experimenting with pastel and colored pencils.

Sources consulted:

Bonesteel, Michael. "The Drawings of Joseph Yoakum." *In'tuit,* IV, no. 1 (Summer 1995), pp. 1, 16–18.

Hirschl and Adler Modern. *Joseph Yoakum.* New York: Hirschl and Adler Modern, 1985.

INTAR Latin American Gallery. *Another Face of the Diamond: Pathways through the Black Atlantic South.* New York: INTAR Latin American Gallery, 1988.

Livingston, Jane, and John Beardsley. *Black Folk Art in America, 1930–1980.* Jackson, Miss.: University Press of Mississippi and the Center for the Study of Southern Culture for the Corcoran Gallery of Art, 1982.

Wilson, Cleo. "A Galaxy of New Stars Discovered at 'Eureka!'" *In'tuit,* II, no. 1 (Summer 1993), pp. 4–7.

Purvis Young

b. 1943 in Miami, Florida

Currently living in Miami, Florida

Young has lived his entire life in Miami, spending most of his youth on ghetto streets. At age eighteen, he was sentenced to prison for four years on armed robbery charges. While there, he received some art instruction, but he did not create on his own until age twenty-five. He began by drawing pictures of war scenes, then gradually expanded his work to include paint and discarded objects. Young's early work also included books, as the artist sometimes pasted his drawings onto book pages after using the volumes to store his pieces. He also creates mixed-media works and assemblages, utilizing found objects as structural supports, frames, and surface decoration.

Young's first large-scale work probably was completed in 1973. (One source suggests it was completed in the late 1960s). This public project simulated a mural and consisted of multiple painted panels attached to the outside of a condemned building. In the 1980s, Young received a variety of commissions to paint inside and outside wall murals.

The subject of Young's work is taken from his experiences and observations of Miami urban life. His themes range from illegal immigration to class struggle, and his subjects include street musicians and prostitutes. Young's art is often highly symbolic, and his style has been influenced by other artists, ranging from the old masters to contemporary practitioners.

Sources consulted:

Joy Moos Gallery. *Purvis Young.* Miami, Fla.: Joy Moos Gallery, 1993.

————. Purvis Young, *Me and My People.* Miami, Fla.: Joy Moos Gallery, 1989.

Trechsel, Gail Andrews, ed. *Pictured in My Mind: Contemporary American Self-Taught Art from the Collection of Dr. Kurt Gitter and Alice Rae Yelen.* Birmingham, Ala.: Birmingham Museum of Art, 1995.

PHOTOGRAPHY CREDITS

All of the artists' photographs are details.

Minnie Adkins
Photo by Ellin Gordon.

Aghassi George Aghassian
Courtesy of Michael D. Hall.

Beverly ("Gayleen") Aiken, 1996
Photo by Don Sunseri, G.R.A.C.E., West Glover, Vt.

Leroy ("Lee") Almon, Sr., 1995
Photo by Ellin Gordon.

Leroy Ramon Archuleta
Photo by Warren Lowe.

Lillian Barker and Linvel Barker, 1990
Photo by Baron Gordon.

Geneva Beavers, 1990
Photo by Ellin Gordon.

Aaron Birnbaum, 1988
Photo by Chantal Regnault; courtesy of K. S. Art, New York, N.Y.

Georgia Blizzard, 1993
Photo by Ellin Gordon.

Freddie Brice, 1990
Photo by Kerry Schuss; courtesy of K. S. Art, New York, N.Y.

Richard Burnside
Photo by Ginger Young, Ginger Young Gallery, Chapel Hill, N. C.

David Butler
Photo by William Fagaly; courtesy of Gasperi Gallery, New Orleans, La.

Miles Burkholder Carpenter
Photo by Arthur Reed; courtesy of Miles B. Carpenter Museum, Archival Papers of C. Jane and Jeffrey Camp.

Henry Ray Clark
Photo by Warren Lowe.

Raymond Coins
Photo by Jimmy Hedges, Rising Fawn Folk Art, Lookout Mountain, Tenn.

Jessie Farris Dunaway Cooper, 1991
Photo by Charles W. Manion © 1991; courtesy of Owensboro Museum of Fine Art, Ky.

Ronald Everett Cooper, 1991
Photo by Charles W. Manion © 1991; courtesy of Owensboro Museum of Fine Art, Ky.

John William ("Uncle Jack") Dey, 1974
Photo by Joshua Horwitz; courtesy of Elinor L. Horwitz.

Thornton Dial, Sr., 1989
Photo by William Arnett; courtesy of Archer Locke Gallery, Atlanta, Ga.

Josephus Farmer, 1982
Photo by Joanne Cubbs.

Howard Finster
Photo by Jimmy Hedges, Rising Fawn Folk Art, Lookout Mountain, Tenn.

Tony Fitzpatrick
Photo by Noreen Betjemann; courtesy of Fleisher/Ollman Gallery, Philadelphia.

Victor Joseph ("Joe") Gatto, 1961
Photo by Jesse Weiss; courtesy of Epstein/Powell American Primitives, New York, N.Y.

Keith Goodhart, 1995
Photo by Singeli Agnew; courtesy of Cavin-Morris, Inc., New York, N.Y.

Denzil Goodpaster
Photo by Jimmy Hedges, Rising Fawn Folk Art, Lookout Mountain, Tenn.

Theodore ("Ted") Gordon, 1996
Courtesy of Theodore Gordon.

Carl Greenberg, 1988
Photo by Chantal Regnault; courtesy of K. S. Art, New York, N.Y.

Oscar E. Hadwiger
Copy photo by Allan Sprecher; courtesy of the American Visionary Art Museum, Baltimore, Md., and John and Stephanie Smither.

Ray Hamilton, 1990
Photo by Kerry Schuss, K. S. Art, New York, N.Y.

O'Tesia ("O.T.") Harper
Photo by Jimmy Hedges, Rising Fawn Folk Art, Lookout Mountain, Tenn.

Bessie Ruth White Harvey
Photo by Jimmy Hedges, Rising Fawn Folk Art, Lookout Mountain, Tenn.

William Lawrence Hawkins
Photo by Frank Maresca, Ricco/Maresca Gallery, New York, N.Y.

Lonnie Bradley ("Sandman") Holley
Photo by Jimmy Hedges, Rising Fawn Folk Art, Lookout Mountain, Tenn.

Robert Howell, 1996
Photo by Ellin Gordon.

Billy Ray Hussey, 1995
Photo by Michael E. Smith.

Levent Isik, 1996
Photo by M. L. Albrecht; courtesy of Frank J. Miele Gallery, New York, N.Y.

Anderson Johnson, 1989
Photo by Ellin Gordon.

Shields Landon ("S. L.") Jones, 1989 or 1990
Photo by Ellin Gordon.

Charles ("Charley") Kinney, 1982
Photo by Larry Hackley.

Tim Lewis
Photo by Jimmy Hedges, Rising Fawn Folk Art, Lookout Mountain, Tenn.

Dwight Mackintosh, 1993
Photo by Julie Polunsky; courtesy of Creative Growth Art Center, Oakland, Calif.

Mona McCalmon
Courtesy of Mona McCalmon.

Justin McCarthy, ca. 1970
Courtesy of Epstein/Powell American Primitives, New York, N.Y.

J. T. ("Jake") McCord, 1991
Photo by Jo Tartt, Jr., The Tartt Gallery, Washington, D. C.

Kenny McKay
Photo © Dona Ann McAdams; courtesy of Hospital Audiences, Inc., New York, N.Y.

Larry McKee, 1996
Photo by Larry Hackley.

Gaetana ("Thomas") Menna, 1988
Photo © Dona Ann McAdams; courtesy of Hospital Audiences, Inc., New York, N.Y.

Peter J. Minchell, 1972
Photo by Lew Alquist and Mary Jo Toles; courtesy of Mary Jo Toles.

Frances ("Lady Shalimar") Montague, 1988

Photo by Chantal Regnault; courtesy of K. S. Art, New York, N.Y.

Sister Gertrude Morgan, 1974

Photo by Guy Mendes; courtesy of Gasperi Gallery, New Orleans, La.

John B. ("J. B.") Murry

Courtesy of Research Material Concerning Untrained Artists, 1984–1986, Archives of American Art, Smithsonian Institution.

Earnest Patton (with family members)

Photo by Ellin Gordon.

Melissa Polhamus

Photo by Ellin Gordon.

Norman Scott ("Butch") Quinn, 1992

Courtesy of The Tartt Gallery, Washington, D. C.

David E. ("Dave") Rawlings, 1993

Photo by Howard Smith; courtesy of Carolyn Rawlings.

Ernest ("Popeye") Reed, 1973

Photo by Jeff Way; courtesy of K. S. Art, New York, N.Y.

Ron Steve Rodriguez

Photo by Warren Lowe.

Anthony Joseph ("Tony Joe") Salvatore

Photo by Randall Morris, Cavin-Morris, Inc., New York, N.Y.

Helen Salzberg, 1996

Photo by Ellin Gordon.

Paulina Santiliz (with Mark Davis), 1986

Photo by Chantal Regnault; courtesy of K. S. Art, New York, N.Y.

John ("Jack") Savitsky, 1978

Courtesy of Epstein/Powell American Primitives, New York, N.Y.

Jon Serl, 1987

Photo by Chantal Regnault; courtesy of Cavin-Morris, Inc., New York, N.Y.

Vollis Simpson

Photo by Ellin Gordon.

Herbert Singleton, 1996

Photo by Maurice O' Rourk, Barrister's Gallery, New Orleans, La.

Oscar Lipscomb ("O. L.") Spencer

Photo by Ellin Gordon.

Jimmy Lee Sudduth

Photo by Marcia Weber, Marcia Weber Art Objects, Inc., Montgomery, Ala.

Moses Earnest ("Mose") Tolliver, 1992

Photo by Marcia Weber, Marcia Weber Art Objects, Inc., Montgomery, Ala.

Philip Travers, 1996

Photo by Kerry Schuss, K. S. Art, New York, N.Y.

Nelson Tygart, 1995

Photo by Ron Kilgore; courtesy of Creative Growth Art Center, Oakland, Calif.

John Vivolo, 1976

Photo by Ken Laffal; courtesy of Folk Art Finder, Essex, Conn.

Inez Stedman Nathaniel Walker

Photo by Pat Parsons, Webb & Parsons, Burlington, Vt.

Hubert Walters

Photo by Ellin Gordon.

Gregory Warmack ("Mr. Imagination" or "Mr. I"), 1991

Photo by Ron Gordon; courtesy of Carl Hammer Gallery, Chicago.

Myrtice Snead West

Photo by Jimmy Hedges, Rising Fawn Folk Art, Lookout Mountain, Tenn.

Joseph Elmer Yoakum

Photo by Christina Ramberg; courtesy of Phyllis Kind Gallery, New York and Chicago.

Purvis Young

Photo by Jimmy Hedges, Rising Fawn Folk Art, Lookout Mountain, Tenn.

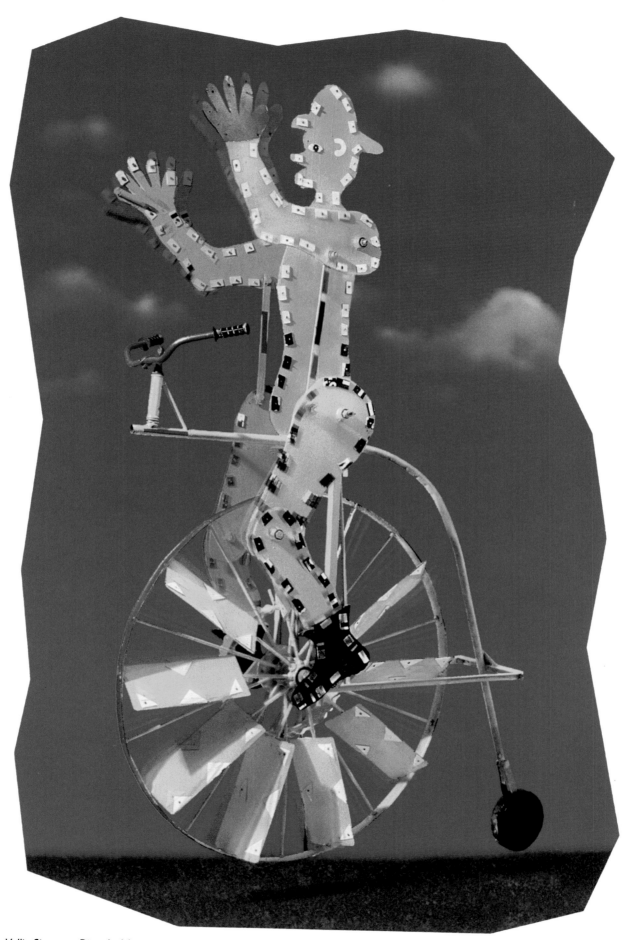

Vollis Simpson, Bicycle Man

Twentieth-century objects in the exhibit are listed alphabetically by the artists' names. Immediately thereafter is a list of the Gordons' nineteenth-century objects that are also on exhibit; among these, works by identified artists are first, followed by works by unidentified artists in order by date.

Locales listed beneath the objects' titles are the places where the objects are believed to have been made. Date lines reflect when the objects are believed to have been made.

Listed dimensions of two-dimensional objects are unframed, unless the frame was made or supplied by the artist and is considered integral to the piece, in which case the size is noted as being "framed." Dimensions designated "sight" reflect the portion of the primary support that is visible within the work's mat or frame.

Similarly, where applicable, integral, artist-made sculptural supports are reflected in the dimensions.

Throughout, height precedes width (the larger of the two horizontal dimensions), which precedes depth (the lesser of the two horizontal dimensions).

Minnie Adkins (b. 1934 Isonville, Kentucky)
Peaceful Valley
Isonville, Kentucky
1990
Paint on cotton muslin with wood
Framed: 50⁵/₈" x 63" x 4¹/₈"

Aghassi George Aghassian (b. ca. 1904 Armenia;
 d. 1985 Saint Clair, Michigan)
Boat
Saint Clair, Michigan
Probably 1979–1983
Ink on heavy paper with printed collage element
Sight: 18¹/₄" x 27¹/₄"

Beverly ("Gayleen") Aiken (b. 1934 Barre,
 Vermont)
My Happy Raimbilli Hill Cousins
Barre, Vermont
1992
Crayon, pencil, and ink on paper
14" x 17"

Leroy ("Lee") Almon, Sr. (b. 1938 Tallapoosa,
 Georgia)
Garden of Eden
Tallapoosa, Georgia
1994
Paint on wood with glitter
48" x 22¹/₂"

Leroy ("Lee") Almon, Sr. See also the joint listing
 for Elijah Pierce and Leroy ("Lee") Almon, Sr.

Leroy Ramon Archuleta (b. 1949 Tesuque, New
 Mexico)
Black and White Bottlecap Snake
Tesuque, New Mexico
1994
Metal, wood, wire, and paint with plastic and glass
13" x 14¹/₂" x 14"

Lillian Barker (b. 1930 Roscoe, Kentucky; d. 1997
 Elliott County, Kentucky) and
Linvel Barker (b. 1929 Crockett, Kentucky)
Bull
Isonville, Kentucky
1990
Linden wood
13" x 16¹/₄" x 6¹/₂"

141

Lillian Barker (b. 1930 Roscoe, Kentucky; d. 1997
 Elliott County, Kentucky) and
Linvel Barker (b. 1929 Crockett, Kentucky)
Giraffe
Isonville, Kentucky
1989
Linden wood
22^1/$_{16}$" x 15^1/$_2$" x 2^3/$_4$"

Geneva Beavers (b. 1913 near Durham, North
 Carolina)
Garden Creatures
Chesapeake, Virginia
1987
Acrylic and sand on canvas
36" x 48"

Aaron Birnbaum (b. 1895 Skola, Poland [then
 Austria-Hungary])
Rabbis
Brooklyn, New York
1992
Paint on hardboard
22" x 29^3/$_8$"

Aaron Birnbaum (b. 1895 Skola, Poland [then
 Austria-Hungary])
Self-Portrait
Brooklyn, New York
1980–1983
Paint on plywood with plastic tape (on frame)
Framed: 23^3/$_4$" x 19^1/$_2$"

Georgia Blizzard (b. 1919 Saltville, Virginia)
Ying Yang (Mae) Face Jug
Area of Glade Springs, Virginia
Probably late 1980s
Pit-fired earthenware
8^7/$_8$" x 8" x 8"

Freddie Brice (b. 1920 Charleston, South
 Carolina)
Head of Christ
New York City
1990
Paint on plywood
48" x 32"

Freddie Brice (b. 1920 Charleston, South
 Carolina)
Tug Boat
New York City
1989
Paint on canvas
36" x 46"

Richard Burnside (b. 1944 Baltimore, Maryland)
Three Wise Men
Pendleton, South Carolina
1986–1987
Paint on hardboard
16^3/$_8$" x 24^3/$_4$"

David Butler (b. 1898 Saint Mary Parish,
 Louisiana)
7-Headed Dragon/Monster
Patterson, Louisiana
ca. 1982
Paint on sheet iron
23^1/$_4$" x 28" x 1^3/$_4$"

Miles Burkholder Carpenter (b. 1889 near
 Brownstown, Pennsylvania; d. 1985 Waverly,
 Virginia)
Leaping Frog
Waverly, Virginia
1975
Paint on wood
6" x 17" x 4"

Miles Burkholder Carpenter (b. 1889 near
 Brownstown, Pennsylvania; d. 1985 Waverly,
 Virginia)
Root Monster
Waverly, Virginia
1975
Paint on root with window-shade pull
10^3/$_4$" x 26" x 14"

Henry Ray Clark (b. 1936 Bottley, Texas)
I am Tanya Queen of This Planet, Neuton
Houston or Huntsville, Texas
1990
Colored markers on paper
18" x 30"

Raymond Coins (b. 1904 Stuart, Virginia)
Adam and Eve
Pilot Mountain, North Carolina
1980s
Schist
20^1/$_4$" x 14^1/$_4$" x 3"

Raymond Coins (b. 1904 Stuart, Virginia)
Dog Tomb
Pilot Mountain, North Carolina
1980s
Schist
16^1/$_2$" x 19" x 1^7/$_8$"

Jessie Farris Dunaway Cooper (b. 1932 Muses
 Mills, Kentucky)
The Eyes of the World Are on You
Flemingsburg, Kentucky
1989
Paint on cow's skull
7" x 19$^1/_2$" x 8$^1/_2$"

Ronald Everett Cooper (b. 1931 Plummers
 Landing, Kentucky)
Sin Street, Any City
Flemingsburg, Kentucky
1990
Paint on wood
29$^3/_4$" x 26" x 16$^1/_2$"

John William ("Uncle Jack") Dey (b. 1912
 Phoebus [now Hampton], Virginia; d. 1978
 Richmond, Virginia)
White Crow
Richmond, Virginia
1975
Paint on hardboard
17" x 21"

Thornton Dial, Sr. (b. 1928 Emelle, Alabama)
Love Piece: Scrambling through the Flowers
Bessemer, Alabama
1992
Enamel paint, plywood, fabric, and industrial
 sealing compound on canvas mounted on
 wood
35$^7/_8$" x 60" x 8$^1/_2$" deep

Thornton Dial, Sr. (b. 1928 Emelle, Alabama)
Flying Free (Woman's Head)
Bessemer, Alabama
1994
Pastel, pencil, and charcoal on paper
42" x 29$^5/_8$"

Josephus Farmer (b. 1894 near Trenton, Tennessee;
 d. 1989 Joliet, Illinois)
Runaway Slave, 1850
Milwaukee, Wisconsin
ca. 1980
Paint on wood
14$^1/_2$" x 40"

Josephus Farmer (b. 1894 near Trenton,
 Tennessee; d. 1989 Joliet, Illinois)
Dixie Land
Milwaukee, Wisconsin
1985
Paint on wood, plywood, and wood putty with
 plastic, wire, and fabric
16$^1/_2$" x 19$^3/_4$" x 12"

Howard Finster (b. 1915 near Valley Head,
 Alabama)
Faith to Move Mountains
Summerville, Georgia
1977
Paint on hardboard
Framed: 18$^1/_4$" x 31$^1/_2$"

Tony Fitzpatrick (b. 1958 Chicago, Illinois)
Conjure Women
Chicago, Illinois
1987–1989
Chalk on slate board with wood
Framed: 1$^1/_2$" x 8$^1/_2$"

Victor Joseph ("Joe") Gatto (b. 1893 New York
 City; d. 1965 Miami, Florida)
The Lorelei
New York City
ca. 1947
Oil on artist's canvas board
16" x 20"

Victor Joseph ("Joe") Gatto (b. 1893 New York
 City; d. 1965 Miami, Florida)
Georgia
New York City or Florida
ca. 1944
Oil on canvas
24" x 29"

Keith Goodhart (b. 1956 Philadelphia,
 Pennsylvania)
The Arctic Slip
Montana
1995
Wood, metal, and paint
23" x 51" x 11"

Denzil Goodpaster (b. 1908 Deniston, Kentucky;
 d. 1995 West Liberty, Kentucky)
Dolly Parton Cane
West Liberty, Kentucky
1988 or 1989
Paint on wood with wire and glass
36$^1/_4$" x 7$^1/_2$" x 2$^1/_4$"

Theodore ("Ted") Gordon (b. 1924 Louisville,
 Kentucky)
Werner Von Sterngazer
California
1987
Ink on cardboard
Sight: 16³/₄" x 13³/₄"

Carl Greenberg (b. 1917 Brooklyn, New York)
Washington Songs
Brooklyn, New York
1987 or 1988
Oil on artist's canvas board
24" x 20"

Oscar E. Hadwiger (b. 1890 [Colorado?]; d. 1989
 Pueblo, Colorado)
Eiffel Tower
Pueblo, Colorado
1967
Wood with plastic and masking tape
42" x 14⁷/₈" x 14³/₄"

Ray Hamilton (b. 1919? Williamston, South
 Carolina?; d. 1996 Brooklyn, New York)
Owl/Eagle
New York City
Probably 1985–1990
Watercolor and ink on paper
Sight: 15³/₄" x 19³/₄"

O'Tesia ("O.T.") Harper (b. 1925 Yazoo County,
 Mississippi)
Coca Cola Quilt
Yazoo City, Mississippi
1990–1993
Cotton fabrics
74" x 74¹/₄"

Bessie Ruth White Harvey (b. 1928 Dallas,
 Georgia; d. 1994 Alcoa, Tennessee)
Untitled
Alcoa, Tennessee
1985
Colored marker on paper
23³/₄" x 18"

Bessie Ruth White Harvey (b. 1928 Dallas,
 Georgia; d. 1994 Alcoa, Tennessee)
Untitled
Alcoa, Tennessee
1985
Paint on wood with glitter, plastic, glass, metal,
 hair, and feathers
23³/₄" x 28¹/₂" x 18"

William Lawrence Hawkins (b. 1895 Union City,
 Kentucky; d. 1990 Columbus, Ohio)
Two Deer
Columbus, Ohio
1983 or 1984
Paint on plywood
31" x 37"

Lonnie Bradley ("Sandman") Holley (b. 1950
 Birmingham, Alabama)
Out of Mother's Blood, the Eye
Birmingham, Alabama
1991
Paint on paper
28" x 22"

Robert Howell (b. 1934 Powhatan, Virginia)
Fish
Powhatan, Virginia
1996
Paint on wood and metal with plastic
On original stand 69¹/₂" x 62¹/₂" x 19"

Billy Ray Hussey (b. 1955 Robbins, North
 Carolina)
Tiger
Robbins, North Carolina
1992
Slip-decorated and glazed pottery
5¹/₂" x 9¹/₂" x 4⁷/₈"

Billy Ray Hussey (b. 1955 Robbins, North
 Carolina)
Face Jug
Robbins, North Carolina
1996
Salt-glazed and cobalt-decorated stoneware
16" x 12" x 11"

Levent Isik (b. 1961 Istanbul, Turkey)
Box with Nude Figure
Columbus, Ohio
1989
Paint, metal, and mixed media on wood
10" x 3¹/₂" x 3"

Anderson Johnson (b. 1915 Lunenburg County,
 Virginia)
Heads of Two Angels
Newport News, Virginia
1985–1988
Watercolor on paper
14³/₄" x 16¹/₂" (irregular)

Anderson Johnson (b. 1915 Lunenburg County,
 Virginia)
Abraham Lincoln
Newport News, Virginia
Dated 1988 but thought to have been done in
 1986
Paint on plywood
20¹/₈" x 18"

Shields Landon ("S. L.") Jones (b. 1901 Indian
 Mills, West Virginia)
Group of Four Family Members
Pine Hill, West Virginia
1976
Paint on wood
Father = 30" x 9¹/₂" x 8¹/₂"; Mother = 27³/₄" x
 10¹/₄" x 9"; Son = 18" x 7" x 4"; Daughter =
 17¹/₄" x 5¹/₂" x 4¹/₄"

Shields Landon ("S. L.") Jones (b. 1901 Indian Mills,
 West Virginia)
Head of a Man
Pine Hill, West Virginia
1989
Paint on wood
13¹/₂" x 12" x 9¹/₂"

Charles ("Charley") Kinney (b. 1906 near
 Vanceburg, Kentucky; d. 1991 near Vanceburg,
 Kentucky)
Haint
Area of Vanceburg, Kentucky
Late 1980s
Paint on paper
Sight: 21⁹/₁₆" x 27⁵/₈"

Tim Lewis (b. 1952 Eddrich, Kentucky)
Standing Bear
Isonville, Kentucky
1993
Sandstone
18¹/₈" x 25" x 7"

Tim Lewis (b. 1952 Eddrich, Kentucky)
Hornbill Cane
Isonville, Kentucky
1993
Paint on wood
35³/₈" x 9¹/₂" x 5"

Tim Lewis (b. 1952 Eddrich, Kentucky)
Cane with Dog's Head holding newspaper in mouth
Isonville, Kentucky
1994
Paint on wood
35¹/₂" x 8¹/₄"

Tim Lewis (b. 1952 Eddrich, Kentucky)
Head of Baron Gordon
Isonville, Kentucky
1994
Paint on wood
14" x 10³/₄" x 5"

Tim Lewis (b. 1952 Eddrich, Kentucky)
Abraham Lincoln
Isonville, Kentucky
1996
Sandstone
47¹/₄" x 11¹/₂" x 6"

Israel Litwak (b. 1868 Odessa, Russia; d. 1960
 Brooklyn, New York)
Jackson Falls, Wild River
Brooklyn, New York
1941
Colored pencil and wax crayon on cardboard
18" x 24¹/₂"

Dwight Mackintosh (b. 1906 Hayward, California)
Yellow Car
Oakland, California
1981
Ink and tempera on paper
26" x 38"

Mona McCalmon (b. 1926 Arkansas)
"Misty" Cane
Arcadia, California
1990–1992
Wood with paint and rubber
38¹/₂" x 3" x 3"

Justin McCarthy (b. 1891 or 1892 Weatherly,
 Pennsylvania; d. 1977 Tucson, Arizona)
Miss America/1946
Weatherly, Pennsylvania
1946–1950
Crayon and graphite on paper
14" x 10½"

Justin McCarthy (b. 1891 or 1892 Weatherly,
 Pennsylvania; d. 1977 Tucson, Arizona)
Racing Sailboats
Weatherly, Pennsylvania
1960s?
Paint on hardboard
18" x 24"

J.T. ("Jake") McCord (b. 1945 Thomson, Georgia)
Girl with Dog
Thomson, Georgia
1989
Paint on plywood
48" x 61"

Kenny McKay (b. 1941 Mount Vernon, New York)
Untitled ("Hi, Sis!")
Queens, New York
1990 or 1991
Watercolor on paper
17" x 14"

Larry McKee (b. 1941 McCreary County,
 Kentucky)
Skeleton Cane
Kentucky (South Central area)
Early 1990s
Paint on wood
38½" x 2½" x 2¼"

Gaetana ("Thomas") Menna (b. 1912 Brooklyn,
 New York)
Yellow Man
Brooklyn, New York
1987
Watercolor and ink on paper
20" x 15"

Peter J. Minchell (b. 1889 Treves [now Trier],
 Germany; d. 1984 West Palm Beach, Florida)
Storm
Florida
Probably late 1960s
Watercolor and ink on paper
19" x 25"

Frances ("Lady Shalimar") Montague (b. 1905
 Paris, France; d. 1996 Brooklyn, New York)
Princess Grace
Brooklyn, New York
1986
Watercolor, ink, and glitter on paper
20" x 15"

Sister Gertrude Morgan (b. 1900 Lafayette,
 Alabama; d. 1980, New Orleans, Louisiana)
Jesus before Pontius Pilate
New Orleans, Louisiana
ca. 1970
Gouache on paper
13¼" x 19½"

John B. ("J. B.") Murry (b. 1908 near Sandersville,
 Georgia; d. 1988 near Sandersville, Georgia)
Untitled (Tall Figures Crowded Together)
Glascock County, Georgia
Probably 1980–1987
Watercolor on paper
24" x 18"

Earnest Patton (b. 1935 Holly Creek, Kentucky)
Cane—Woman's Head with Snakes
Area of Campton, Kentucky
1988 or 1989
Paint on wood with plastic
37¾" x 4⅞" x 2¼"

Elijah Pierce (b. 1892 Baldwyn, Mississippi; d.
 1984 Columbus, Ohio)
Pete Rose
Columbus, Ohio
1981
Paint on wood with glitter and rubber
13" x 5¼" x 4½"

Elijah Pierce (b. 1892 Baldwyn, Mississippi;
 d. 1984 Columbus, Ohio) and Leroy ("Lee")
 Almon, Sr. (b. 1938, Tallapoosa, Georgia)
Crucifixion
Columbus, Ohio
1979–1982
Paint on wood panel with glitter and twig frame
Framed: 24½" x 10¾" x 1½"

Melissa Polhamus (b. 1957 Ludwigsburg, Germany)
Krasno Wall
Virginia Beach, Virginia
1991 or 1992
Watercolor and ink on paper
Sight: 10 $^3/_4$" x 13 $^1/_2$"

Melissa Polhamus (b. 1957 Ludwigsburg, Germany)
Kansas City
Virginia Beach, Virginia
1994
Watercolor and ink on paper
22 $^1/_2$" x 29 $^1/_2$"

Norman Scott ("Butch") Quinn (b. 1939 Oil City, Pennsylvania)
MX Missile Taking Off, Going into the Heavens to Deity
Oil City, Pennsylvania
1988
Paint on wooden ironing board
54" x 11 $^1/_4$"

David E. ("Dave") Rawlings (b. 1917 Washington, D. C.)
Black-Tailed Rattler
Roanoke, Virginia
Probably 1991–1992
Paint on wood
Length: 35"

Ernest ("Popeye") Reed (b. 1919 Jackson, Ohio; d. 1985 Fort Jackson, South Carolina)
Four Faces
Ohio
ca. 1975
Sandstone
12 $^1/_4$" x 7 $^3/_8$" x 6 $^3/_4$"

Ron Steve Rodriguez (b. 1968 Santa Fe, New Mexico)
Bear with Fish in Mouth
Tesuque, New Mexico
1994
Paint on cottonwood with glass and plastic
22" x 41 $^1/_2$" x 15"

Ron Steve Rodriguez (b. 1968 Santa Fe, New Mexico)
Bull
Tesuque, New Mexico
1995
Paint on cottonwood with glass, metal, and hemp
27 $^1/_2$" x 49" x 21"

Anthony Joseph ("Tony Joe") Salvatore (b. 1938 Youngstown, Ohio; d. 1994 Youngstown, Ohio)
Luke V:29
Youngstown, Ohio
1987
Acrylic and oil pastel on paper
Sight: 31 $^5/_8$" x 39 $^3/_4$"

Helen Salzberg (b. 1923 New York City)
Bar Mitzvah Boy
New York City
1980s
Paint on glass
Sight: 17 $^3/_4$" x 23 $^3/_4$"

Paulina Santiliz (b. 1925 Puerto Rico; d. 1987 New York City)
Figure/"Zip 10025"
New York City
1987
Colored pencil on paper
22" x 15"

John ("Jack") Savitsky (b. 1910 Silver Creek [now New Philadelphia], Pennsylvania; d. 1991 Coaldale, Pennsylvania)
Two Figures in Landscape with Moon
Lansford, Pennsylvania
1964
Colored pencil on paper
Sight: 8 $^1/_2$" x 11 $^1/_2$"

John ("Jack") Savitsky (b. 1910 Silver Creek [now New Philadelphia], Pennsylvania; d. 1991 Coaldale, Pennsylvania)
Princess Mae
Lansford, Pennsylvania
1975
Oil on hardboard
10 $^7/_8$" x 37 $^3/_8$"

Jon Serl (b. 1894 Olean, New York; d. 1993 Lake
 Elsinore, California)
The Collector
California
Late 1960s or early 1970s
Oil on plywood
32³/₄" x 26³/₈"

Jon Serl (b. 1894 Olean, New York; d. 1993 Lake
 Elsinore, California)
The Blue Barrel
California
Mid-1960s
Oil on hardboard
24³/₈" x 30"

Vollis Simpson (b. 1919 Lucama, North Carolina)
Airplane
Lucama, North Carolina
1994
Paint on metal and wood with reflective coating
29" x 67¹/₂" x 42"

Vollis Simpson (b. 1919 Lucama, North Carolina)
Man Pumping Water
Lucama, North Carolina
1994
Paint on metal
37¹/₂" x 54¹/₂" x 29³/₄" (diameter of wheel)

Vollis Simpson (b. 1919 Lucama, North Carolina)
Bicycle Wheel
Lucama, North Carolina
1994
Paint on metal with reflective coating
38¹/₂" x 55" x 38¹/₂"

Vollis Simpson (b. 1919 Lucama, North Carolina)
Yellow Airplane
Lucama, North Carolina
1994
Paint on metal and wood with plastic (decal)
19" x 30" x 24"

Vollis Simpson (b. 1919 Lucama, North Carolina)
Ice Cream Scoop Sculpture
Lucama, North Carolina
1995
Paint on metal with reflective coating and plastic
 film
27" x 19" x 18³/₄"

Vollis Simpson (b. 1919 Lucama, North Carolina)
Whirligig Duck
Lucama, North Carolina
1995
Paint on metal with reflective coating, rubber,
 and plastic film
53" x 53³/₄" x 40¹/₄"

Vollis Simpson (b. 1919 Lucama, North Carolina)
Bicycle Man
Lucama, North Carolina
1996
Paint on metal with reflective coating and
 reflector tape
123¹/₂" x 79" x 29" (measurements exclude
 hand flags)

Herbert Singleton (b. 1945 New Orleans,
 Louisiana)
The House of David
New Orleans, Louisiana
1994
Paint on wood
83" x 34¹/₈" x 1³/₁₆"

Robert Eugene Smith (b. 1927 Saint Louis,
 Missouri)
Alcatraz
Springfield, Missouri
Probably 1985–1990
Watercolor and marker on paper
Sight: 29³/₄" x 39¹/₂"

Oscar Lipscomb ("O. L.") Spencer (b. 1908
 Franklin County, Virginia; d. 1993 Blue Ridge,
 Virginia)
Big White Rattler
Blue Ridge, Virginia
1980s
Paint on wood with plastic and wire
Length: 66⁵/₈"

Oscar Lipscomb ("O. L.") Spencer (b. 1908
 Franklin County, Virginia; d. 1993 Blue Ridge,
 Virginia)
Moxican
Blue Ridge, Virginia
1980s
Paint on wood
Length: 39¹/₂"

Oscar Lipscomb ("O. L.") Spencer (b. 1908
 Franklin County, Virginia; d. 1993 Blue Ridge,
 Virginia)
Short Green Snake
Blue Ridge, Virginia
1980s
Paint on wood with plastic and wire
Length: 25³/₄"

Oscar Lipscomb ("O. L.") Spencer (b. 1908
 Franklin County, Virginia; d. 1993 Blue Ridge,
 Virginia)
Little Snake with Raised Head
Blue Ridge, Virginia
1980s
Paint on wood with plastic and wire
Length: 30"

Oscar Lipscomb ("O. L.") Spencer (b. 1908
 Franklin County, Virginia; d. 1993 Blue Ridge,
 Virginia)
*Brown Snake with Dark Brown, White-Ringed
 Diamonds on Back*
Blue Ridge, Virginia
1980s
Paint on wood with plastic and wire
Length: 54¹/₂"

Jimmy Lee Sudduth (b. 1910 Caines Ridge,
 Alabama)
House
Fayette, Alabama
ca. 1985
Paint and earth on plywood
23⁷/₈" x 32"

Moses Earnest ("Mose") Tolliver (b. 1921
 Montgomery County, Alabama)
Statue of Liberty
Montgomery, Alabama
1980s
Paint on plywood
24" x 19³/₁₆"

Philip Travers (b. 1914 New York City)
Humpty Dumpty's Horoscope
New York City
1986
Colored pencil, ink, and marker on paper
24" x 18"

Philip Travers (b. 1914 New York City)
Elizabeth Taylor
New York City
1989
Colored pencil, ink, and marker on paper
24" x 18"

Philip Travers (b. 1914 New York City)
A Discordant Note
New York City
1990
Colored pencil, ink, and marker on paper
24" x 18"

Philip Travers (b. 1914 New York City)
What's Happened to Alice?
New York City
1990
Colored pencil, ink, and marker on paper
24" x 18"

Philip Travers (b. 1914 New York City)
The Red King
New York City
1990
Colored pencil, ink, and marker on paper
24" x 18"

Philip Travers (b. 1914 New York City)
City of Mecca
New York City
Probably 1995
Colored pencil, ink, and marker on paper
24" x 18"

Nelson Tygart (b. 1961 Auburn, California)
Tiger
Oakland, California
1992
Oil pastel on paper
20" x 26"

John Vivolo (b. 1886 Accri, Italy; d. 1987 Hartford,
 Connecticut)
Man in Green
Hartford, Connecticut
1970–1975
Paint on wood
16¹/₂" x 9" x 6³/₄"

Inez Stedman Nathaniel Walker (b. 1911 Sumter,
 South Carolina; d. 1990 Willard, New York)
Cocktails
Upstate New York or area of Philadelphia,
 Pennsylvania
1975
Graphite and colored pencil on paper
18" x 23³/₄"

Hubert Walters (b. 1931 Kingston, Jamaica)
Big Ben
Troutman, North Carolina
Probably late 1980s or early 1990s
Paint on wood with metal and plastic
74⁵/₈" x 19¹/₄" x 19¹/₂"

Gregory Warmack ("Mr. Imagination" or "Mr. I")
 (b. 1948 Chicago, Illinois)
Cane with Head
Chicago, Illinois
1993
Paint on modeling compound with wood, plastic,
 and metal
39" x 6" x 3"

Myrtice Snead West (b. 1923 Cherokee County,
 Alabama)
Song of Moses
Centre, Alabama
1992
Paint on fabric with wood and glitter
Framed: 34¹/₂" x 53¹/₂"

Joseph Elmer Yoakum (b. 1886 or 1888 near
 Window Rock, Arizona; d. 1972 Chicago,
 Illinois)
Mountain Range in S.W. Pacific Ocean at Honalula
Chicago, Illinois
ca. 1964
Watercolor and ink on paper
18" x 24"

Joseph Elmer Yoakum (b. 1886 or 1888 near
 Window Rock, Arizona; d. 1972 Chicago,
 Illinois)
*Mt. Eboa near tocatil Idaho (Maude Horsman
 Ranch)*
Chicago, Illinois
1971
Graphite on paper
13" x 19"

Purvis Young (b. 1943 Miami, Florida)
Faces over the City
Miami, Florida
Probably 1984–1994
Paint on plywood
60" x 48"

NINETEENTH-CENTURY OBJECTS

William A. Macquoid & Co. (active 1863–1879)
Crock: "Good Health"
New York City
1864–1870
Salt-glazed and cobalt-decorated stoneware with
 Albany slip
12" x 13³/₈" x 12³/₄"

William Matthew Prior (b. 1806 Bath, Maine;
 d. 1873 Boston, Massachusetts)
Portrait of a Woman
Possibly Boston, Massachusetts
ca. 1850
Oil on canvas
27" x 22"

James Chapman Tuttle (b. ca. 1772 Salem,
 Massachusetts; d. 1849 Salem, Massachusetts)
Pair of Windsor *Side Chairs* (from a set of four)
Salem, Massachusetts
ca. 1800
Paint on wood (probably white pine seats and
 ash spindles)
Each approximately 37³/₄" x 22" x 20"

Artist unidentified
Dome-lid Box
America
ca. 1820
Paint on basswood with metal hinges and clasp
7⁷/₈" x 20" x 10"

Artist unidentified
Box
Possibly New York State
ca. 1825
Paint on wood with metal hinges, ring, and clasp
4³/₈" x 9⁷/₈" x 6"

Artist unidentified
Rattle
Possibly New York State
ca. 1825
Paint on wood
4$^{1}/_{4}$" x 2$^{5}/_{8}$" x 2$^{1}/_{2}$"

Artist unidentified
Dish with Chicken Design
Probably Pennsylvania
ca. 1830
Slip-decorated and lead-glazed earthenware
Diameter: 3$^{3}/_{4}$" x $^{3}/_{4}$"

Artist unidentified
Ornamental Painter's Sample Kit
Probably New England or Middle Atlantic States
ca. 1830
Oil and gilt on wood with metal hinges
16" x 17" x 1$^{1}/_{2}$"

Artist unidentified
Stencil-decorated Box
America
ca. 1830
Paint on maple with metal hinges and clasp
2$^{5}/_{8}$" x 12" x 7$^{5}/_{8}$"

Artist unidentified
Teas Trade Sign for C. D. Cobb & Brothers
Boston, Massachusetts
1830–1850
Paint on wood with iron battens
31$^{7}/_{8}$" x 75$^{1}/_{16}$" x 9$^{1}/_{2}$" (Measurements
 include the battens on the front of the piece)

Artist unidentified
Crock with Face
Probably New York State or New Jersey
ca. 1840
Salt-glazed and cobalt-decorated stoneware with
 Albany slip
8$^{3}/_{4}$" x 8" x 7$^{1}/_{2}$"

Artist unidentified
Sun Dial
Possibly Pennsylvania or Athens, New York
Probably 1850–1875
Salt-glazed and cobalt-decorated stoneware with
 copper gnomon
5$^{1}/_{2}$" x 8$^{1}/_{2}$" x 8$^{1}/_{2}$"

Artist unidentified
Eagle
Maine
1875–1900
Paint on pine
20" x 12" x 12"

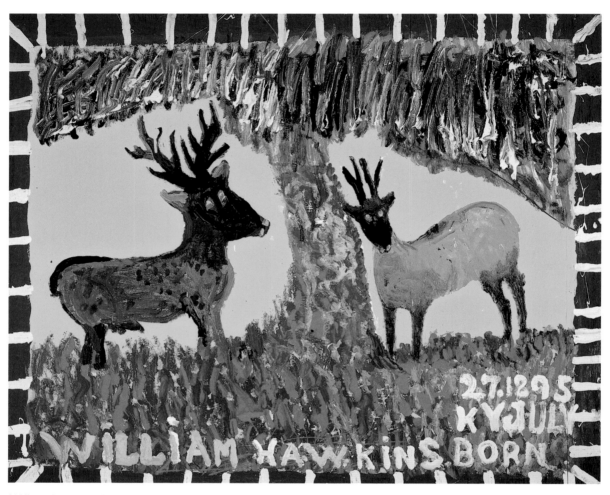

William Lawrence Hawkins, Two Deer

BOOKS

Abby Aldrich Rockefeller Folk Art Center. *Folk Art USA since 1900 from the Collection of Herbert Waide Hemphill, Jr.* New York: Publishing Center for Cultural Resources, 1980. Exhibit catalog.

Akron Art Museum. *Pillar of Fire: The Visionary Art of Anthony Joseph Salvatore.* Akron, Ohio: Akron Art Museum, n.d. Exhibit brochure.

American Center for Design. *Personal Voice: Outsider Art and Signature Style.* Chicago, Ill.: American Center for Design, 1991. Exhibit brochure.

Art and Culture Center of Hollywood. *Purvis Young: Paintings from the Street.* Hollywood, Fla.: Art and Culture Center of Hollywood, 1993. Exhibit catalog.

Art Galleries of Ramapo College. *Jon Serl: Painter.* Mahwah, N. J.: Ramapo College of New Jersey, 1986. Exhibit catalog.

Artists' Alliance. *It'll Come True: Eleven Artists First and Last.* Lafayette, La.: Artists' Alliance, 1992.

Artists Space. *Art's Mouth.* New York: Artists Space, 1991. Exhibit catalog.

Artists of Vision and Purpose. Northfield, Minn.: Carleton College, 1994.

Art Museum of South Texas. *Lions and Tigers and Bears, Oh My!: New Mexican Folk Carvings from the Collection of Christine and Davis Mather.* Corpus Christi, Tex.: Art Museum of South Texas, 1987. Exhibit catalog.

Baraka, Amiri [LeRoi Jones], and Thomas McEvilley. *Thornton Dial: Image of the Tiger.* New York: Harry N. Abrams Inc., in association with the Museum of American Folk Art, the New Museum of Contemporary Art, and the American Center, 1993.

Barrett, Didi. *Muffled Voices: Folk Artists in Contemporary America.* New York: Museum of American Folk Art at the PaineWebber Art Gallery, 1986. Exhibit catalog.

Bishop, Robert. *American Folk Sculpture.* New York: E. P. Dutton, 1974.

————. *Folk Painters of America.* New York: E. P. Dutton, 1979.

Cardinal, Roger. *Outsider Art.* New York: Praeger Publishers, 1972.

Carpenter, Miles B. *Cutting the Mustard.* Tappahannock, Va.: American Folk Art Co., 1982.

Carr, Simon, et al., eds. *Portraits from the Outside: Figurative Expression in Outsider Art.* New York: Groegfeax Publishing, 1990. Exhibit catalog.

Carter, Curtis L. *Contemporary American Folk Art: The Balsley Collection.* Milwaukee, Wis.: Patrick & Beatrice Haggerty Museum of Art, Marquette University, 1992.

Collection de L'Art Brut. *Made in USA: Collection de Chuck et Jan Rosenak.* Lausanne: Collection de L'Art Brut, 1993. Exhibit catalog.

Columbus Museum of Art. *Popular Images, Personal Visions: The Art of William Hawkins, 1895–1990.* Columbus, Ohio: Columbus Museum of Art, 1990. Exhibit catalog.

————. *Elijah Pierce: Woodcarver.* Columbus, Ohio: Columbus Museum of Art, 1992.

Contemporary Arts Center. *20th Century American Folk Art: The Hemphill Collection.* Cincinnati, Ohio: Contemporary Arts Center, n.d. Exhibit brochure.

Cubbs, Joanne. *The Gift of Josephus Farmer.* Milwaukee, Wis.: Milwaukee Art History Gallery, University of Wisconsin, 1982. Exhibit catalog.

Dallas Museum of Art. *Black Art—Ancestral Legacy: The African Impulse in African-American Art.* Dallas, Tex.: Dallas Museum of Art, 1989.

Dubuffet, Jean. *L'Art brut préféré aux culturels.* Paris: Galerie René Douin, 1949. Exhibit catalog.

Faircloth, Stephen, and Suzan Courtney. *Enisled Visions: The Southern Non-Traditional Folk Artist.* Mobile, Ala.: Fine Arts Museum of the South, n.d.

Fine Arts Museum of the South. *Southern Outsider, Visionary and Folk Art from the Collection of Dr. A. Everette James, Jr.* Mobile, Ala.: Fine Arts Museum of the South, 1994. Exhibit catalog.

Finster, Howard. *Howard Finster: Man of Visions.* Atlanta, Ga.: Peachtree Publishers, 1989.

Finster, Howard, and Tom Patterson. *Howard Finster, Stranger from Another World: Man of Visions Now on This Earth*. New York: Abbeville Press, 1989.

Fitzpatrick, Tony. *The Hard Angels: Drawings and Poems*. Philadelphia: Janet Fleisher Gallery, 1988.

Flossie Martin Gallery. *Miles Carpenter: A Second Century*. Radford, Va.: Flossie Martin Gallery, Radford University, 1990. Exhibit catalog.

Folk Art Society of Kentucky. *Howard Finster: Painter of Sermons*. Lexington, Ky.: Folk Art Society of Kentucky in cooperation with the Berea College Appalachian Museum, 1988. Exhibit catalog.

Fowler, Miriam Rogers, comp. *Outsider Artists in Alabama*. Montgomery, Ala.: Alabama State Council on the Arts, 1991. Exhibit catalog.

Fox, Nancy Jo. *Liberties with Liberty: The Fascinating History of America's Proudest Symbol*. New York: E. P. Dutton in association with the Museum of American Folk Art, 1986.

Galerie St. Etienne. *The Forgotten Folk Art of the 1940s*. New York: Galerie St. Etienne, 1994. Exhibit catalog.

————. *New York Folk: Lawrence Lebduska, Abraham Levin, Israel Litwak*. New York: Galerie St. Etienne, 1996. Exhibit catalog.

Gallery Nine. *Good and Evil: Visions by Eastern Kentucky Folk Artists*. N.p.: Gallery Nine in association with the School of Art and Design, University of Illinois at Urbana-Champaign, the Eastern Kentucky Folk Art Collection, and the Morehead State University, 1989. Exhibit catalog.

Gallo, Peter. *Rooms and Rooms: The Art of Gayleen Aiken*. West Glover, Vt.: Grass Roots Arts & Community Efforts, 1993. Exhibit brochure.

Glimcher, Marc, ed. *Jean Dubuffet: Towards an Alternative Reality*. New York: Pace Publications, 1987.

Gordon, Ellin, and Baron Gordon. *Virginia Originals*. Virginia Beach, Va.: Virginia Beach Center for the Arts, 1994. Exhibit catalog.

Grass Roots Art and Community Effort. *10 Years of G.R.A.C.E.: An Exhibition of Vermont Grass Roots Art*. St. Johnsbury, Vt.: G.R.A.C.E./Catamount Arts, n.d. Exhibit catalog.

Hall, Michael D., and Eugene W. Metcalf, Jr. *The Artist Outsider: Creativity and the Boundaries of Culture*. Washington, D. C.: Smithsonian Institution Press, 1994.

Hand Workshop. *Miles B. Carpenter, Centennial Exhibition*. Richmond, Va.: Hand Workshop, 1989. Exhibit catalog.

Hartigan, Lynda Roscoe. *Made with Passion: The Hemphill Folk Art Collection in the National Museum of American Art*. Washington, D. C.: Smithsonian Institution Press for the National Museum of American Art, 1990.

Hemphill, Herbert W., Jr., and Julia Weissman. *Twentieth-Century American Folk Art and Artists*. New York: E. P. Dutton, 1974.

Heritage Plantation of Sandwich. *The Herbert Waide Hemphill, Jr. Collection of 18th, 19th, and 20th century American Folk Art*. Sandwich, Mass.: Heritage Plantation of Sandwich; Columbus, Ga.: Columbus Museum of Arts and Crafts, Inc., 1974. Exhibit catalog.

Hirschl & Adler Modern. *Intuitive Line*. New York: Hirschl & Adler, n.d. Exhibit brochure.

————. *Joseph Yoakum*. New York: Hirschl & Adler Modern, 1985. Exhibit brochure.

Hoffberger, Rebecca, Roger Manley, and Colin Wilson. *Tree of Life*. Baltimore, Md.: American Visionary Art Museum, 1996.

Horwitz, Elinor Lander. *The Bird, the Banner, and Uncle Sam: Images of America in Folk and Popular Art*. Philadelphia: J. B. Lippincott Co., 1976.

————. *Contemporary American Folk Artists*. Philadelphia: J. B. Lippincott Co., 1975.

Hospital Audiences, Inc. (HAI). *Outsider Artists of Hospital Audiences, Inc. (HAI)*. New York: Capital Cities/ABC, Inc., 1996. Exhibit catalog.

Huntington Museum of Art. *Figural Quilts: Minnie Adkins & Sarah Mary Taylor*. Huntington, W.Va.: Huntington Museum of Art, 1991. Exhibit brochure.

INTAR Latin American Gallery. *Another Face of the Diamond: Pathways through the Black Atlantic South*. New York: INTAR Latin American Gallery, 1988.

Janet Fleisher Gallery. *Animistic Landscapes: Joseph Yoakum Drawings*. Philadelphia, Pa.: Janet Fleisher Gallery, 1989.

Janis, Sidney. *They Taught Themselves: American Primitive Painters of the 20th Century*. New York: Dial Press, 1942.

Jensen, Dean. *Material Obsessions: Folk and Outsider Art from Wisconsin Collections*. Milwaukee, Wis.: Frederick Layton Gallery, Milwaukee Institute of Art & Design, 1989. Exhibit catalog.

Johnson, Jay, and William C. Ketchum, Jr. *American Folk Art of the Twentieth Century*. New York: Rizzoli, 1983.

Joy Moos Gallery. *Purvis Young*. Miami, Fla.: Joy Moos Gallery, 1993.

————. *Purvis Young*. Miami, Fla.: Joy Moos Gallery, n.d. Exhibit brochure.

————. *Purvis Young, Me and My People*. Miami, Fla.: Joy Moos Gallery, 1989. Exhibit brochure.

Kaufman, Barbara Wahl, and Didi Barrett. *A Time to Reap: Late Blooming Folk Artists*. South Orange, N. J.: Seton Hall University; New York: Museum of American Folk Art, 1985. Exhibit catalog.

Kemp, Kathy. *Revelations: Alabama's Visionary Folk Artists*. Birmingham, Ala.: Crane Hill Publishers, 1994.

Kentucky Art and Craft Foundation. *Generations of Kentucky: An Exhibition of Folk Art with Photographs by Guy Mendes*. Louisville, Ky.: Kentucky Art and Craft Foundation, 1994. Exhibit catalog.

————. *Remembrances: Recent Memory Art by Kentucky Folk Artists*. Louisville, Ky.: Kentucky Art and Craft Foundation, 1986. Exhibit catalog.

————. *Sticks: Historical and Contemporary Kentucky Canes*. Louisville, Ky.: Kentucky Art and Craft Foundation, 1988. Exhibit catalog.

Ketchum, William C., Jr. *All-American Folk Arts and Crafts*. New York: Rizzoli, 1986.

Kraskin, Sandra. *Black History and Artistry: Work by Self-Taught Painters and Sculptors from the Blanchard-Hill Collection*. New York: Sidney Mishkin Gallery, Baruch College, CUNY, 1993. Exhibit catalog.

Laffal, Ken. *Vivolo and His Wooden Children*. Essex, Conn.: Gallery Press, Inc., 1976.

Lampell, Ramona, and Millard Lampell. *O, Appalachia: Artists of the Southern Mountains*. New York: Stewart, Tabori & Chang, 1989.

Lavitt, Wendy. *Animals in American Folk Art*. New York: Alfred A. Knopf, 1990.

Lehigh University. *Natural Scriptures: Visions of Nature and the Bible*. Bethlehem, Pa.: Lehigh University Art Galleries, 1990.

Lippard, Lucy R. *Mixed Blessings: New Art in a Multicultural America*. New York: Pantheon Books, 1990.

Livingston, Jane, and John Beardsley. *Black Folk Art in America, 1930–1980*. Jackson, Miss.: University Press of Mississippi and the Center for the Study of Southern Culture for the Corcoran Gallery of Art, 1982.

Longwood Center for the Visual Arts. *Folk Art: The Common Wealth of Virginia*. Farmville, Va.: Longwood Center for the Visual Arts, Longwood College, 1996. Exhibit brochure.

MacGregor, John M. *The Discovery of the Art of the Insane*. Princeton, N. J.: Princeton University Press, 1989.

————. *Dwight Mackintosh: The Boy Who Time Forgot*. Oakland, Calif.: Creative Growth Art Center, 1990. Exhibit catalog.

Maizels, John. *Raw Creation: Outsider Art and Beyond*. London: Phaidon Press Limited, 1996.

Manley, Roger. *Signs and Wonders: Outsider Art inside North Carolina*. Raleigh, N. C.: North Carolina Museum of Art, 1989.

————. *Visionary Clay by Georgia Blizzard*. N.p.: Privately distributed essay, 1986.

Maresca, Frank, and Roger Ricco. *American Self-Taught: Paintings and Drawings by Outsider Artists*. New York: Alfred A. Knopf, 1993.

Marks, Elizabeth, and Thomas Klocke. *The HAI Collection of Outsider Art, 1980–1990: Selected Works Created by Mentally Ill Artists in New York City from the Hospital Audiences, Inc., Art Workshop Program*. New York: Hospital Audiences, Inc., 1990. Exhibit catalog.

Meadow Farm Museum. *How the Eagle Flies: Patriotic Images in Twentieth-Century Folk Art*. Richmond, Va.: Meadow Farm Museum, 1989. Exhibit catalog.

————. *Life and Legend: Folk Paintings of "Uncle Jack" Dey*. Richmond, Va.: Meadow Farm Museum, 1986. Exhibit brochure.

Metcalf, Eugene, and Michael Hall. *The Ties That Bind: Folk Art in Contemporary American Culture*. Cincinnati, Ohio: Contemporary Arts Center, 1986.

Meyer, George H. *American Folk Art Canes: Personal Sculpture*. Bloomfield Hills, Mich.: Sandringham Press in association with the Museum of American Folk Art and the University of Washington Press, 1992.

Miami University Art Museum. *Contemporary American Folk, Naive, and Outsider Art: Into the Mainstream?* Oxford, Ohio: Miami University Art Museum, 1990. Exhibit catalog.

Miles B. Carpenter Museum. *One Hundred Miles! The 100th Anniversary of Miles Carpenter's Birth*. Waverly, Va.: Miles B. Carpenter Museum, 1989. Exhibit catalog.

Milwaukee Art Museum. *Common Ground/Uncommon Vision: The Michael and Julie Hall Collection of American Folk Art.* Milwaukee, Wis.: Milwaukee Art Museum, 1993.

———. *Driven to Create: The Anthony Petullo Collection of Self-Taught & Outsider Art.* Milwaukee, Wis.: Milwaukee Art Museum, 1993.

Montgomery Museum of Fine Arts. *1992 Montgomery Biennial: In/Outsiders from the American South.* Montgomery, Ala.: Montgomery Museum of Fine Arts, 1992.

Morehead State University. *Local Visions: Folk Art from Northeast Kentucky.* Morehead, Ky.: Folk Art Collection, Morehead State University, 1990. Exhibit catalog.

Museum of American Folk Art. *Ape to Zebra: A Menagerie of New Mexican Woodcarvings, the Animal Carnival Collection of the Museum of American Folk Art.* New York: Museum of American Folk Art, 1985. Exhibit catalog.

Museum of York County. *Living Traditions: Southern Black Folk Art.* Rock Hill, S. C.: Museum of York County, 1991. Exhibit catalog.

Newark Museum. *A World of Their Own: Twentieth-Century American Folk Art.* Newark, N. J.: Newark Museum, 1995.

New Jersey State Museum. *A Density of Passions.* Trenton, N. J.: New Jersey State Museum, 1989. Exhibit catalog.

New Orleans Museum of Art. *David Butler.* New Orleans, La.: New Orleans Museum of Art, 1976. Exhibit brochure.

Noyes Museum. *American Folk Art from the Collection of Herbert Waide Hemphill, Jr.* Oceanville, N. J.: Noyes Museum, 1988. Exhibit catalog.

———. *Drawing Outside the Lines: Works on Paper by Outsider Artists.* Oceanville, N. J.: Noyes Museum, 1995. Exhibit catalog.

———. *Twentieth Century Self-Taught Artists from the Mid-Atlantic Region.* Oceanville, N. J.: Noyes Museum, 1994. Exhibit catalog.

Oppenhimer, Ann. *Unto the Hills: Folk Art of Eastern Kentucky.* Richmond, Va.: Marsh Gallery, University of Richmond, 1989. Exhibit brochure.

Oppenhimer, Ann Frederick, and Susan Hankla, eds. *Sermons in Paint: A Howard Finster Folk Art Festival.* Richmond, Va.: Marsh Gallery, University of Richmond, 1984.

Owensboro Museum of Fine Art. *Kentucky Spirit: The Naive Tradition.* Owensboro, Ky.: Owensboro Museum of Fine Art, 1991. Exhibit catalog.

Patterson, Tom. *'Ashe: Improvisation & Recycling in African-American Visionary Art.* Winston-Salem, N. C.: Diggs Gallery at Winston-Salem State University, 1993.

———. *Not by Luck: Self-Taught Artists in the American South.* Milford, N. J.: Lynne Ingram Southern Folk Art, 1993.

———. *Reclamation and Transformation: Three Self-Taught Chicago Artists.* Chicago, Ill.: Terra Museum of American Art, 1994.

Peacock, Robert, with Annibel Jenkins. *Paradise Garden: A Trip through Howard Finster's Visionary World.* San Francisco, Calif.: Chronicle Books, 1996.

Peninsula Fine Arts Center. *Miles Carpenter.* Newport News, Va.: Peninsula Fine Arts Center, n.d. Exhibit brochure.

Perry, Regenia A. *Free within Ourselves: African-American Artists in the Collection of the National Museum of American Art.* Washington, D. C.: National Museum of American Art, Smithsonian Institution, in association with Pomegranate Artbooks, 1992.

Philadelphia Art Alliance. *Howard Finster: Man of Visions, the Garden and Other Creations.* Philadelphia, Pa.: Philadelphia Art Alliance, 1984. Exhibit catalog.

Philadelphia College of Art. *Transmitters: The Isolate Artist in America.* Philadelphia: Philadelphia College of Art, 1981. Exhibit catalog.

Piedmont Arts Association. *Fine Folk: Art 'n' Facts from the Rural South from the Collection of Howard and Anne Smith.* Martinsville, Va.: Piedmont Arts Association, 1989. Exhibit catalog.

Prince, Dan. *Passing in the Outsider Lane: Art from the Heart of Twenty-One Self-Taught Artists.* Boston, Mass.: Charles E. Tuttle Co., Journey Editions, 1995.

Prinzhorn, Hans. *Artistry of the Mentally Ill: A Contribution to the Psychology and Psychopathology of Configuration.* Translated by Eric von Brockdorff. 1972. Reprint, Wien, Germany: Spring-Verlag, 1995.

Ricco, Roger, and Frank Maresca. *American Primitive: Discoveries in Folk Sculpture.* New York: Alfred A. Knopf, 1988.

————. *William L. Hawkins, 1895–1990.* New York: Ricco/Maresca Gallery, 1990. Exhibit catalog.

Roche, Jim. *Unsigned, Unsung . . . Whereabouts Unknown: Make-Do Art of the American Outlands.* Tallahassee, Fla.: Florida State University Gallery & Museum Press, 1993.

Rosenak, Chuck, and Jan Rosenak. *Contemporary American Folk Art: A Collector's Guide.* New York: Abbeville Press, 1996.

————. *Museum of American Folk Art Encyclopedia of Twentieth-Century American Folk Art and Artists.* New York: Abbeville Press, 1990.

Rutgers, the State University of New Jersey. *The Naive Figure: Eccentric Visions.* Newark: N. J.: Robeson Center Gallery, Rutgers, State University of New Jersey, at Newark Campus, 1987. Exhibit catalog.

Sellen, Betty-Carol. *20th Century American Folk, Self Taught, and Outsider Art.* New York: Neal-Schuman Publishers, 1993.

Sidney Mishkin Gallery. *Wrestling with History: A Celebration of African American Self-Taught Artists from the Collection of Ronald and June Shelp.* New York: Sidney Mishkin Gallery, Baruch College, City University of New York, 1996.

Sieveking, Brian. *Georgia Blizzard: Southern Visionary Artist.* Danville, Va.: Danville Museum of Fine Arts & History, 1993. Exhibit brochure.

Southeastern Center for Contemporary Art. *Georgia Blizzard: Cleansing Vessels.* Winston-Salem, N. C.: Southeastern Center for Contemporary Art, 1996.

Southern Queens Park Association, Inc. *Thornton Dial: Strategy of the World.* Jamaica, N.Y.: Southern Queens Park Association, Inc., 1990. Exhibit catalog.

Squires Gallery. *Intuitive Art: Three Folk Artists, Abe Criss, Howard Finster, and James Harold Jennings.* Blacksburg, Va.: Squires Gallery, Virginia Polytechnic Institute, 1986. Exhibit brochure.

Stebich, Ute. *Justin McCarthy.* Allentown, Pa.: Allentown Art Museum, 1984.

Thevoz, Michel. *Art Brut.* Trans. James Emmons. New York: Rizzoli, 1976.

Thompson, Robert Farris. *Face of the Gods: Art and Altars of Africa and the African Americas.* New York: Museum for African Art, 1993.

————. *Flash of the Spirit: African and Afro-American Art and Philosophy.* New York: Random House, Inc., 1983.

Trechsel, Gail Andrews, ed. *Pictured in My Mind: Contemporary American Self-Taught Art from the Collection of Dr. Kurt Gitter and Alice Rae Yelen.* Birmingham, Ala.: Birmingham Museum of Art, 1995.

Tuchman, Maurice, and Carol S. Eliel. *Parallel Visions: Modern Artists and Outsider Art.* Los Angeles, Calif.: Los Angeles County Museum of Art; Princeton, N. J.: Princeton University Press, 1992.

Turner, J. F. *Howard Finster, Man of Visions: The Life and Work of a Self-Taught Artist.* New York: Alfred A. Knopf, 1989.

University Art Museum. *Baking in the Sun: Visionary Images from the South, Selections from the Collection of Sylvia and Warren Lowe.* Lafayette, La.: University Art Museum, University of Southwestern Louisiana, 1987.

University Center Gallery. *Vernacular Pottery of North Carolina: 1982–1986, from the Collection of Leonidas J. Betts.* Raleigh, N. C.: University Center Gallery, N. C. State University, 1987. Exhibit catalog.

University of Chicago. *20th Century American Folk Art: The Herbert W. Hemphill, Jr., Collection.* Chicago: Renaissance Society, University of Chicago; Sheboygan, Wis.: John Michael Kohler Arts Center; Oshkosh, Wis.: Oshkosh Public Museum, 1975. Exhibit catalog.

University of Wisconsin—Milwaukee Art Museum. *Personal Intensity: Artists in Spite of the Mainstream.* Milwaukee, Wis.: University of Wisconsin—Milwaukee, 1991. Exhibit catalog.

Very Special Arts Gallery. *American Folk Art & Craft Show.* Washington, D. C.: Very Special Arts Gallery, 1991. Exhibit catalog.

Virginia Commonwealth University, Anderson Gallery. *Miles Carpenter: The Wood Carver from Waverly.* Richmond, Va.: Virginia Commonwealth University Publications, 1985.

Wake Forest University Fine Arts Gallery. *Diving in the Spirit.* Winston-Salem, N. C.: Wake Forest University Fine Arts Gallery, 1992. Exhibit catalog.

Walker Art Center. *Naives and Visionaries.* New York: E. P. Dutton & Co., 1974.

Yelen, Alice Rae. *Passionate Visions of the American South: Self-Taught Artists from 1940 to the Present.* New Orleans, La.: New Orleans Museum of Art, 1993.

Zug, Charles G., III. *Turners & Burners: The Folk Potters of North Carolina.* Chapel Hill, N. C.: University of North Carolina Press, 1986.

JOURNALS

Aiken, Gayleen. "An Autobiography by Gayleen Aiken." *G.R.A.C.E. News* (Fall 1995), p. 1.

Almon, Leroy, Sr. "Speakeasy." *New Art Examiner,* XIX, no. 1 (September 1991), pp. 13–14.

Ardery, Julie. "The Designation of Difference." *New Art Examiner,* XIX, no. 1 (September 1991), pp. 29–32.

Aronson, Steven M. L. "Naive Melody in Manhattan: A Collector's Eye for Singular American Folk Art." *Architectural Digest,* XLVII, no. 11 (October 1990), pp. 244–249, 290.

Art Papers, XVIII, no. 5 (September–October 1994).

Atkins, Jacqueline M. "Joseph A. Yoakum: Visionary Traveler." *Clarion,* XV, no. 1 (Winter 1990), pp. 50–57.

Bonesteel, Michael. "The Drawings of Joseph Yoakum." *In'tuit,* IV, no. 1 (Summer 1995), pp. 1, 16–18.

Borum, Jenifer P. "Passionate Visions of the American South: Self-Taught Artists from 1940 to the Present." *New Art Examiner,* XXI, no. 6 (February 1994), pp. 41–44.

———. "Strategy of the Tiger: The World of Thornton Dial." *Folk Art,* XVIII, no. 4 (Winter 1993–1994), pp. 34–40.

———. "Term Warfare." *Raw Vision,* no. 9 (Winter 1993–1994), pp. 24–31.

———. "They Taught Themselves: An Interview with Roger Ricco & Frank Maresca." *Folk Art,* XVIII, no. 3 (Fall 1993), pp. 53–56.

———. "Will the Real Outsiders Please Stand Up?" *New Art Examiner,* XX, no. 10 (Summer 1993), pp. 18–21.

Brewster, Todd. "Fanciful Art of Plain Folk." *Life* (June 1980), pp. 112–117.

DeBouzek, Jeanette. "Animal Woodcarvers in Northern New Mexico Speak about Their Art in Dana Everts-Boehm's 'New Mexican Hispano Animal Carving in Context.'" *Clarion,* XVI, no. 2 (Summer 1991), pp. 36–40.

Epstein, Gene. "The Art and Times of Victor Joseph Gatto." *Clarion,* XIII, no. 2 (Spring 1988), pp. 56–63.

———. "What Kind of Art Is This? Justin McCarthy and the Age of Outsiderism." *Folk Art,* XVII, no. 2 (Winter 1992–1993), pp. 49–56.

Everts-Boehm, Dana. "New Mexican Hispano Animal Carving in Context." *Clarion,* XVI, no. 2 (Summer 1991), pp. 34–36.

Finster, Beverly. "Howard Finster's Paradise Garden Today." *Folk Art Finder,* XVII, no. 1 (January–March 1996), p. 9.

Frankel, Claire. "Outside's in." *Art & Auction* (October 1992), pp. 102–109.

Garver, Thomas H. "Giving Outsider Art a Home." *House & Garden* (November 1991), pp. 6, 18.

Gaver, Eleanor E. "Inside the Outsiders." *Art & Antiques* (Summer 1990), pp. 72–86, 159–163.

Gregson, Chris. "Miles Carpenter: The Man and His Art." *Folk Art Messenger,* II, no. 3 (Spring 1989), pp. 1, 3.

Haart, Anton. "Mose Tolliver Goes to Washington." *Raw Vision,* XII (Summer 1995), pp. 22–29.

Hackley, Larry. "Discoveries in Contemporary Kentucky Canes." *Folk Art Finder,* XIII, no. 2 (April–June 1992), pp. 14–17.

Hackley, Larry, and Ann Tower. "Denzil Goodpaster (1908–1995)." *Folk Art Finder,* XVII, no. 1 (January–March 1996), p. 19.

Hall, Michael D. "The Mythic Outsider: Handmaiden to the Modern Muse." *New Art Examiner,* XIX, no. 1 (September 1991), pp. 16–21.

Hand Workshop. "Miles B. Carpenter Centennial Exhibition Will Celebrate His Life and Work." *Hand Workshop,* V, no. 2 (April 1989), p. 1.

Hartigan, Lynda Roscoe. "Collected with Passion." *Clarion,* XV, no. 3 (Summer 1990), pp. 34–40.

———. "The Hemphill Folk Art Collection." *Magazine Antiques,* CXXXVIII, no. 4 (October 1990), pp. 798–809.

Hines, Jack. "Creative Process." *Southwest Art* (August 1995), pp. 43–44.

Hobbs, Karen, with Chris Ruys and Christin Crampton. "Chicago Youth Center Sculpture Park." *Folk Art Finder,* XV, no. 4 (October–December 1994), pp. 4–9.

Hood, John. "Jimmy Lee Sudduth." *Folk Art,* XVIII, no. 4 (Winter 1993–1994), pp. 47–51.

"Howard Finster." *Folk Art Finder,* XVII, no. 1 (January–March 1996), p. 5.

"Howard Finster, Man of Visions: A Retrospective." *Folk Art Finder,* X, no. 4 (October–December 1989), pp. 8–9.

"Howard Finster: Visions from Paradise Garden." *Folk Art Finder,* XVII, no. 1 (January–March 1996), p. 4.

Hughes, Robert. "The View from Outside." *Time* (December 14, 1992), pp. 64–65.

James, Everette Jr., and Kathleen Knight. "The Art of Whimsey." *Raw Vision,* VII (Summer 1993), pp. 48–52.

Joel, Jane M. "Vollis Simpson: The Don Quixote of East-Central North Carolina." *Folk Art Messenger,* IX, no. 3 (Spring 1996), pp. 1, 3.

Karlins, N. F. "Four from Coal Country: Friendships & the Contemporary Folk Artist." *Clarion,* XII, nos. 2–3 (Spring–Summer 1987), pp. 54–61.

————. "A Visit to L'Aracine: A Museum of Art Brut." *Folk Art,* XVII, no. 4 (Winter 1992–1993), pp. 57–61.

Kogan, Lee. "Mose Tolliver: Picture Maker." *Folk Art,* XVIII, no. 3 (Fall 1993), pp. 44–56.

Laffal, Florence. "Elijah Pierce's Walking Stick." *Folk Art Finder,* XIII, no. 2 (April–June 1992), p. 19.

Laffal, Jules. "The Life and Art of Walking Sticks and Staffs." *Folk Art Finder,* XIII, no. 2 (April–June 1992), pp. 4–7.

Lampell, Millard. "O, Appalachia—Artists of the Southern Mountains." *Mid-Atlantic Country* (February 1990), pp. 34–41.

Lindsey, Jack. "Selected Works by African-American Folk Artists: A Recent Installation at the Philadelphia Museum of Art." *Folk Art,* XVII, no. 4 (Winter 1992–1993), pp. 62–67.

MacFarquhar, Larissa. "But Is It Art?" *New York* (January 29, 1996), pp. 38–43.

Mai, Anne. "A Little Pepper, a Little Salt: Aaron Birnbaum." *Folk Art,* XX, no. 3 (Fall 1995), pp. 48–55.

Manley, Roger. "Separating the Folk from Their Art." *New Art Examiner,* XIX, no. 1 (September 1991), pp. 25–28.

McWillie, Judith. "Lonnie Holley's Moves." *Artforum,* XXX, no. 8 (April 1992), pp. 80–84.

"Miles B. Carpenter Centennial Exhibition Will Celebrate His Life and Work." *Hand Workshop [Newsletter],* V, no. 2 (April 1989), p. 1.

"Miniatures." *Clarion,* XIV, no. 1 (Winter 1989), p. 26.

"Miniatures." *Clarion,* XV, no. 4 (Fall 1990), p. 23.

"Miniatures." *Clarion,* XVI, no. 3 (Fall 1991), p. 18.

"Miniatures." *Folk Art,* XVIII, no. 3 (Fall 1993), p. 18.

"Miniatures." *Folk Art,* XIX, no. 4 (Winter 1994–1995), p. 23.

"Miniatures." *Folk Art,* XX, no. 1 (Spring 1995), pp. 25–26.

"Miniatures." *Folk Art,* XXI, no. 1 (Spring 1996), p. 22.

"Miniatures." *Folk Art,* XXI, no. 2 (Summer 1996), p. 24.

"Minnie Adkins." *Folk Art Finder,* X, no. 4 (October–December 1989), p. 6.

Morris, Shari Cavin. "Bessie Harvey: The Spirit in the Wood." *Clarion,* XII, nos. 2–3 (Spring–Summer 1987), pp. 44–49.

Murphy, Jay. "Cultural Recycling: The Work of Lonnie Holley." *Raw Vision,* VII (Summer 1993), pp. 20–24.

Parsons, Pat. "Outsider Artist Inez Nathaniel Walker Dies." *Folk Art Finder,* XI, no. 4 (October–December 1990), p. 15.

Patterson, Tom. "Bessie Harvey (1929–1994)." *Art Papers,* XVIII, no. 6 (November–December 1994), p. 57.

Patton, Phil. "The Art of Innocence." *Metropolitan Home* (September 1989), pp. 107–111.

Photograph of S. L. Jones's "Family Group." *Goldenseal,* XIV, nos. 2–3 (April–September 1978), inside front cover.

"Raves (and Execs) at HAI Outsider Art Exhibit in Capital Cities/ABC, Inc. Gallery." *HAI News* (Spring 1996), p. 3.

"Raymond Coins." *Folk Art Finder,* IX, no. 2 (April–June 1988), p. 7.

"Remembering Two of the Best—HAI's Outsider Artists." *HAI News* (Spring 1996), p. 6.

"Robert E. Smith." *Folk Art Finder,* IX, no. 3 (July–September 1988), cover, p. 13.

Rosenak, Chuck. "A Kiln Opening at the Hussey's." *Folk Art Messenger,* IX, no. 3 (Spring 1996), pp. 10–11.

————. "A Person Has to Have Some Work to Do." *Goldenseal,* VIII, no. 1 (Spring 1982), pp. 47–52.

"S. L. Jones." *Folk Art Finder,* X, no. 4 (October–December 1989), cover, pp. 2, 4.

Sargeant, Winthrop. "Joe Gatto, Primitive." *Life* (November 8, 1948), pp. 5–6, 72, 74, 76, 78, 80.

Savitt, Mary Lou, and Jack Savitt. "Jack Savitzky (1910–1991)." *Folk Art Finder,* XIII, no. 2 (April–June 1992), cover, p. 2.

Schwindler, Gary J. "William Hawkins: Master Storyteller." *Raw Vision,* IV (Spring 1991), pp. 40–45.

Screven, Tom. "Red Clay Country Pilgrimage: A Report on Editor's Trip to the Winter Folk Festival at Chapel Hill." *Goldenseal,* II, no. 2 (April–June 1976), pp. 50–55.

"Separate but Equal?" Letter to editor and rebuttal. *New Art Examiner,* XX, no. 7 (March 1993), pp. 2–3.

"Sermons in Wood." *Ebony* (July 1974), pp. 67–74.

Sherman, Joe. "An Arts Program in Vermont That Draws People Out." *Smithsonian,* XXIII, no. 8 (November 1992), pp. 76–87.

Smith, Mike. "Melissa Polhamus." *Folk Art Finder,* XIV, no. 3 (July–September 1993), p. 13.

Sunseri, Don. "Some Notes on Gayleen." *G.R.A.C.E. News* (Fall 1995), p. 3.

———. "Ronald and Jessie Cooper." *Folk Art Finder,* XII, no. 4 (October–December 1991), pp. 10–11.

———. "Slow Time: The Art of Charley, Noah and Hazel Kinney." *Folk Art Finder,* XVI, no. 3 (July–September 1995), pp. 8–11.

Swain, Adrian. "Denzil Goodpaster: Kentucky Folk Artist." *Folk Art Messenger,* XXI, no. 1 (Spring 1996), pp. 8–9.

Thompson, Roy. "Face Jugs, Chickens, and Other Whimseys: Vernacular Southern Pottery." *Folk Art Finder,* XIII, no. 3 (July–September 1992), pp. 16–19.

Turner, J. F. "Howard Finster: Man of Visions." *Clarion,* XIV, no. 4 (Fall 1989), pp. 38–43.

———. "Paradise Garden: Howard Finster Man of Visions." *Raw Vision,* II (Winter 1989–1990), pp. 8–15.

Vlach, John Michael. "A Call for a New Approach to Folk Art: The Wrong Stuff." *New Art Examiner,* XIX, no. 1 (September 1991), pp. 22–24.

"Vollis Simpson." *Folk Art Finder,* IX, no. 2 (April–June 1988), pp. 4–5.

Weiss, Allen S. *Art Brut: Madness and Marginalia. Art & Text,* no. 27 (December 1987–February 1988).

William and Mary Review, XXVI, no. 1 (Spring 1988), front cover.

Wilson, Allen. "Life with PawPaw (Reverend Howard Finster)." *Folk Art Finder,* XVII, no. 1 (January–March 1996), p. 6.

Wilson, Cleo. "A Galaxy of New Stars Discovered at 'Eureka!'" *In'tuit,* II, no. 1 (Summer 1993), pp. 4–7.

Wood, Wilfrid. "Jungle Cats, African Queens and Cold Beer: A Visit with Richard Burnside." *Raw Vision,* IX (Summer 1994), pp. 18–23.

Wright, R. Lewis, Jeffrey T. Camp, and Chris Gregson. "'Uncle Jack': John William Dey." *Clarion,* XVII, no. 1 (Spring 1992), pp. 34–40.

NEWSPAPERS

"Artist Jon Serl Dies at 98." *Antiques and the Arts Weekly,* July 16, 1993, p. 45.

Biggins, Virginia. "Eternal Praise." *Newport News (Va.) Daily Press,* March 5, 1992, Denbigh section.

Conner, Sibella. "Preacher & Artist: From His Faith Mission, Anderson Johnson Paints with Abandon." *Richmond (Va.) News Leader,* February 1, 1991, Flair section.

Constable, Lesley. "Childlike Sense of Wonder Pops Out Merrily at Exhibit." *Columbus (Ohio) Dispatch,* August 11, 1991.

———. "Isik Conveys Warmly Human, Humorous Visions." *Columbus (Ohio) Dispatch,* September 13, 1992.

———. "Ralph Bell's Works Spark Exhibit's Theme: Artists' Sympathetic Spirits Unified in Freshness of Vision." *Columbus (Ohio) Dispatch,* December 27, 1992.

———. "State Fair: Breadth, Excellence Reign at This Winning Art Exhibit." *Columbus (Ohio) Dispatch,* August 4, 1991, Visual Arts section.

———. "Urban Folk Are Likely to Enjoy This Ingenuous 'Folk' Exhibit." *Columbus (Ohio) Dispatch,* March 17, 1992.

Cotter, Holland. "Lonnie Holley." *New York Times,* September 16, 1994, Art in Review section.

Cullum, Jerry. "Strange Parallels: Complex Pleasures of Unschooled Art." *Atlanta (Ga.) Journal-Constitution,* April 19, 1996, Weekend Preview section.

Erickson, Mark St. John. "Vivid Visions: Preacher's Chapel Packed with Lively, Colorful Folk Art." *Newport News (Va.) Daily Press,* August 13, 1989, Arts & Leisure section.

Erlert, Bob. "Folk Carver Miles Carpenter." *Virginian-Pilot* (Norfolk, Va.), December 7, 1978, sec. B, pp. 1–2.

Fayette County (Ala.) Broadcaster, September 23, 1971.

Ficklen, Ellen. "Having Fun with Folk Art." *Washington (D. C.) Star*, November 23, 1980, Home Life section.

Hewlett, Jennifer, and Andy Mead. "Noah Kinney, Carver, Dies." *Lexington (Ky.) Herald-Leader,* September 25, 1991, sec. B, p. 1.

Jaggears, M. M. "Even an Aesthete Praises Humble Artist's Work." *Chesapeake (Va.) Clipper*, December 26–27, 1989, Seniors section.

James, Curtia. "Just Plain Folk." *Port Folio Home,* October 1995, pp. 10–11.

"Jon Serl, 98, Painter; Used Scraps as Canvas." *New York Times,* July 1, 1993, Obituary section.

Kemp, Kathy. "Heartache Reveals Creative Soul." *Birmingham (Ala.) Post-Herald,* November 15, 1993, sec. B, pp. 1, 4.

Louie, Elaine. "Where Art's Outsiders Are Totally in." *New York Times*, February 1, 1996, Arts section.

McGreevy, Linda. "Fun Folks." *Port Folio Magazine,* June 10, 1986, Previews section.

McKenna, Kristine. "Inside the Mind of an Artistic Outsider." *Los Angeles Times*, November 12, 1989, Calendar section.

Merritt, Robert. "Carver's Creativity Gave Joyful Fun." *Richmond (Va.) Times-Dispatch*, June 2, 1985, sec. J, p. 4.

————. "Human Form's Gracefulness Highlighted in Exhibit at UR." *Richmond Times-Dispatch*, January 14, 1991, sec. C, p. 5.

Mydans, Seth. "In Scrapheap Art, a Reason for Hope." *New York Times National*, September 22, 1991, Watts Journal section.

Nusbaum, Eliot. "'Outsider' Aiken's Work in Show." Des Moines (Iowa) *Sunday Register,* February 28, 1993, Arts section.

"Outsider Artist Inez Walker Dies." *Antiques and the Arts Weekly*, August 17, 1990, p. 54.

Payton, Crystal. "Portrait of Robert Eugene Smith." *Maine Antique Digest*, October 1993, sec. C, pp. 8–10.

Reif, Rita. "Memories Filtered through a Rosy Lens." *New York Times,* January 21, 1996, Arts/Artifacts section.

"Saving the Artistry of a Visionary." *New York Times,* August 3, 1995, sec. C, p. 3.

Shinn, Dorothy. "Books Provide Touchable Art Exhibit at Museum." *Akron (Ohio) Beacon Journal,* April 2, 1989, sec. H, p. 4.

Snead, Elizabeth. "Drawing on His Talents: Tony Fitzpatrick, Painter and Actor." *USA Today,* August 19, 1991, Life section.

Trotter, Robert. "Beavers Paints with Uninhibited Whimsy." *Virginian Pilot and the Ledger-Star* (Norfolk, Va.), April 24, 1988.

Wallach, Amei. "The Eye of the Tiger." *New York Newsday,* November 21, 1993, Art section.

Woestendiek, Jo. "Art from Adversity: Georgia Blizzard Takes Her Art from a Hard Life." *Winston-Salem (N. C.) Journal,* August 10, 1986, sec. C, pp. 1, 6.